JAPANESE
STREET STYLE

First published in 2012 by A & C Black,
an imprint of Bloomsbury Publishing Plc.
50 Bedford Square,
London WC1B 3DP
www.acblack.com

Text and images copyright © Pat Lyttle 2012

CIP Catalogue records for this book are available from the British Library and the US Library of Congress.

Publisher: Susan James
Copy Editor: Julian Beecroft
Book and cover design by James Watson

ISBN 978-1-4081-5671-1

Printed and bound in China.

JAPANESE STREET STYLE

PAT LYTTLE

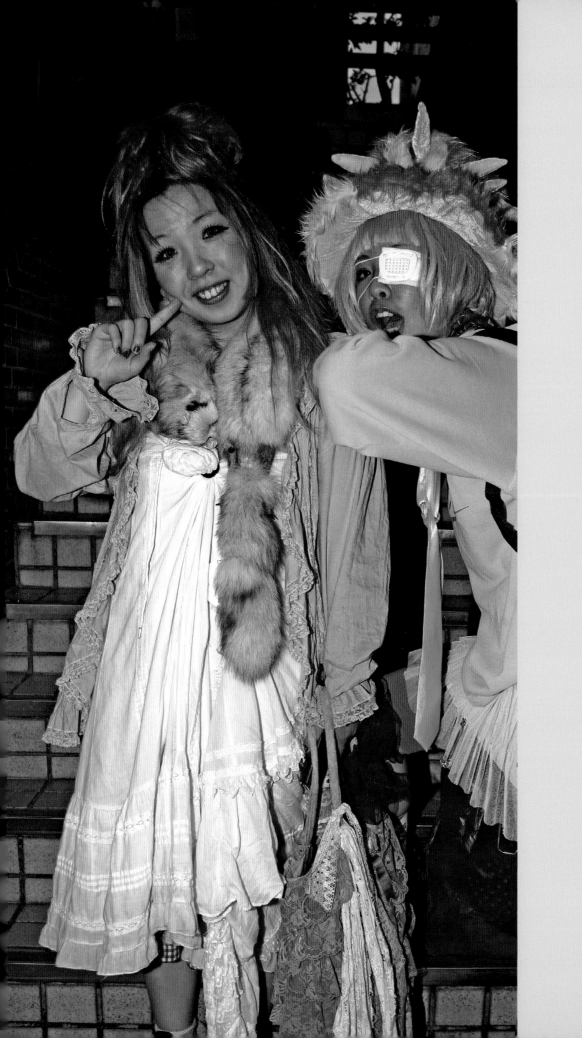

Contents

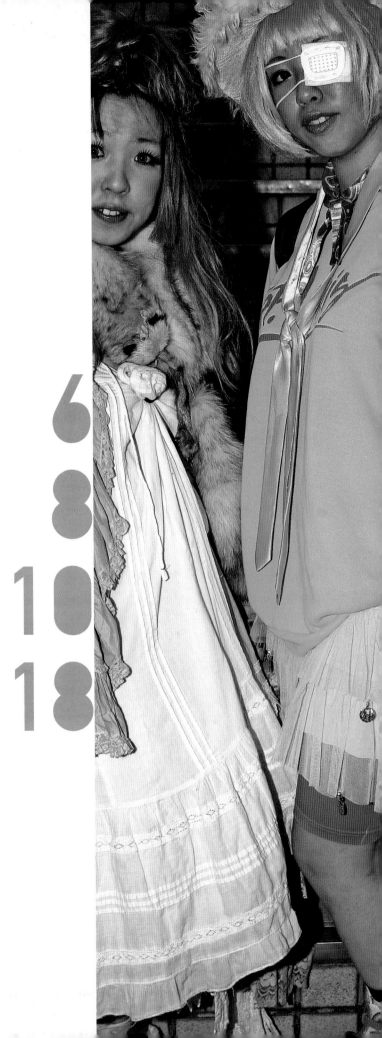

Foreword

A published photographer specialising in Japanese culture and street fashion, I started taking an interest in photography in my late teens when I first saw a copy of Vogue and was inspired by the glossy artisan approach to the images within the style bible. I wanted to take pictures like those I saw and, being a fan of silver-screen Hollywood, considered it to be the natural starting place. Years later, having taken pictures of Betty Davis, Joan Collins, Diana, Princess of Wales and a constellation of other celebrities and stars, I began to publish my celebrity images and soon afterwards gave up my profession as a chef specialising in Japanese cuisine, to pursue a career as a showbiz photographer. Although totally untrained in this field, being

on the street day and night taught me many photographic techniques. All that hands-on experience paid off as national newspapers and international magazines began publishing my images.

Japan has always been close to my heart and imagery always a vital part of my life. I developed an appetite for fashion magazines and started really paying attention, soaking up what I had read. I soon found myself asking the various celebrities I photographed what they were wearing and why. My interest in fashion was born without my being aware of it. In fact, it was only years later, when I finally got my chance to visit Japan for the first time back in the late 1990s and was amazed by the immense sense of style of Japanese people, both young and old,

that I realised that this was what I really wanted to do.

Street fashion was where I found I could get the people I photographed to interact with me in a way that made for a more exciting image rather than just a straightforward snap. It was my own fun angle on fashion.

At this stage I had given up photographing the rich and the famous, choosing to work in the picture-editing industry on editorial and entertainment imagery.

I work on fashion shoots, styling and doing the photography. I always keep an eye on fashion within Japan – both mainstream and alternative, and know what is happening on the streets of Ginza in Tokyo or Osaka as well as in London where I am currently based.

In the late 1990s in Harajuku in Tokyo I bought several fanzine-type magazines called Fruits, created by photographer Shoichi Aoki. He was doing what I was doing. Street fashion has since become so popular it is now a major influence on mainstream fashion not only in Japan but globally. While many photographers shoot street style today, I have tried to retain the fun, interactive nature of the images I produce, where a certain spontaneity is introduced to the subject, I hope adding a little magic to it along the way.

This is my style and though primarily I am recording fashion trends I see before me, I'm also paying homage to the very people that create those fashions. I study what they have to say though their expressive styling and presentation. Some may find it shocking. Some may not understand it at all. But many have come to love it. I am one of them and my wish is to share how I feel about these people and what they are doing.

I just try to be a part of it in some way. With my camera in hand I can play along.

The young people of Japan have a wonderful energy. I love seeing it expressed creatively in a way that is rare in the West. When it comes to fashion you'd be mad not to turn to the streets of Tokyo or Osaka for inspiration.

JStreetstyle

Japan has a rich and exciting culture, a mixture of strong historical reference and the modernity it has embraced from Western influences. Taking strong visual cues from Western cultures, Japanese culture has developed and adapted them incredibly well to suit its people. Over the years the country has also become one of the strongest stages for fashion and style in the world, yet it remains very modest about its status as such. We all know about the titans of the fashion world, the fashion-week circuit – Paris, London, Milan and New York – and the major style influences and trends. But many aren't as aware of the incredibly powerful role Japan's capital city, Tokyo, plays within the greater scheme of Western fashion.

The big designers have for many years sought inspiration in Tokyo's rich visual culture of fine textiles and techniques, its classical and historical costumes forming rich palettes to work from.

But in recent years the streets are what have aroused greatest interest in the West. Tokyo itself seems only modestly aware of the true impact it has on the global fashion industry. Tokyo teens, in and around the style Meccas of Harajuku, Shibuya, Shinjuku and even the classy upmarket area of Ginza, live in their bubble world, happy to focus their ambitions on being featured in one of the many popular Japanese fashion magazines that focus on what they call 'street snap'. 'Fruits', 'Street' and 'Kera' are just a few of these influential titles, but there are many others.

What a wonderful bubble to live in. Why would one venture out or care what lies beyond when the life of a stylish Tokyo teenager seems so perfect? Dressing up, cruising the streets to be greeted by the media lining up to interview you and put you in one of their glossies. What more could you want when fashion is your passion and your obsession?

The reason for all this interest in Japanese teenagers is their uniquely fertile sense of style. Walk through the streets of Tokyo or downtown Osaka – Takeshita Dori, Omote-sando, Amerika Mura. These are names you might have seen from time to time, and you'll hear many Westerners describe them as 'another world' where these sartorially creative teenagers congregate. These teenagers are able to create a visual look in a way the greatest of the fashion designers aspire to.

In the West, there is a fashion rule book. The magazines love to quote from it. Telling us what we should and shouldn't wear for the seasons approaching as well as the current one. You must not do this, you must do that. Wear only this colour, what and how to mix and match. For many, these fashion rules are adhered to without question.

The Japanese mind, on the other hand, is very different to the Western mind, and that of a Japanese teenager even more so. They have a definite interest in what's hot and what's not, but they will use all those rules and ideas to fertilise and cultivate their very own style. It is this independent streak that has turned the world's attention to the streets of Tokyo and surrounding cities like Osaka, because there is no more lively playground for style than you'll find here. There are so many fashion tribes, so many trends, so much to choose from here, but more importantly these areas are so rich in

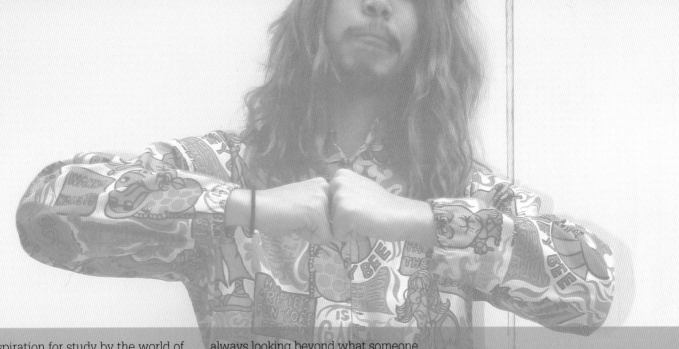

inspiration for study by the world of fashion because what these kids do is unique.

They will take something from a major designer and totally rework it in a way the designer would never have imagined. This has been going on in many subcultures of Japanese society, such as the growing Otaku culture. The Otaku, their their obsessive focus and passion for fashion, has attained a revered social status, because they spot things others normally do not. Street fashion has become such a global phenomena precisely because it is so local and individual, it is the antidote to the high street. Most major mainstream fashion publications now have pages dedicated exclusively to street fashion, while the number of online street fashion websites and trend-analysis agencies taking their cue from street style has exploded in recent years.

JStreetstyle takes a slightly different approach to things. Yes, there's a strong passion for fashion and for Japanese culture, but the focus at JStreetstyle is on the motivations and the individual personalities of the people photographed.

Style is an expression of one's feelings – how you feel and how you choose to display those feelings visually. This is what I try to get from the various people I encounter. I am always looking beyond what someone wears, trying to look within. Many times you see it but can't reach it. But there are rare moments when an opportunity arises for the quality you see in a person to manifest itself, adding to the picture, creating a street fashion image that's different because the subject, that crazy teenager or colourful old man, refuses to let go of his sense of wonder and fun, which, as adults, we're told is childlike and most leave behind.

This interaction is what I seek above all in my images and luckily many people I photograph give freely, willingly, and generously of themselves, granting us a glimpse of true individual style. It's something that is becoming increasingly rare in the West, which is precisely why street fashion in Japan has become such a big deal. In Japanese society individuality has traditionally been viewed as less of a positive thing while the group identity is strongly enouraged. Here, as elsewhere, the looks created by large fashion houses and brands cause everyone to appear more stylish but at the same more alike. But in Japanese teenagers from Tokyo to Osaka you'll find possibly the largest concentration of individual style on the planet, a unique teenage culture of individual self-expression that seeks neither understanding nor approval, but just to be itself.

Fashion Tribes & Trends

In order to better understand the images within this book, here are some brief explanations of the many style tribes and trends you'll see on the streets of Tokyo and Osaka. Some of these have become so well loved in the West they've now migrated well beyond the borders of Japan, finding their way into Gwen Stefani music videos via the famed Harajuku Girls, while Loli Goths and even Cosplayers are becoming a more mainstream occurrence on the streets of London, Paris and New York.

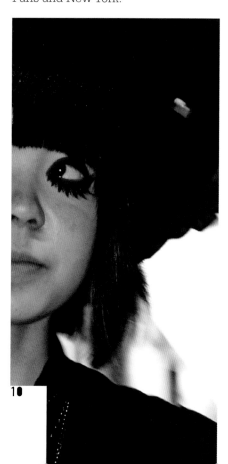

Classical Lolita

This style leans towards the darker tones of black and white with dark browns, deep reds and smoky shades, but also sometimes pastel shades. The look is also about the origins of the Lolita style, and features A-line skirts or dresses and a more Victorian feel with demure, elegant shapes. It's a classier style of dress rather than the fun and playful Sweet Lolita style. Patterns and motifs on dresses and skirts are of a more traditional nature, simple yet elegant, unlike other styles such as Sweet Loli, with its teacups, cakes, cherries and other cute, pretty motifs.

Wa-Loli and Qi-Loli refer to Chinese and Japanese fusion styles of Lolita.

Gothic Lolita

A darker version of the Lolita style, taking its cue more from Eastern European countries, and characterised by exaggerated and extreme make-up, such as black lipstick, and use of religious symbols such as large crucifixes.

Punk Lolita

Similar to Gothic but more street-style-focused and influenced by London's punk scene, with ripped or slashed trousers and tops. Bias cutting is the norm with this style.

Elegant Gothic Lolita

A more sophisticated version of Gothic Lolita often using the Victorian or Edwardian look as a point of reference. Serious EGLs often wear original items of Victoriana in place of the well-known Japanese EGL brands. Corsets play a large role. Well-known brands are Sexy Dynamite London and Moi-même-Moitié.

Elegant Gothic Lolita is predominantly black and white. As with everything cool and much-loved by Japan's teenagers, the name Lolita is often shortened to Loli. Extreme make-up is also a feature of the Loli style.

Kuro-Loli and Shiro-Loli refer to Black Lolita and White Lolita respectively.

The most popular dresses are in a monochrome palette.

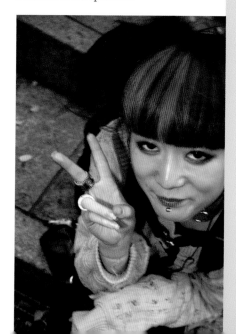

Sweet Lolita

A very pretty and succinctly focused form of the Lolita style, where the focus is more on doll-like perfection, with pretty pink dresses or skirts with pinafore tops and a frilly, elaborately laced blouse underneath. Pastel colours appear for the warmer seasons, while darker and deeper blues, reds and other hues are reserved for the winter. Cute socks with delicate patterns of cherries, hearts or musical notes are worn with a mixture of footwear ranging from patent black, red or white Mary Janes to large wooden-soled, Japanese-inspired geta sandals designed by Vivienne Westwood. Winter-wear versions of this look will often include fur-lined skirts worn with boots rather than shoes. Make-up on a Sweet Lolita is cuter and more fun, doll-like, so cherry or pink rouges are the norm, often with false eyelashes and a small hat or bonnet placed to the side, with cute adornments of hairclips shaped as fruit, teapots or slices of cake. Accessories such as bags or parasols are often used all year round.

Dolls themselves also play a vital part in the look, with many of the girls carrying a doll dressed exactly as they are. These can range from Blythe dolls to larger ball-jointed dolls such as the Dollfie, but the popular choice seems to be the Pullip doll with its perfect look and ideal size to fit in a bag. Sweet Lolitas also wear bag-shaped dolls or bears on their backs.

Sweet Lolita is a fun style and for obvious reasons these girls are often referred to outside of Japan as Frillies or Frilly friends. I love the look for its strong, perfect visual style. A Sweet Lolita fashion shoot is one of the most fun shoots to do.

Well-known brands are Baby, The Stars Shine Bright (often referred to by teenagers as Baby, Angelic Pretty), Metamorphose temps de fille, Milk, Innocent World, Putumayo, Excentrique and Victorian Maiden, to name a few.

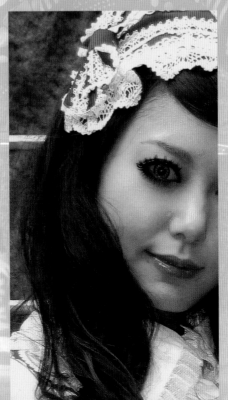

Male Lolita

Boys also have a role to play in the Lolita look, though the masculine version goes by different names: Kodona (from the words kodomo and otana, child and adult), Oji and Oji-sama. It is a dandy look with trousers or jodhpurs just below the knee or just above the ankles, and socks with brogue shoes or velvet slippers. If one can have embroidery on them, such as those of Christian Louboutin's Autumn/Winter 2010 collection, then so much the better. A waistcoat, possibly velvet or satin, is another part of the look, with a frilly shirt emerging from underneath, sporting large, open, frilly sleeves, and a high-neck collar or flat lace lapels. Pageboy looks with corduroy pantaloons are also typical. The classic influence is often that of a Victorian boy rather than a man. The look is often referred to as being Prince-like, a good fusion of man and boy.

Punk Lolita

This is often a more deconstructed form of Lolita style with the use of metal fastenings, chains and bias cutting as opposed to traditional cuts, unfinished hemlines, and a colour palette of black and white with red and/or deep-blue hues. Black Peace Now, Stigmata and h. NAOTO are major brands with a huge following.

Guro Lolita

Guro Loli is a style you often see at Yoyogi Park in Harajuku on a Sunday afternoon. Guro refers to grotesque or injured. The look often has punk elements but you'll see the Loli wearing an eye patch or mask often with fake blood stains. Occasionally, you'll see an arm sling or an apron again with spatters of fake blood. Sometimes the look includes a damaged doll as an accessory, perhaps with limbs missing.

Kogal or Kogyaru

This style is a subtle reworking of a school uniform with a blue or beige colour overall. Oversized white socks or legwarmers are a feature of this look, along with very short, pleated miniskirts topped by a sweater with a blouse underneath. There's also the obligatory mobile phone (or keitai, as it's known) with a multitude of pendants, good-luck charms and cute adornments hanging from it. The hair is long and dark or, if she's from Shibuya, long and bleached blonde against a tanned face.

Dolly Kei

This is a relatively new style taking its visual queue from Eastern European folklore and fairytales mixed with vintage clothing in woodland or autumnal colours. Dolls often sport their own strange doll faces or even carry damaged and dismembered dolls. The girls have an air of cuteness about them, their hair in plaits or a fringed bob cut. Tokyo is famed for its many stylish hairdressing academies like Shima and Block, which produce sharp or classic cuts to suit this look.

A Mecca for Dolly Kei is the shop Grimoire. Tucked away above various fashion shops in Shibuya, it has the most impressive array of visual delights for anyone into this look, with Victoriana and vintage European dresses. The shop has a distinctive personality that it's hard not to fall in love with: it is like stepping into a fairytale, an idyllic gypsy land with clothes to match. It's a look of pure fantasy and escapism that the shop's staff wear to perfection, but in a cute and soft way with the edges rounded off by a touch of the odd or unusual from the world of dolls or the stories and tales it draws inspiration from.

From time to time among some Dolly Keis you may see old books peeking from a bag.

Visual Kei

This is among the most striking looks, and one of the most well-known in the West thanks to the kids dressed up on a Sunday afternoon in Yoyogi Park by Harajuku Station. Kids would take the Yamanote Line, change out of their school uniform in the station restrooms, and emerge transformed into something like a rock star with a look straight out of 1970s glam rock. Extreme make-up with equally striking hairstyles take inspiration from many of the big Japanese rock bands of the 1990s, such as Malice Mizer, X, Japan and Glay.

These bands had a strong visual look that fans imitated in adoration of their idols. Think of Western groups like Kiss with their distinctive monochrome make-up. Now add colour and a surgeon's mask with blood stains. The look appeals to both boys and girls. The boys' looks are often more carefully constructed and visually effective than most of the girls'. Today the Visual Kei look has evolved to encompass softer boy-band looks, but make-up is always at the centre of the style.

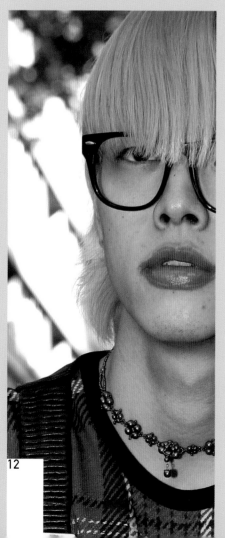

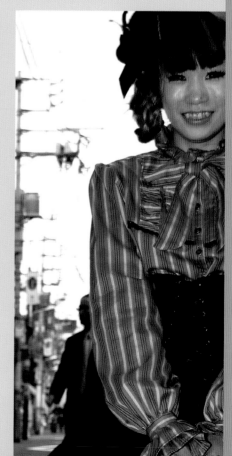

Ganguro

Of all the looks and styles in Japan's many fashion tribes, possibly the most striking and visually extreme is the Ganguro. Rebellion plays a vital part in the life of a teenager. While Western teens are almost expected to behave outrageously, in Tokyo or Osaka the rebellious Ganguro looks, which were hugely popular from the mid-1990s to about 2004, caused outrage among many parents, who felt ashamed and were left wondering where they had gone wrong.

The look was simple. The aim was to shock and this it did to the extreme. Girls primarily, but boys too, bleached their hair as silver-blonde as was possible, then tanned their skin as dark as possible. Make-up was extreme.

With the aforementioned canvas now set, oversized eye shadow in white or silver was then applied in a haphazard approach often lampooned by many Japanese fashion mags except the look's style bible, 'Egg Magazine', which is still going strong today. Make-up was thought to be so scary that the name Yamanba was used, referring to the Japanese folk tale of the scary, ghostly figure with terrifying make-up.

The clothing chosen by the teenager seeking the Ganguro look varies from distressed Japanese school uniforms to the more popular affiliation with surf culture and the US cartoon characters Lilo & Stitch. Flannelette towelling or clothing with images from the Lilo & Stitch shows, even fluffy bedroom slippers, were part of the look, as were shorts, miniskirts or sarongs with bright and clashing colours. Offence and rebellion was the game, and the teenagers that played it loved it. A silent rebellion, Ganguro was still a distinctive style, tribe and trend.

Cosplay

The name derives from the words 'costume play' and is another of the trends unique to Japan which has evolved and emigrated from Japan's shores and can now be seen in London, Paris and New York. The aim is to dress up in the style of one's favourite anime, manga or gaming character. Some people even go as far as to assume the personae of these on-screen characters, carrying giant swords and guns (obviously non-functioning). Today the best cosplayers go to conventions to amaze onlookers with costumes that are incredibly detailed reproductions of the cartoon originals.

On the street the look is watered down somewhat, but the white overalls of a medic or a blue jacket and black trousers are common looks, while brightly-coloured wigs are always popular.

Furry Tails

This trend is hugely popular in Tokyo, especially in the Shibuya area. Young girls and boys, and even adult men and women, can be seen with a fur tail dangling from the back of their shorts, trousers, skirt or bag. Most are faux fur, but the real ones tend to be fox fur. Japan has long had a love affair with the charms of fur, unlike in the West, where the wearing of fur provokes strong reactions. To Japanese teenagers it's just a fun trend they want to enjoy.

Fur

For the Autumn/Winter 2010 season, fur was an obvious hit trend. When Karl Lagerfeld strutted his models around an icy glacier in Paris for his Chanel Autumn/Winter 2010 collection wearing fur boots and fur legwarmers, light bulbs in many a head flashed 'WOW!' Shops wasted no time in stocking this overnight winning trend, especially one that had been so warmly embraced by the hip girls of Shibuya in Tokyo. Boots, legwarmers, hats, bag inlays, fur-lined ponchos, mittens and hoods abounded; fur was a guaranteed hit for both buyers and shoppers hungry for style.

Denim shorts

For the summer and warm autumnal months, denim shorts are hugely popular among women and teenage girls. It's a look that women the world over know well. Every girl wants longer legs; wear denim shorts and you're halfway there already.

Date Megane

Pronounced 'da-te me-gan-e', this look stems from the current trend for 1980s-style, oversized black-framed glasses. Now growing in popularity among both male and female celebrities in the United States, on the streets of Tokyo the girls take things one step further and wear their glasses with no lenses. The prettier the face, the larger the frame is the standard equation. So popular is this look, boys and men of all ages are wearing it too. Some girls say it makes them look smarter, some say cooler. Women in their thirties and forties say it makes them feel and seem younger. You can't miss this look; it is everywhere and it is pure fun.

Decora and Kawaii

This is possibly the look that people in the West most readily associate with Japanese street style and fashion. The name derives from the rather obvious word 'decorative'. Japanese teenagers love to shorten well-known words. It's cool, it's cute, it's Kawaii.

In Japan, kawaii is a word frequently used by teenagers. The closest western translation is 'cute' or 'cuteness', but it means much more than that. Cuteness in Japan is not frowned upon as childish or childlike as it is in the West, but rather is much preferred to 'sexiness'. A fashion shoot in the West will tend to have a more sexual look, with posture and clothing leaning towards sexuality, whereas in Japan a fashion shoot will have a brighter, more colourful, cute and playful feel. This works a treat with the Kawaii look.

The look has cute hairstyles and an assortment of colourful hair accessories to match. Shoes or trainers are oddly matched in colour and the same approach is applied to socks, tights or leggings. Shoelaces are swapped or replaced by different-coloured pieces of lace or even rope.

At the heart of the look, other than the fearless, expressive use of colour, is the skill and art of multilayering. Nobody does multilayering like a Japanese teenager from Harajuku in Tokyo or Ame Mura in Osaka. Many mainstream fashion designers embrace it, sometimes to good effect, but they're not a patch on the street teens in Japan.

With vibrant use of colour at the heart of this look, the classic Japanese take on the West is always in play. Young teenagers will use Disney characters on T-shirts and dolls. Stitch from Lilo & Stitch is very popular, as is Mickey Mouse. Barbie dolls and Teletubbies can be seen hanging from chains around the neck or waist.

Cuteness works its way into most parts of this look, including make-up as well as hairstyles.

Be it Harajuku girls, the girls of the 6% DokiDoki shop or vintage maidens, the look of Kawaii and cuteness is a style in itself and holds in thrall Japan's many fashion mags and also a growing number of similar titles around the world.

Cool Britannia

The flag of the UK became a huge fashion trend for summer and autumn 2010. In and around Tokyo many teenagers can be seen wearing the distinctive red, white and blue Union Jack. Through scarves, bags, shoes, sweaters and cardigans it's safe to say Japan's teenagers have a special relationship with the UK from which many a politician could learn a thing or two.

Kigurumi

In winter or when times are colder such as after dark when walking down Takeshita Dori, one of the coolest and most vibrant streets in Harajuku, you can often come across a girl, or even a few of them, dressed in a cute animal costume. This is Kigurumi. It's often worn indoors

when the weather is cold. Imagine groups of friends sitting on the floor watching the TV or gaming with snacks in front of them. Outdoors the fun continues as teens in costume hold hands. What you see, walking past, are tree bears and pandas strolling down the street.

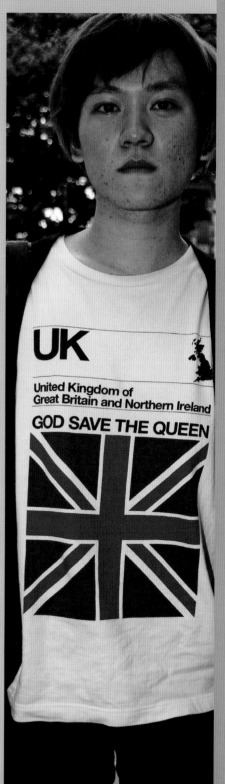

Street Style

The images within this book represent a fraction of the amazing style and talent you'll come across as you stroll through the streets of downtown Tokyo or Osaka. Nowhere in the world is style so abundantly expressive as on the streets of Japan. It has drawn attention from around the world, from the domestic citizens going about their everyday lives to the tourists and even international fashion designers seeking inspiration. Every day, whatever their motivation, you'll see teenagers and adults trying their best to express how they inwardly feel in how they outwardly appear. All eyes turn to Japan when it comes to street fashion, and street style, as it is popularly known, is a strong, confident means of expressing one's identity through style in a truly individual way.

Many of the brands mentioned within this book are international, although they were born within Japan. Thanks to the internet, many have global recognition and devoted international followers. You can see people in Paris, London, New York and elsewhere around the globe wearing Japanese street fashion brands. Even high-profile celebrities such as the British Oscar-winning actress Helena Bonham Carter, herself a fan of Japanese Gothic Lolita, demonstrate an understanding of the importance of individuality through style expressed in this way.

Some young people today want to be famous, some mainly want to be noticed, but most just feel a compulsion to be themselves and to express that in the best way they can. It's been a natural thing for the teenager, ever since the term was coined in the early 1950s, to express themselves visually through clothing. Today's fashion-focused Japanese teenagers are highly imaginative and creative, and some even end up being headhunted by design houses to become fashion designers and stylists themselves.

We see this in a classic example in the cult movie 'Shimotsuma Monogatari', known in the West as 'Kamikaze Girls'. The lead character Momoko, played by J-Pop singer and actress Kyoko Fukada, is a fan of sweet and elegant Lolita style and makes her own creations with the most exquisite and intricate of details. Due to her passion and skills, her dreams are answered. Strangely, as a result of this movie, the quiet city setting of Sendai, where both Momoko and the actress who plays her originated from, became a Mecca for Gothic Lolita fans. The very same Sendai that tragically experienced the terrible earthquake in March 2011 was often referred to as Loli Central.

Next time you're commuting into work, or watching a music-video TV channel, see if you can spot a badge or T-shirt from Bathing Ape, or a Hello Kitty bag, or a skirt or blouse from Baby, The Stars Shine Bright or Angelic Pretty, or a T-shirt or jacket from Super Lovers. Chances are you'll spot a few wherever you are.

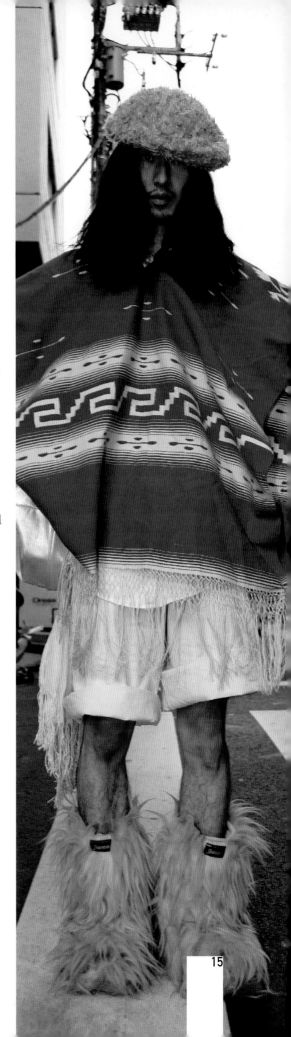

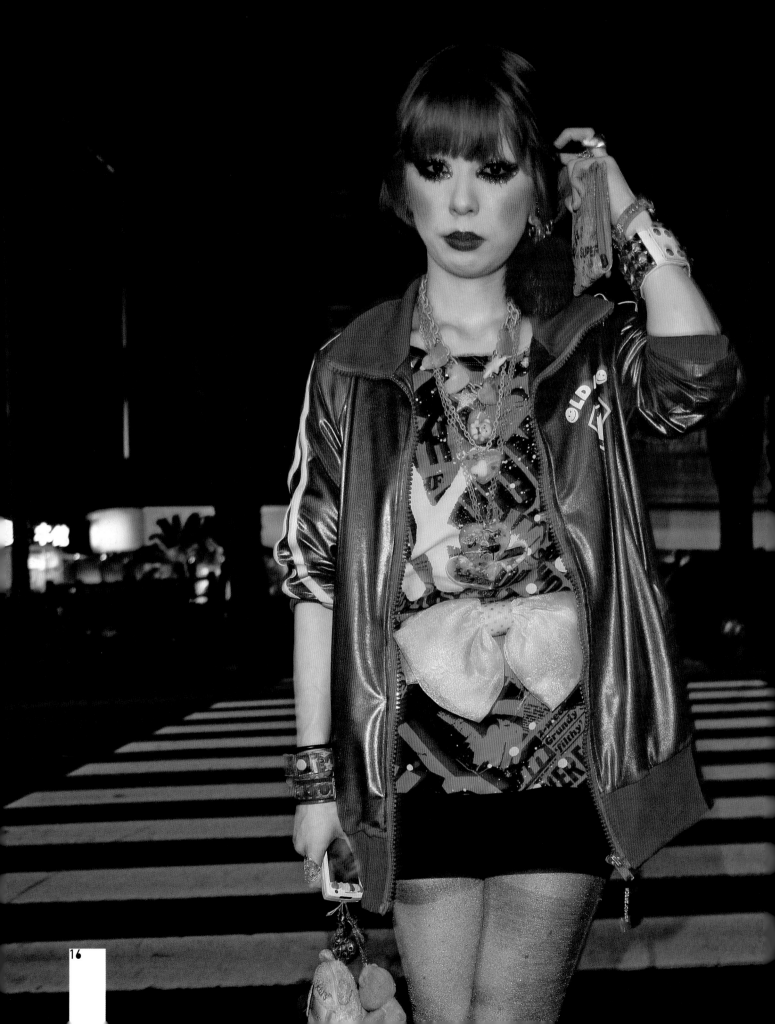

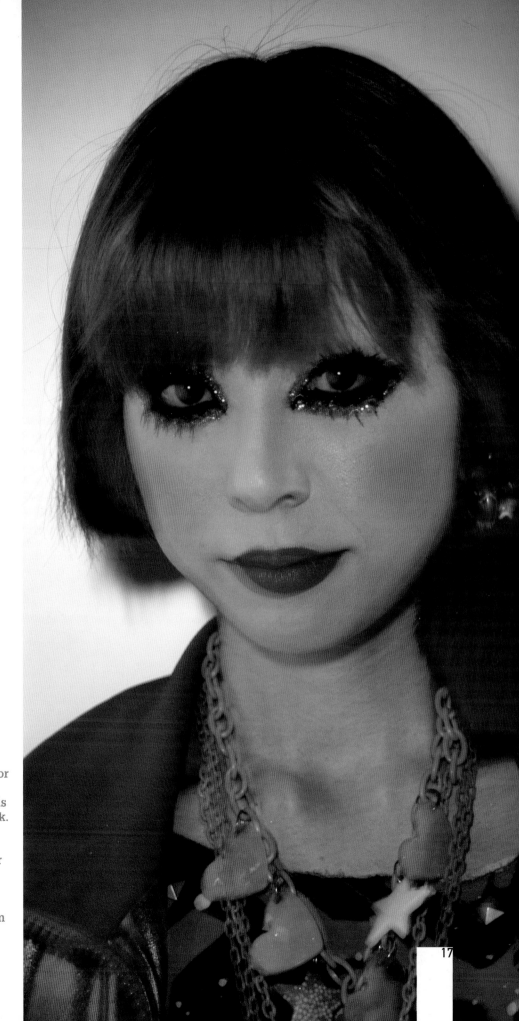

< Erika, a model for Japanese fashion brand Super Lovers. Here you can see her in all her technicolor glory. As with many of the brands it's all about the finer details, in this case a celebration of the colour pink.

> Erika poses for a portrait. Stars and hearts are are strung round her neck. Bright colours, a fun feel and eyes that sparkle are all courtesy of the brand, but it's Erika's own beauty that really shines through in this image.

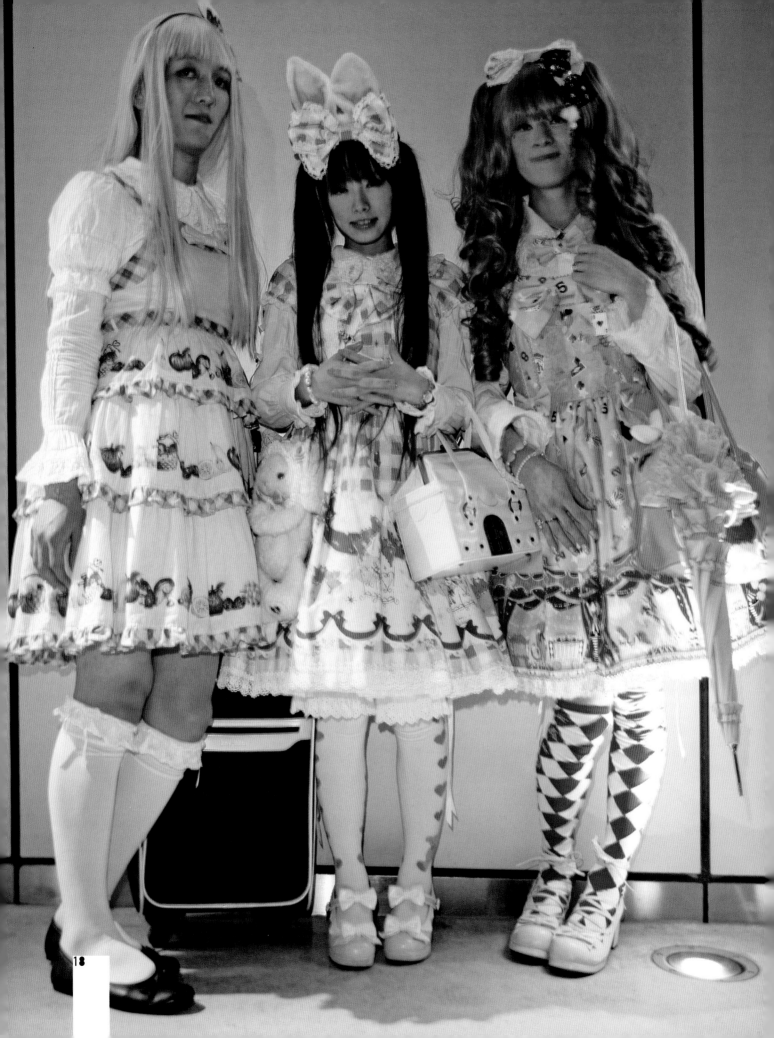

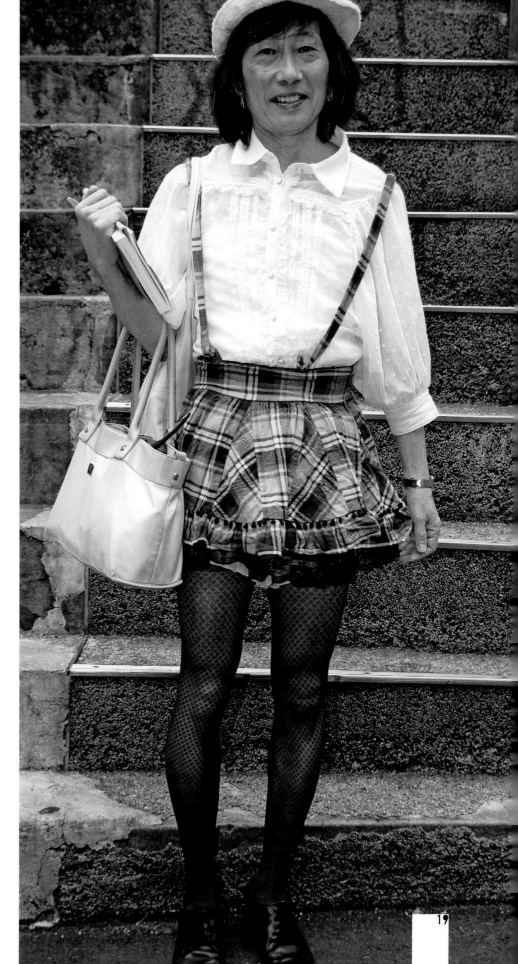

> **Crossover.** A man dressed as he feels: comfortable and stylish. Just take a look at the trouble he has taken to get the look: the blouse, the skirt, the tights, even the bloomers. Freedom of expression epitomised in style.

< **Crossing over.** It's always good to know you have the support of a friend at the centre of things to hold your hand. All three here are wearing Sweet Lolita-style dresses with a blouse. Cross-dressing is quite popular in and around the Harajuku area. It's something many either take for granted or never notice, but if you're open to it, or a skilled people watcher, it's good to spot the rather larger Lolis as they stride down Omotesando, occasionally causing you to do a double take. For whatever their reason to dress the way they feel, I admire these men who are brave enough to be themselves and to do it with style.

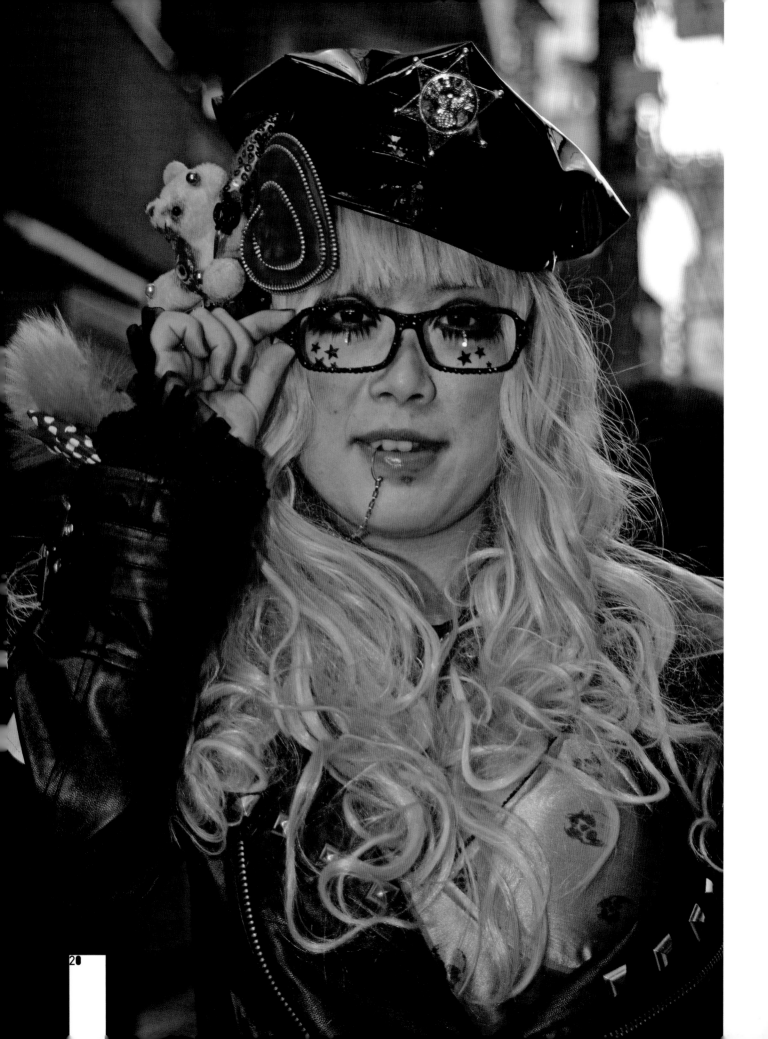

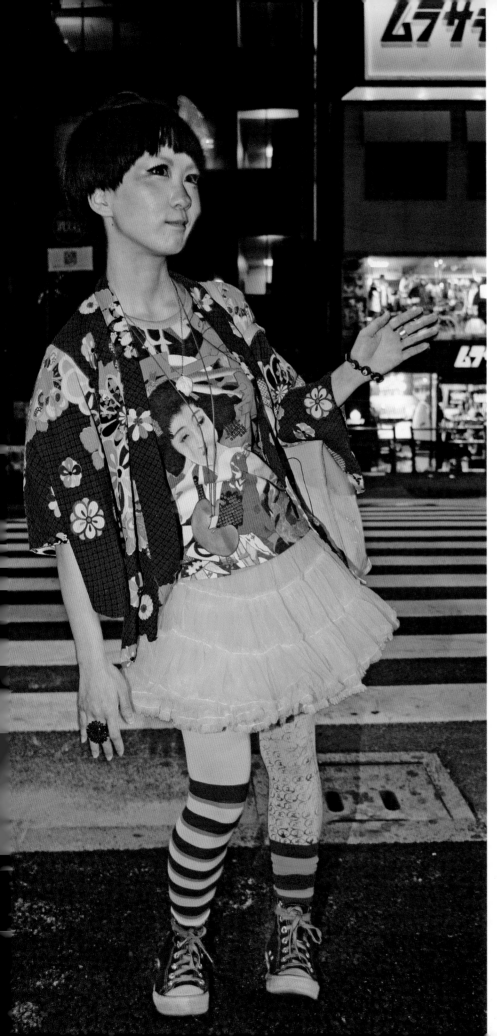

<< Trail blazer, star gazer. With stars in her eyes, this biker babe shines brightly with her leathers softened with pink and cute accessories.

< Mizuho from Tokyo strikes a pose. I stumbled across this amazing little dynamo of style (with the name of a pop group) at the foot of Takeshita Dori. Speaking perfect English which in Japan is never English but more accurately American, she informed me she was just out shopping for something new. Her style fuses Japanese and Western, a flower-print kimono or yukata with a lime-green tutu.

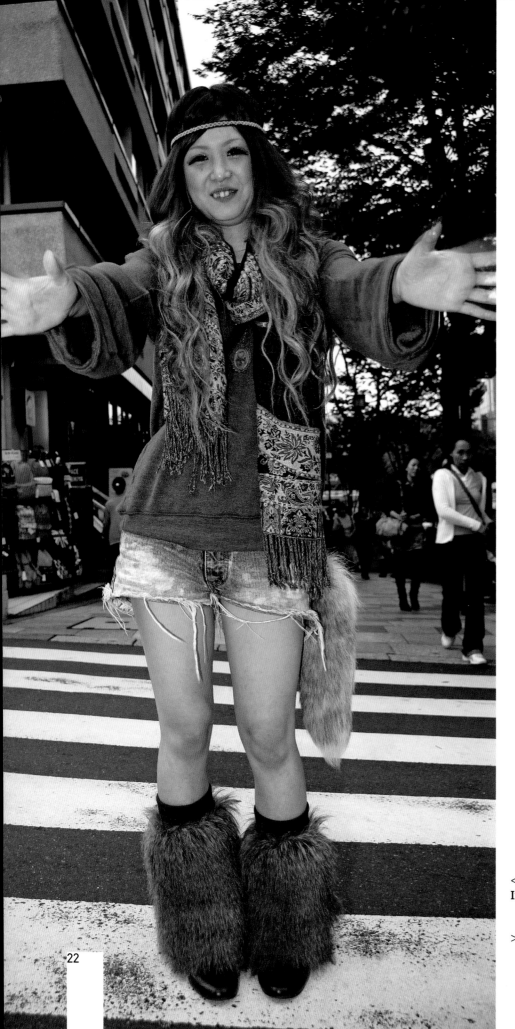

22

< A happy welcome with open arms.
Irrashaimase.

> A joyful mix of eclectic styles.

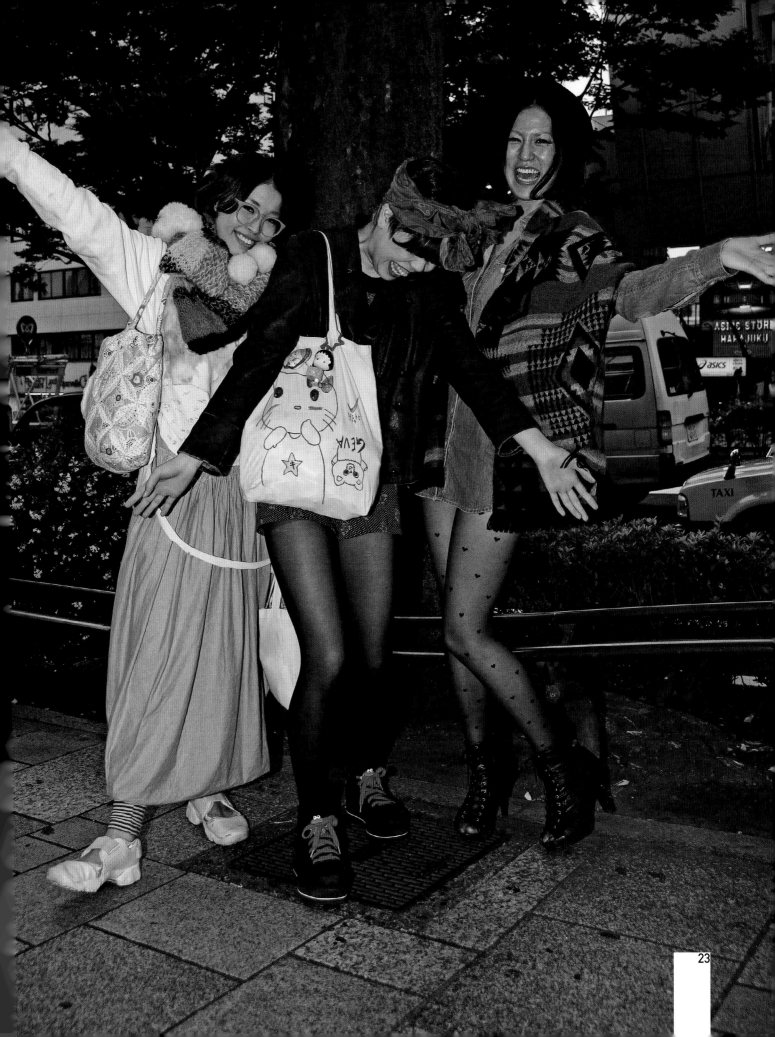

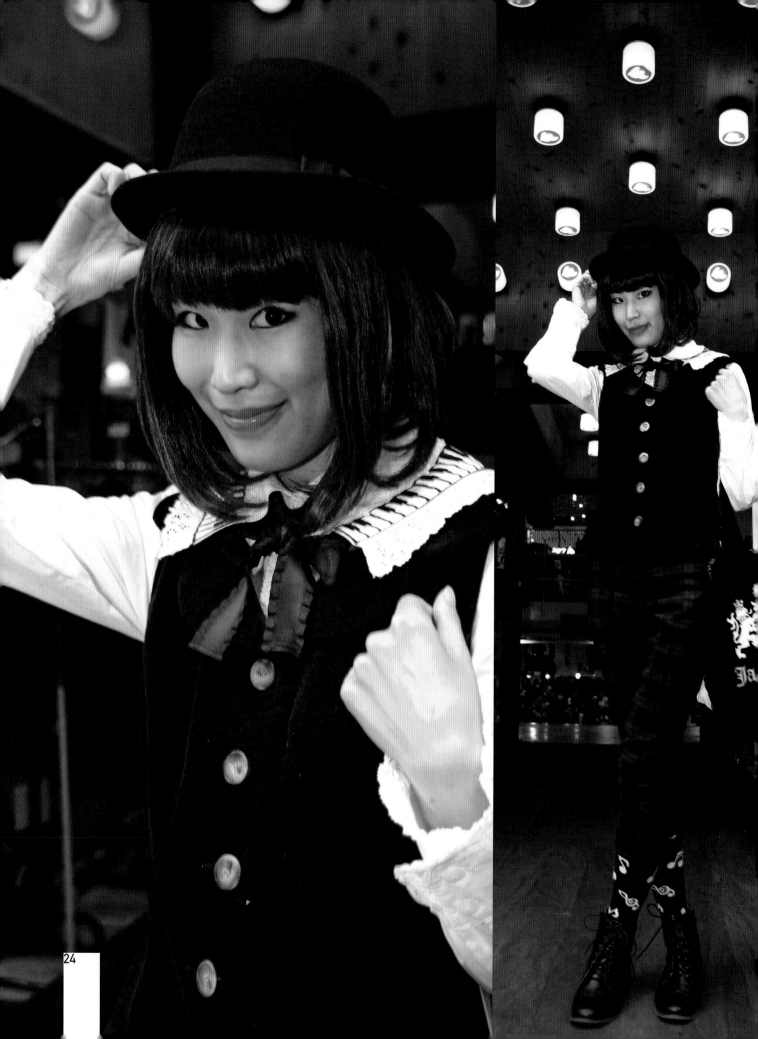

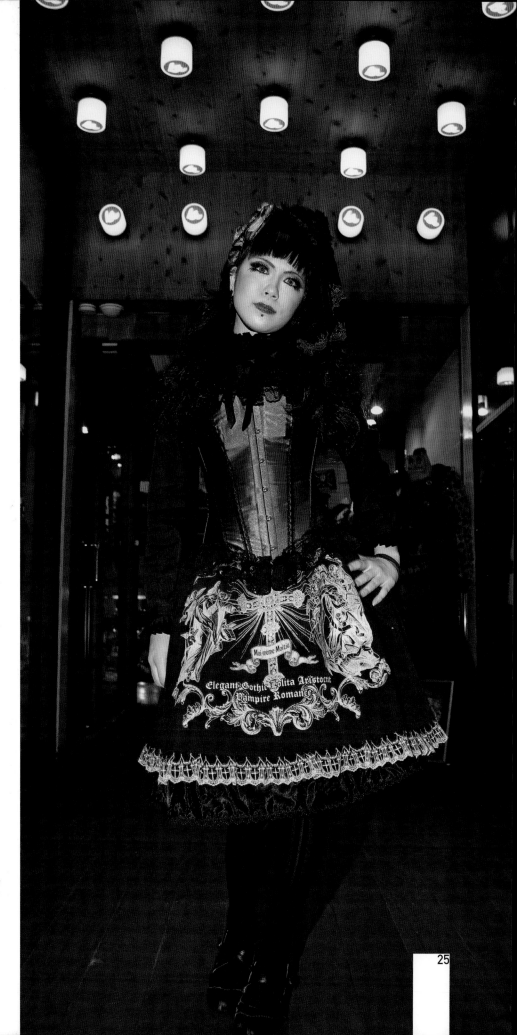

<< Ayako from Kyoto dressed in the Kodona style of Gothic Lolita. I love the finer details of her look, like the delicate piano-key detail on her blouse collar, and the satin tie. The traditional bowler really suits her too.

< Dandy Candy. Ayako's top and waistcoat are from Emily Temple and Innocent World. Her trousers are from Uniqlo and her bag is by Jane Marple – all big names in the world of Lolita style and culture. I love the finer details. Her 'foot notes' finish the outfit perfectly.

> Gothic Lolita style. This young woman models a striking corset and skirt by Moi-même-Moitié, one of the Lolita mega-brands. Looking black and blue sometimes isn't all bad when you're a teenager in Ame Mura.

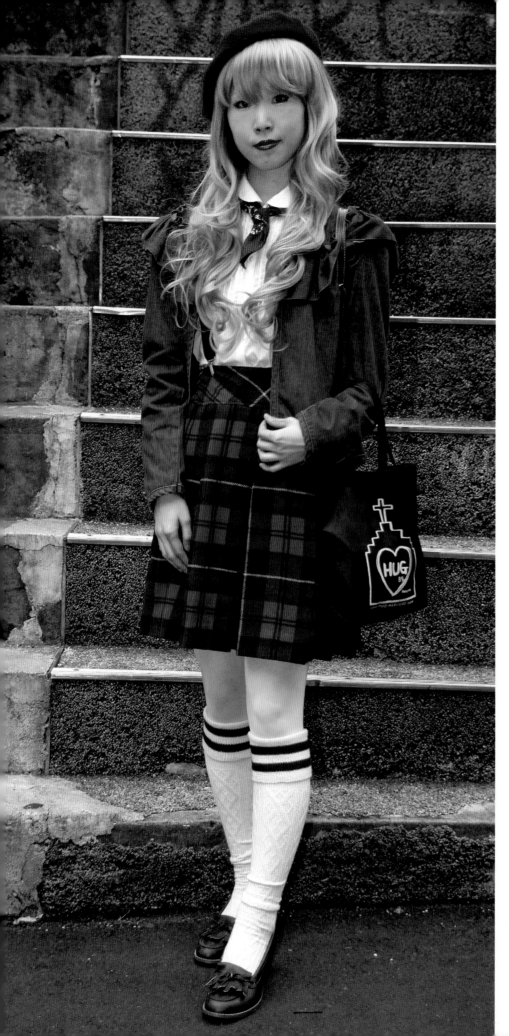

< **Hannah from Nagano dressed in Euro-prep style.** Done to perfection with her perfect blonde flowing locks (very likely a wig), the combination of detail and presentation is a delight. It's all there: the red beret, the patterned socks with red stripes, the tartan-print skirt delicately held in place using braces, and the perfect white blouse with a dainty red tie.

>**Jump street.** These two young women have a passion for all things Jamaican. They love the music, the culture and, in the sweltering summer heat on this particular day, they're perfectly dressed to enjoy themselves.

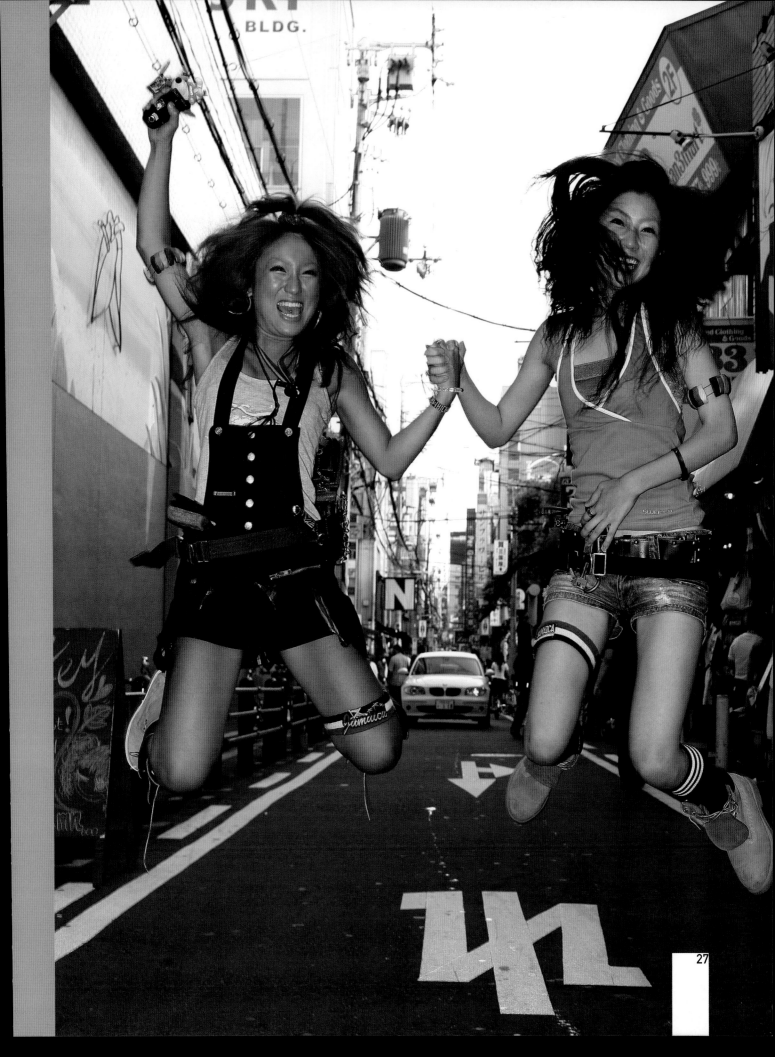

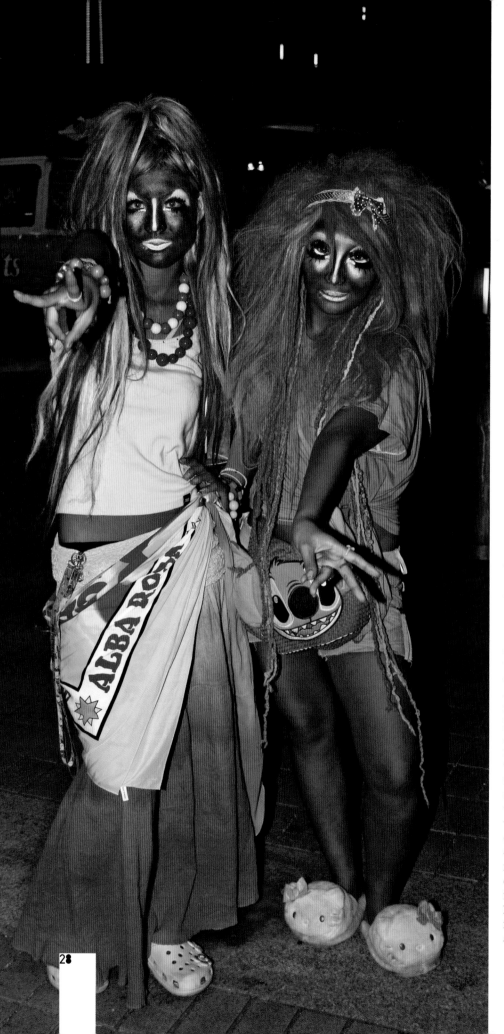

< **Two Ganguro girls with** their make-up in swirls. I came across these two colourful girls in Namba, wandering around and perfecting their look, making tiny adjustments to create maximum impact. The Ganguro look still manages to offend and trouble the strongly conservative-minded adult with a disapproving view of the youth of today. Obviously it is too much colour and excitement for them to handle.

> **Bibbidi-Bobbidi-Boo.** This is a group of happy girls jumping for joy that I found in Ame Mura, a small district of a few streets tucked away in the heart of Shinsaibashi in Osaka. This American-influenced place takes its name, properly Amerika Mura (American town), from a group of American men in the early 1950s who brought US surfer culture to the area. You can still see signs of that influence today among the many heavily-tanned young men and women that gather on the streets of this little enclave. I stumbled across these funky girls, dressed in Decora style, out on a girlie shopping spree. They invited me to join them at Bibbidi-Bobbidi-Boo, the shop responsible for every facet of what they wear to achieve this image.

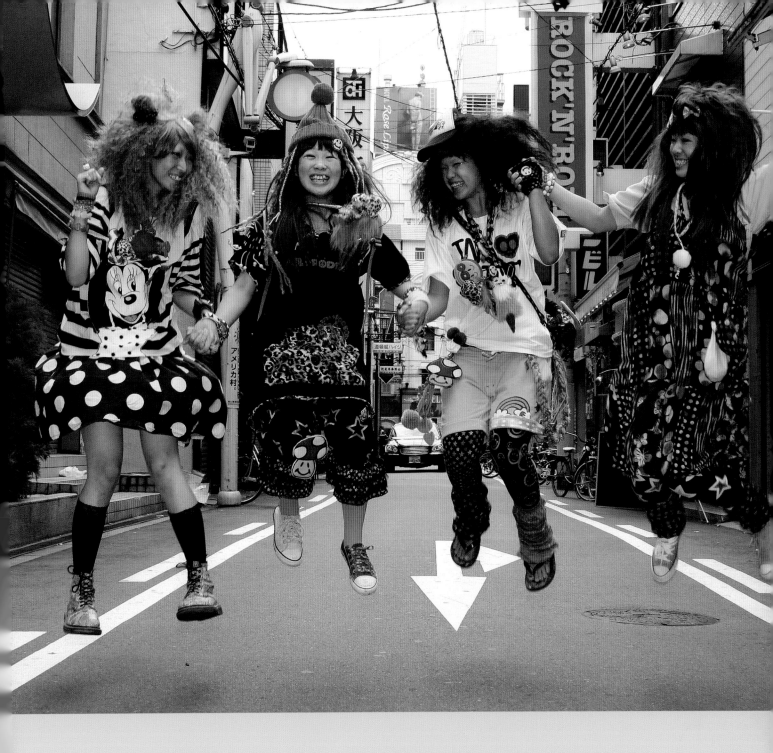

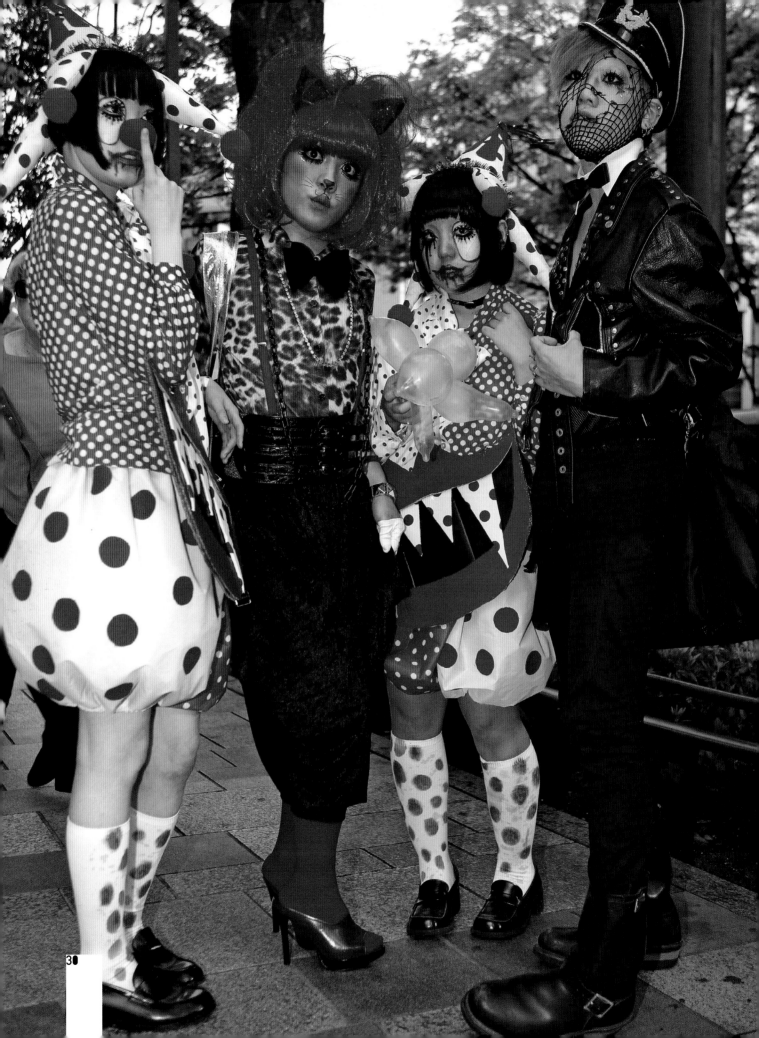

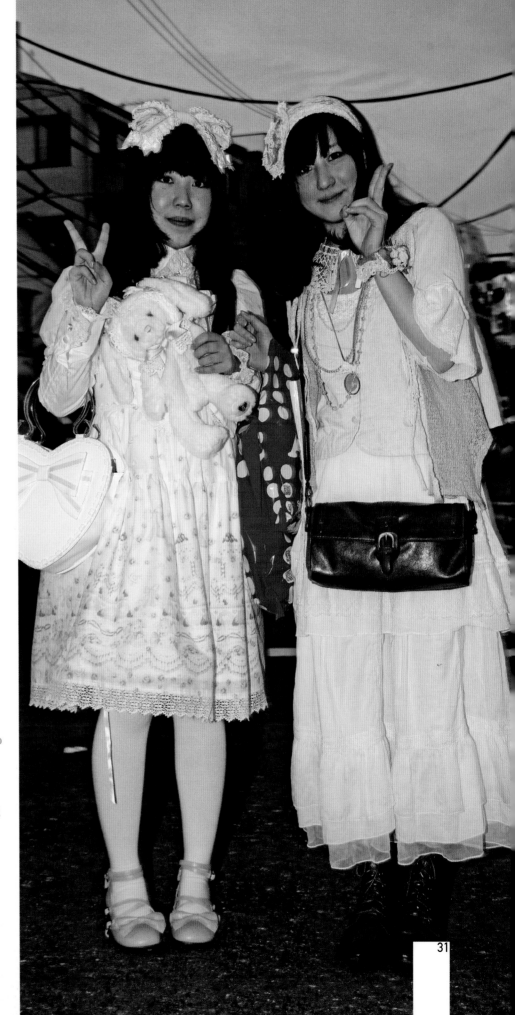

< Wanna be in my gang? A gang
of girls really pushing the limits of
their creativity and not forgetting to
have a little fun with it all strike a
pose on Omotesando.

> Peace on earth and goodwill to all
that's cute. Two young girls pose
for a picture dressed in one of the
many Harajuku fashion styles. On
the right an ensemble by Wonder
Rocket and on the left an Elegant
Gothic Lolita-style dress by Baby,
The Stars Shine Bright and top by
Angelic Pretty.

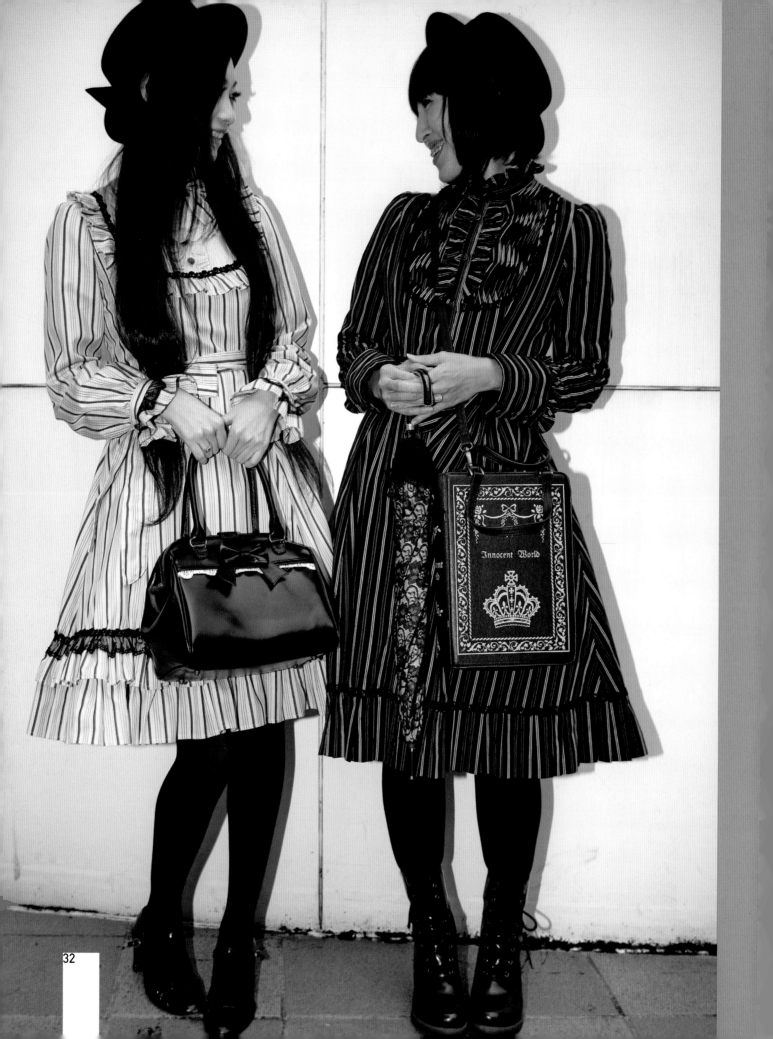

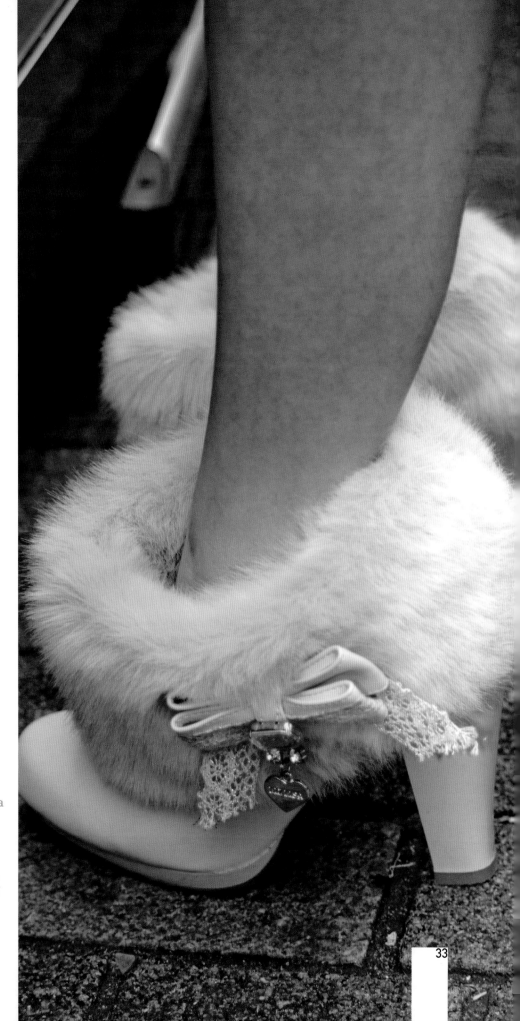

< **Here's looking at you, kid.** Mitsuka and Yuki in Innocent World.

> **Liz Lisa shoes from Harajuku. I love shoes**. They are the most perfect contemporary form of attire, with many designers really pushing the boundaries of what is possible. These are a lovely example of that fine work.

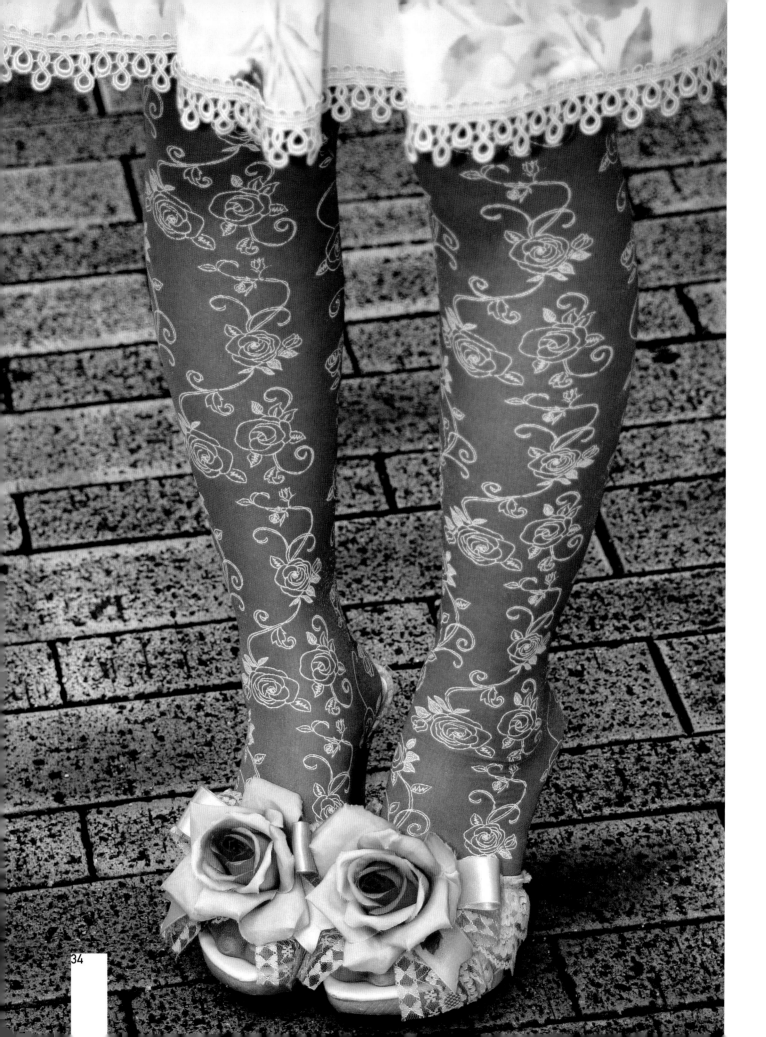

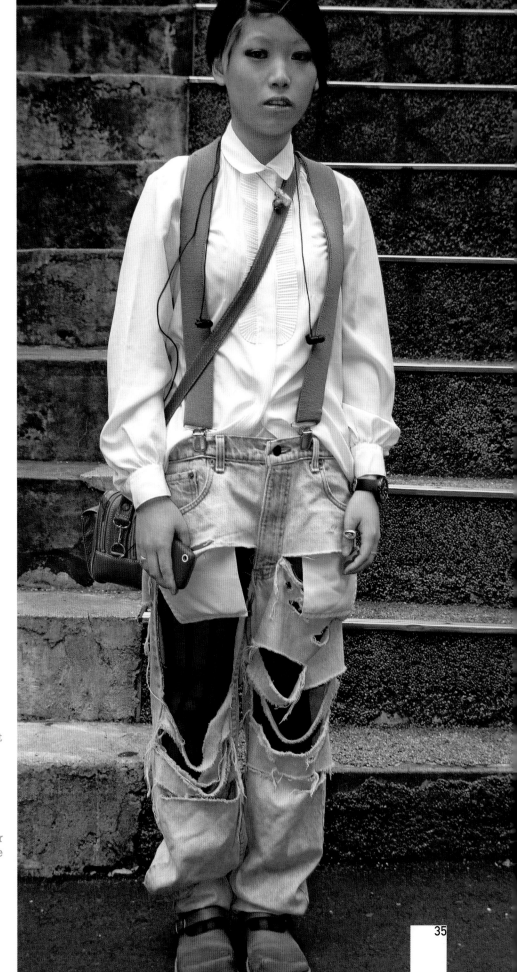

< **Twinkle toes.** Dress, tights and other footsy delights, all by popular Japanese fashion brand Jesus Diamante. With a slightly different take on the Lolita culture and style camp, this look is total prettiness perfected. Literally head-to-toe cuteness.

> **Hack & slash.** Eve from Shizuoka wearing her super-slashed jeans. She's very proud of her creation. The showing of pockets is a huge trend and her stripey tights add that extra something. She wears a white shirt with delicate detail, a slightly masculine style with the retro tiny collar, her trousers held in place by braces. I love the details teenagers embrace, like the large watch – a trend among young girls. The bigger they are, the better, with brands like G-Shock being very popular in and around the Harajuku area. You can see many on sale along Takeshita Dori.

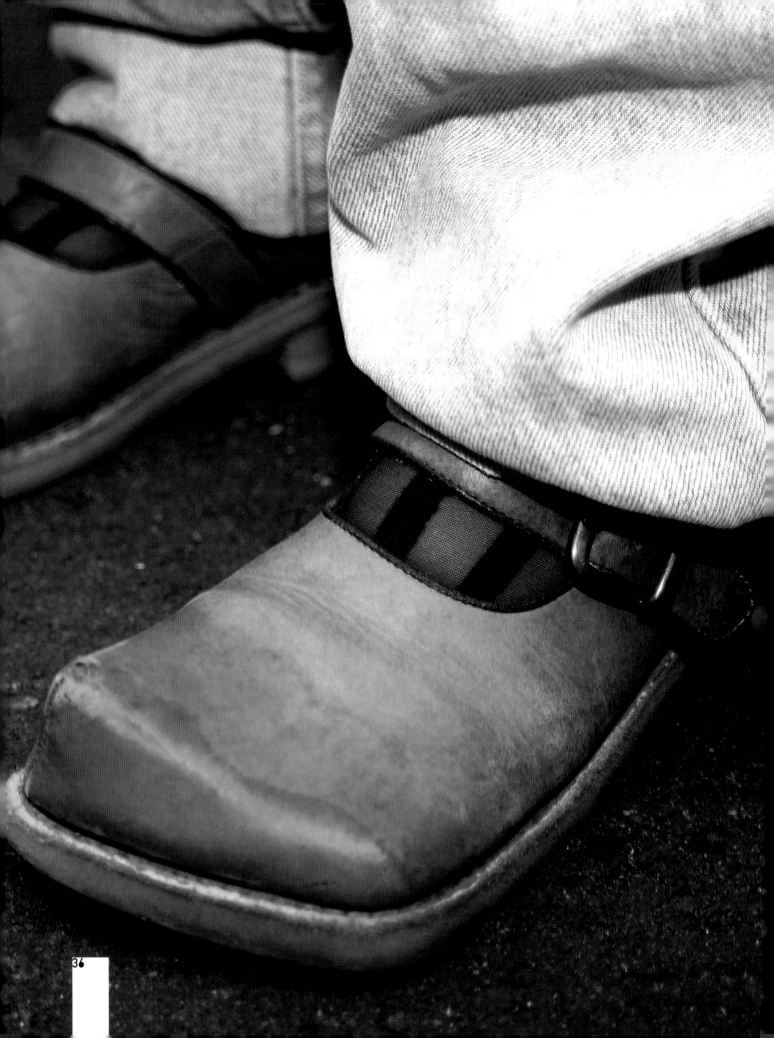

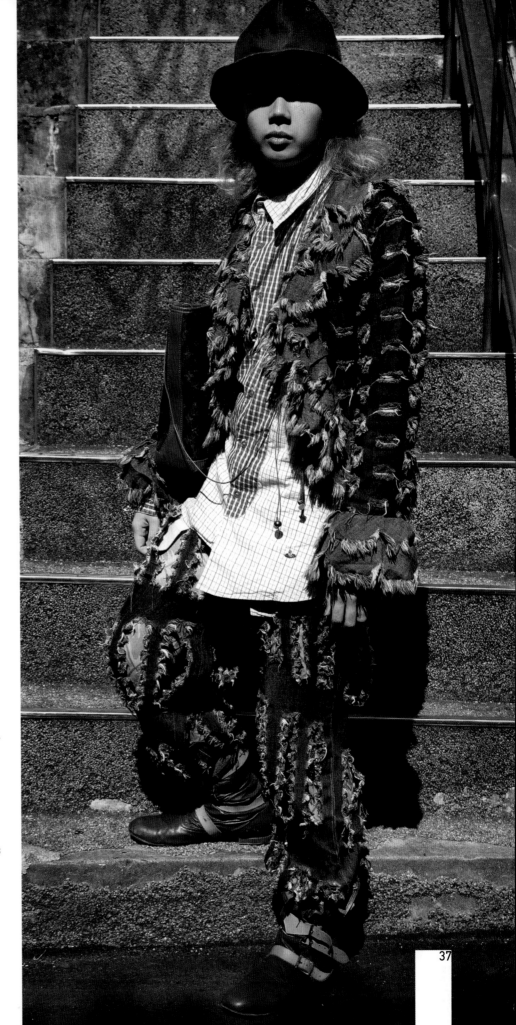

< **Shoes are a big deal in Japan,** though not like in Europe, especially London, where there's a taste for designer madness with heels as high as the sky. In Japan it's about a quiet subtlety with unique personality and Eve's shoes certainly express that. Square-toed, leather, with a discreet buckle, you can really make your mark in these.

> **A cut above the rest.** A young man dressed from head to toe in Vivienne Westwood. Cut and Slash, one of the hugely popular British designer's earlier signature collections where the clothing was heavily distressed and accented with further cuts, slashes and fringing detail. A stylish Louis Vuitton monogram bag is the perfect accessory to complement his look.

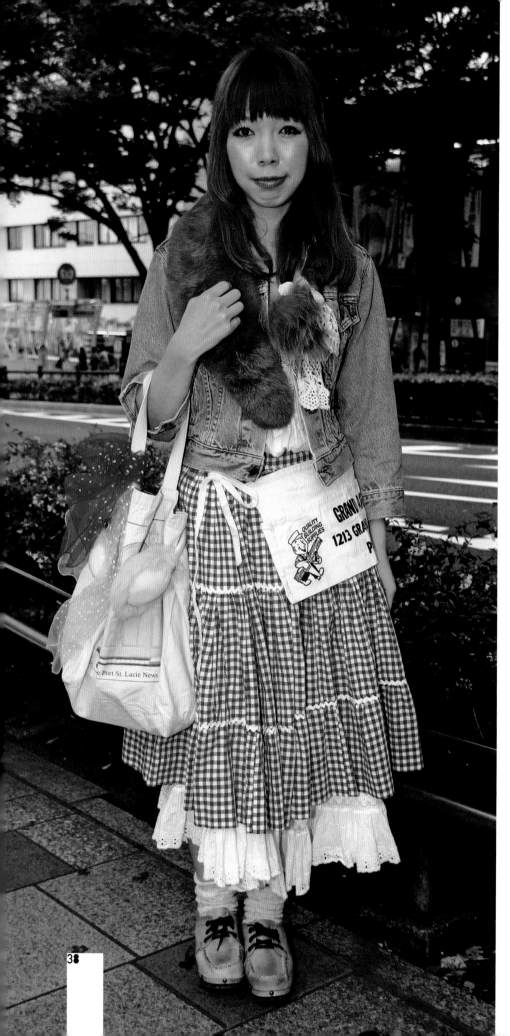

< **Check point.** Korumo from Saitama. Her gingham-print skirt is the centre of attention. Multilayered skirts are done best by Japanese teenagers. I like how she softens the overall look with the delicate accents: the ear muffs, the blue and lilac scarves tied to her bag, the fur and the lace on her denim.

> **Euro dollies and Osaka Lolis.** On the left, Andrea from Argentina with a skirt by Angelic Pretty and blouse, jacket and shoes from Bodyline. On the right, Christina from Spain in a dress from Angelic Pretty with a bag from Tralala.

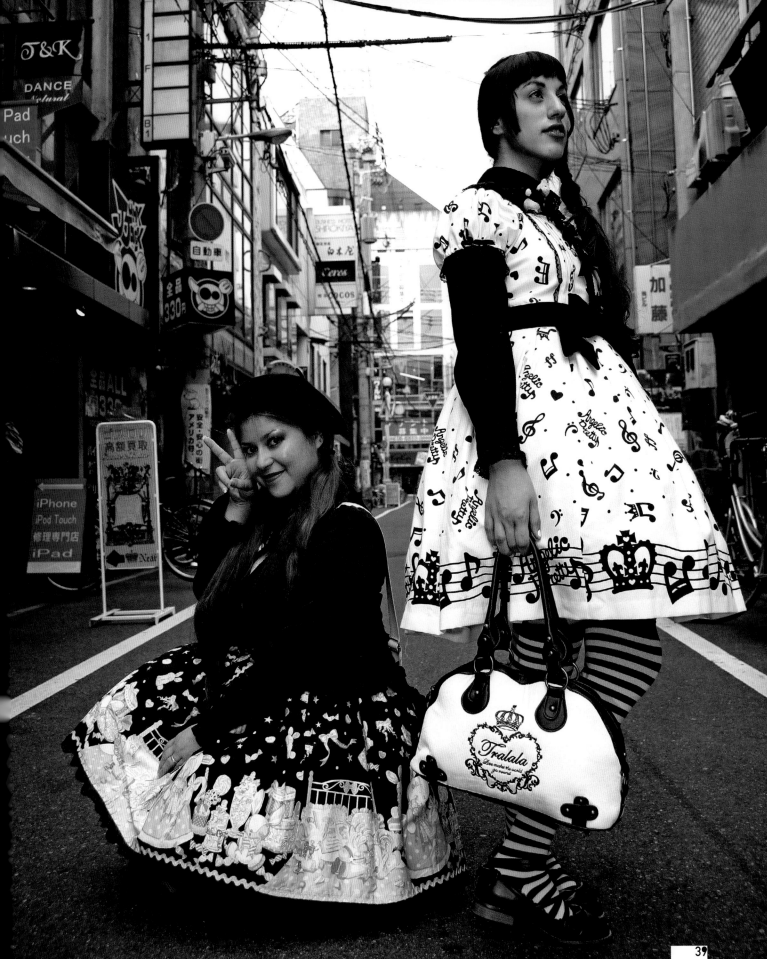

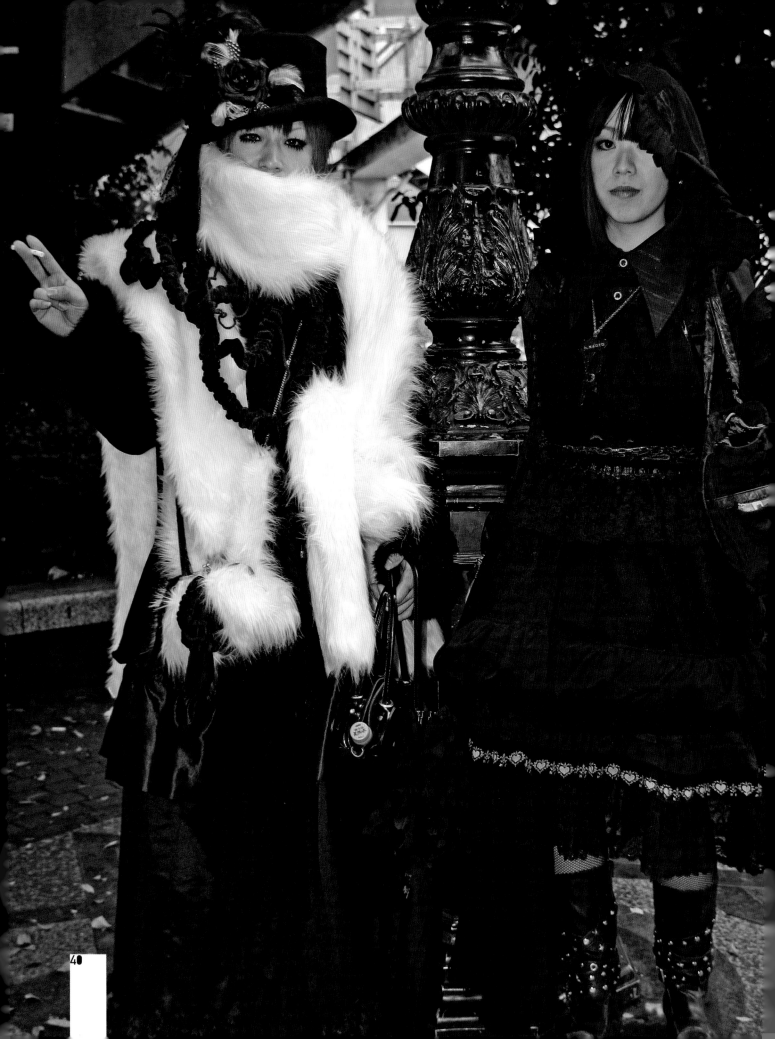

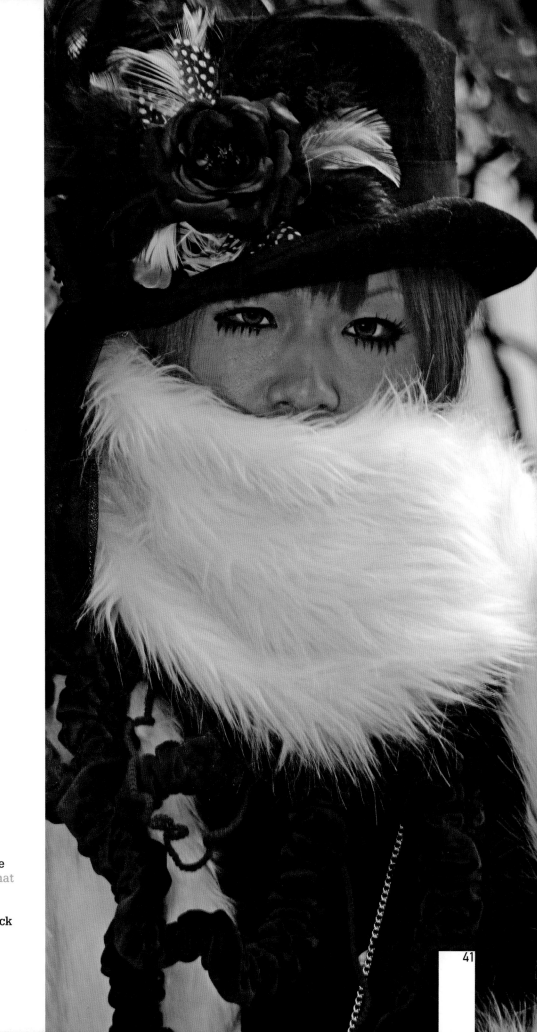

> **Between the shadows and the dark of night,** the piece of fur that makes bright the light.

< **On the right is Setsuna in black** and on the left is Reo.

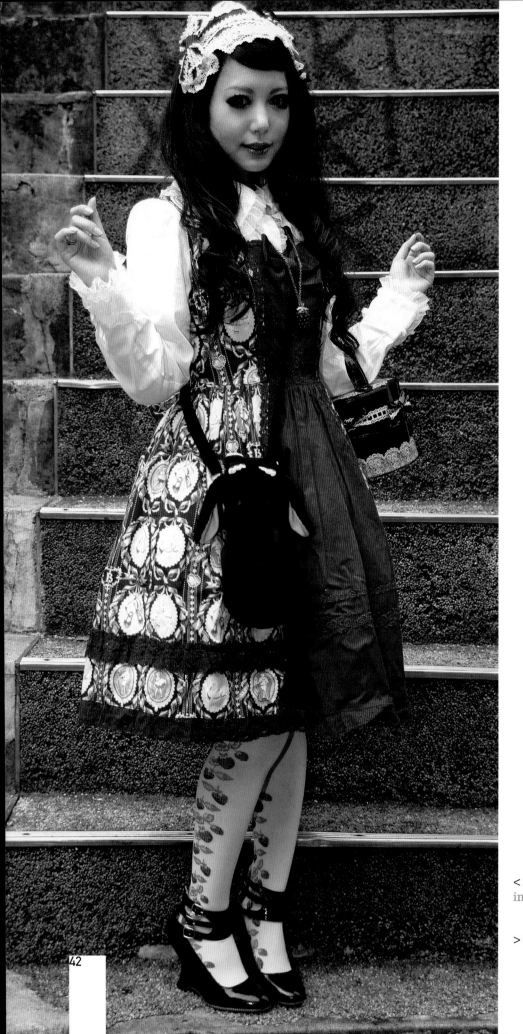

< **The perfect doll.** Hina from Niigata in Baby, The Stars Shine Bright.

> **That special relationship.**

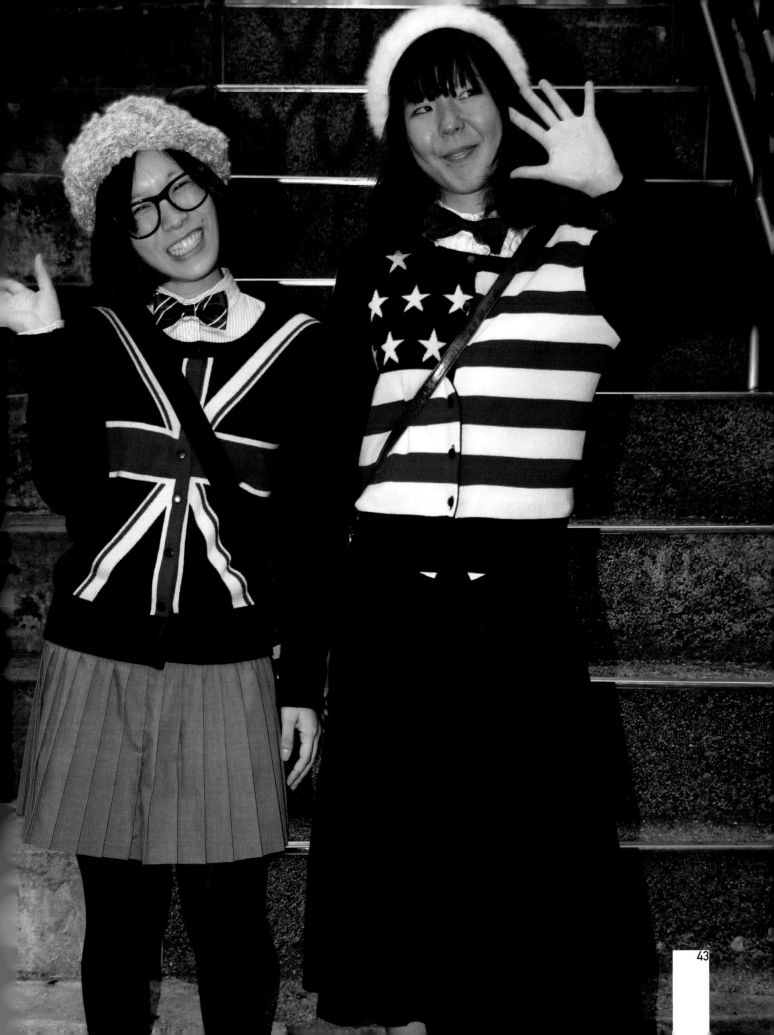

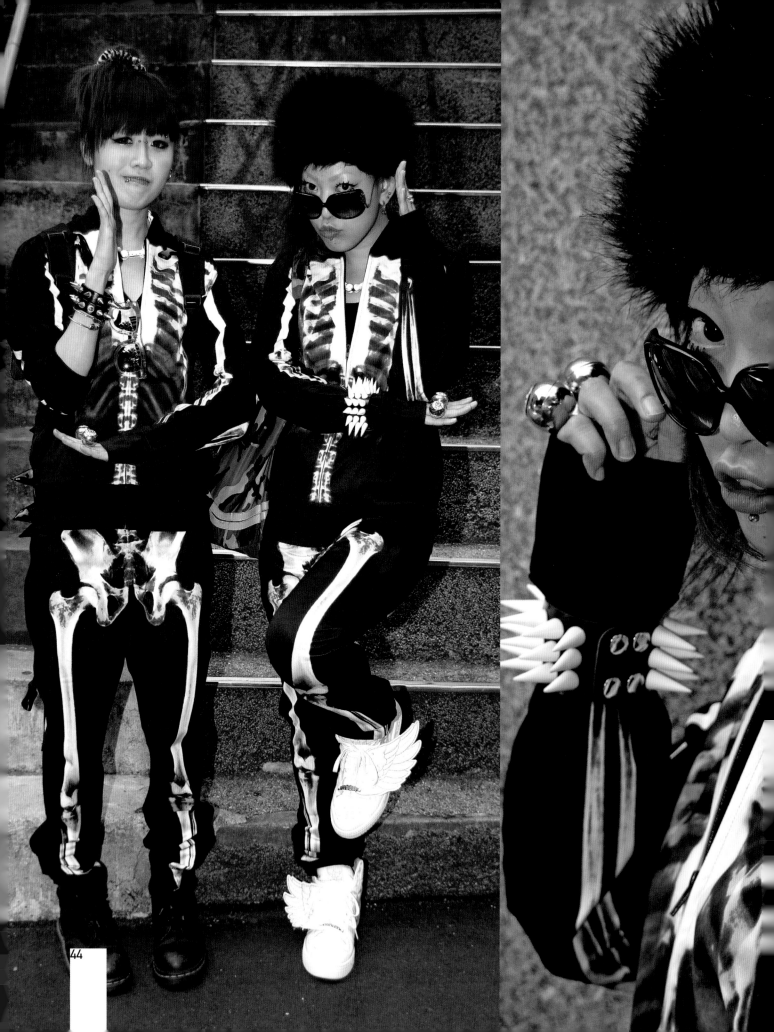

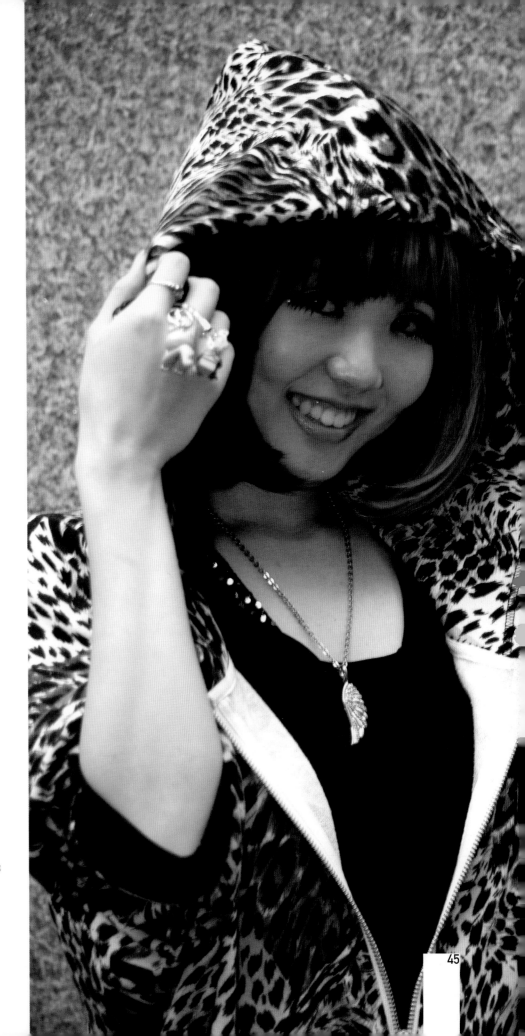

< Let's make our last stand right here, right now. Two teenage girls wearing Jeremy Scott for Adidas tracksuits.

> The eyes have it.

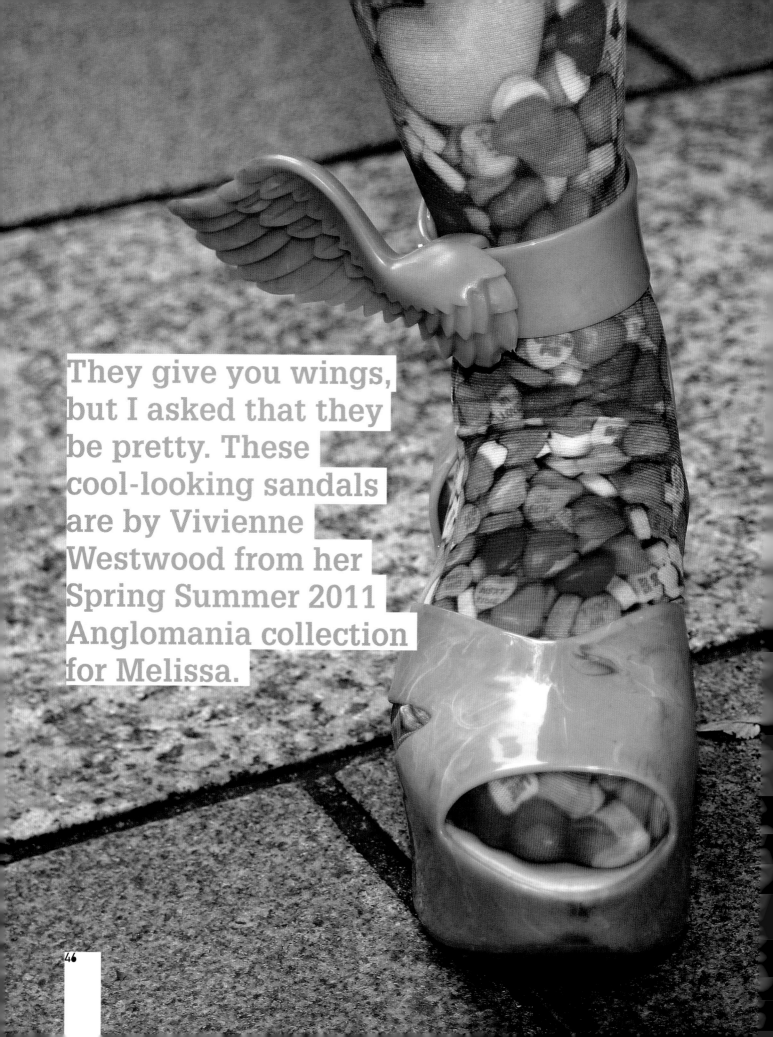

They give you wings, but I asked that they be pretty. These cool-looking sandals are by Vivienne Westwood from her Spring Summer 2011 Anglomania collection for Melissa.

46

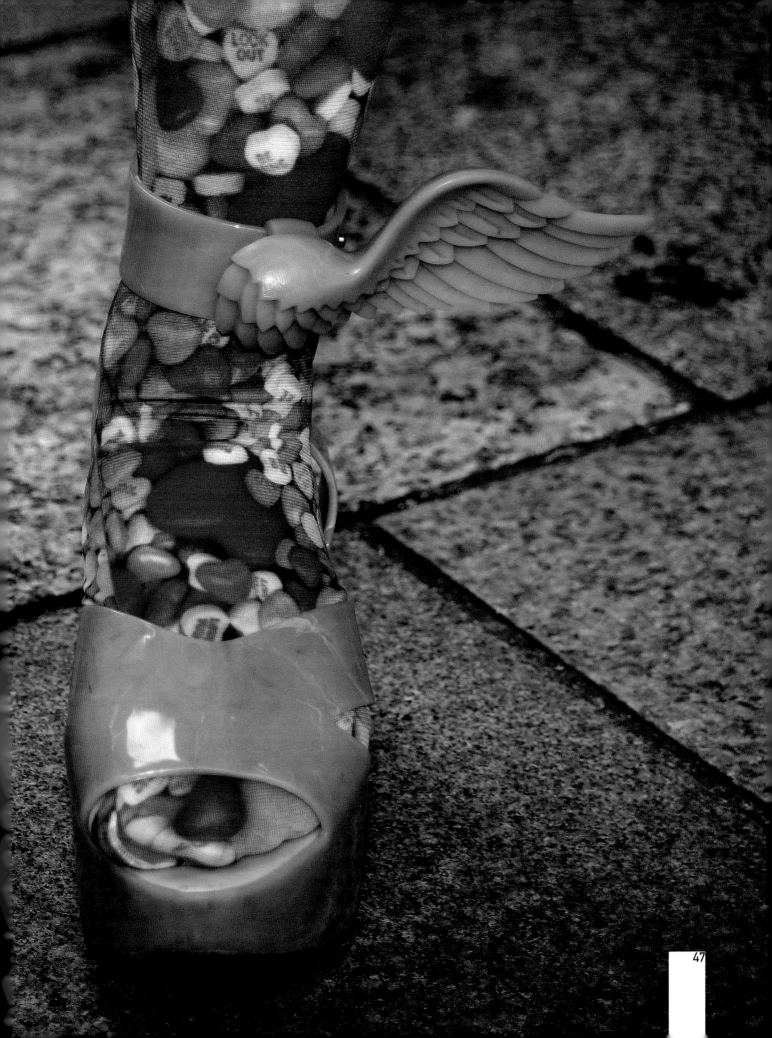

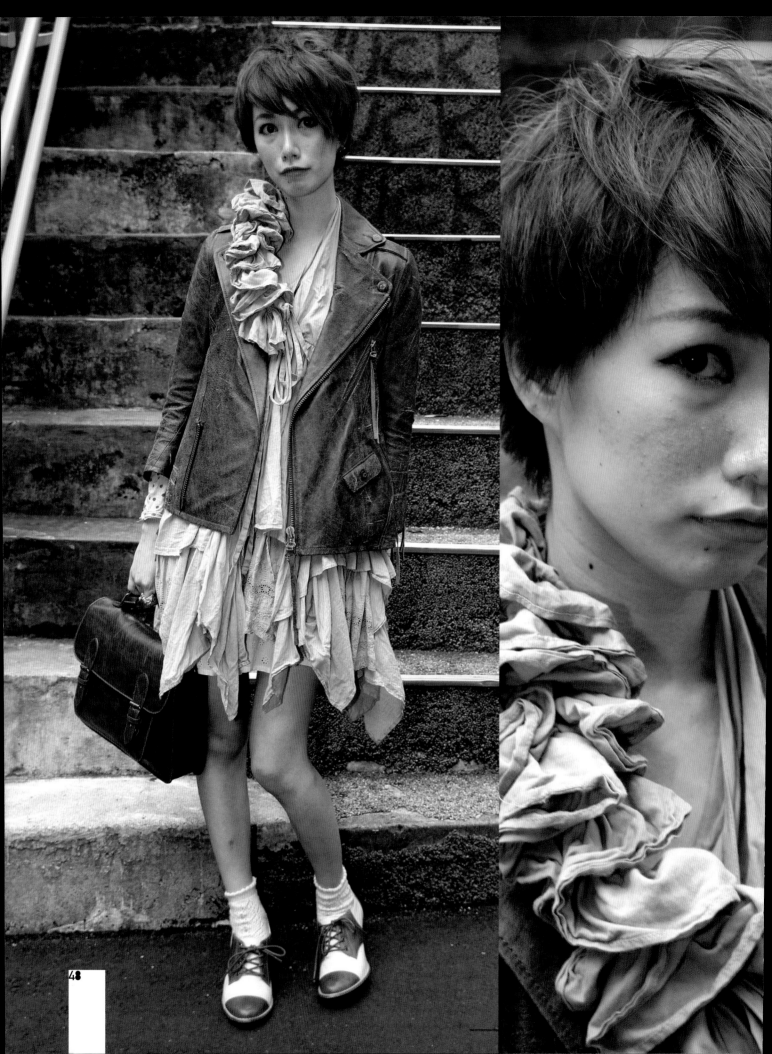

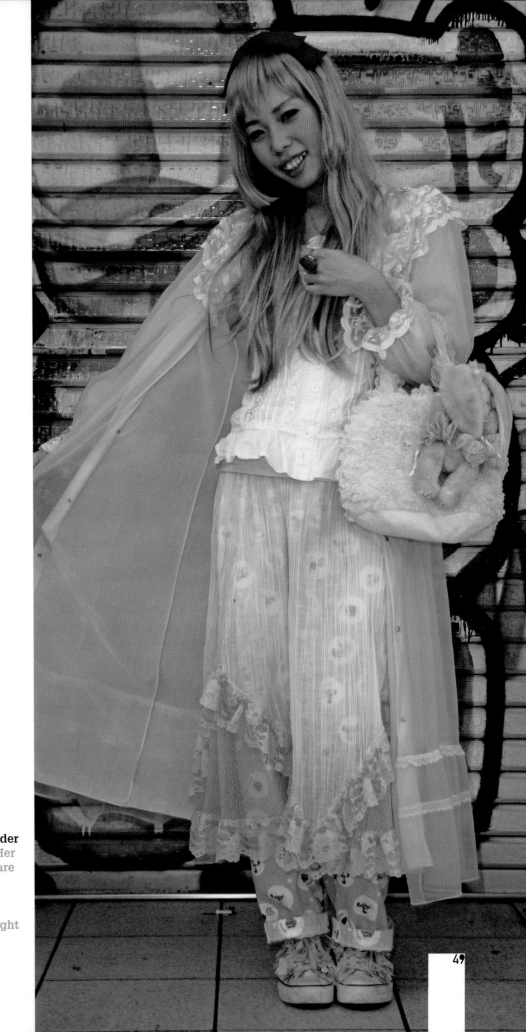

< Yuko from Kokubunji in Alexander Cole with a leather satchel bag. Her coordinated variations of brown are matched to perfection.

> Marien from Kanagawa. Only light and delicate hues used.

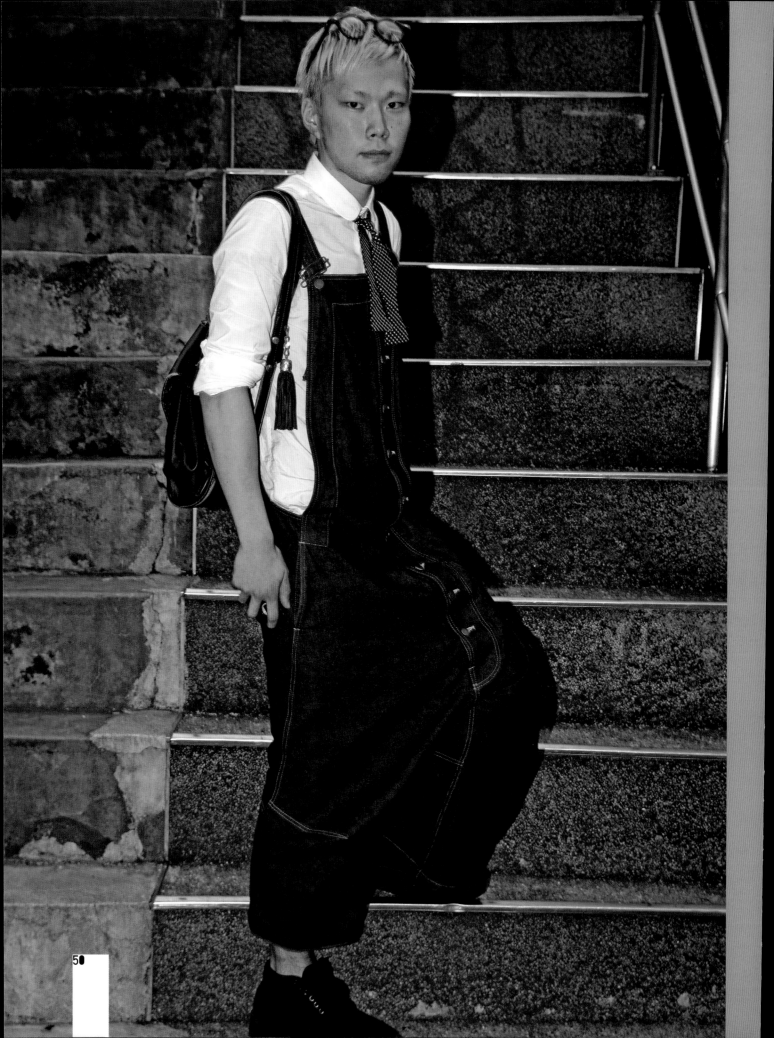

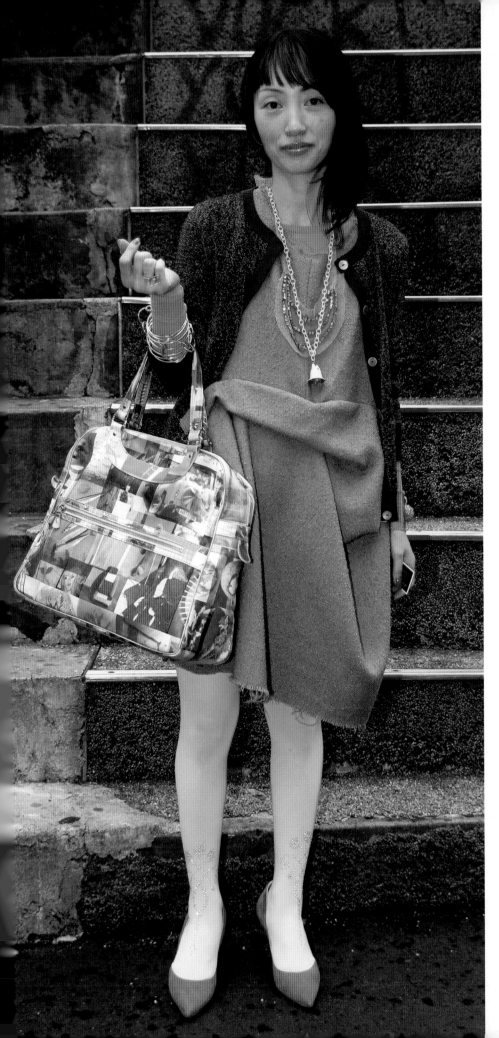

<< I love my dungarees.

< Megumi, we love your style.

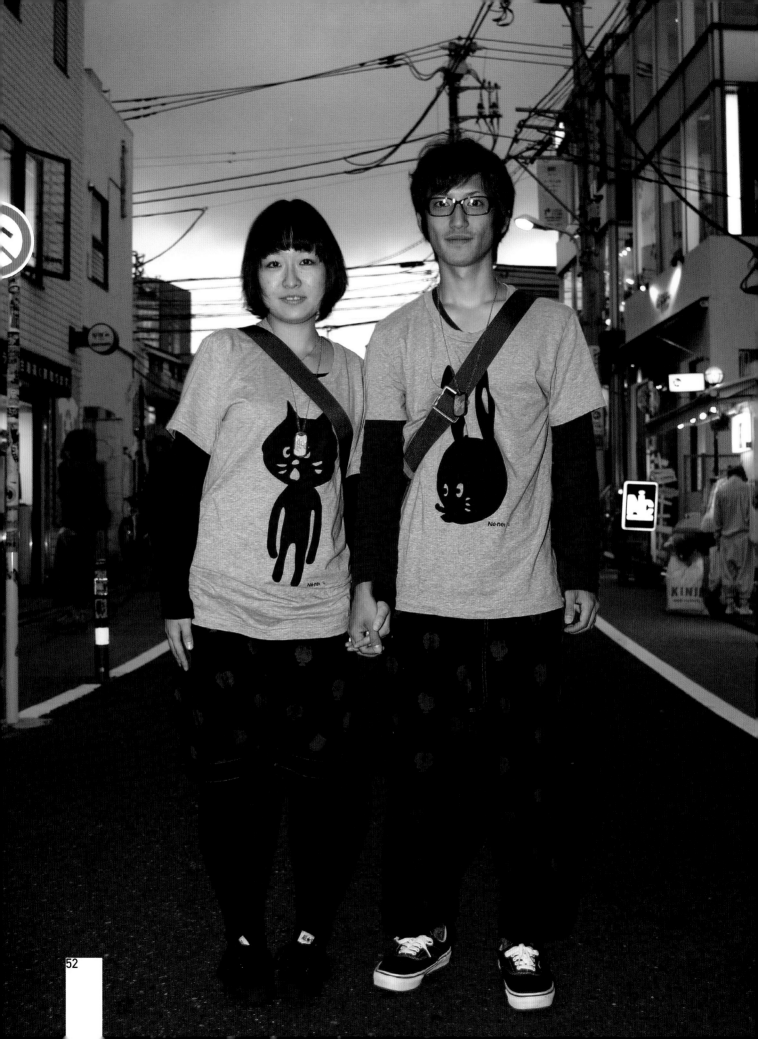

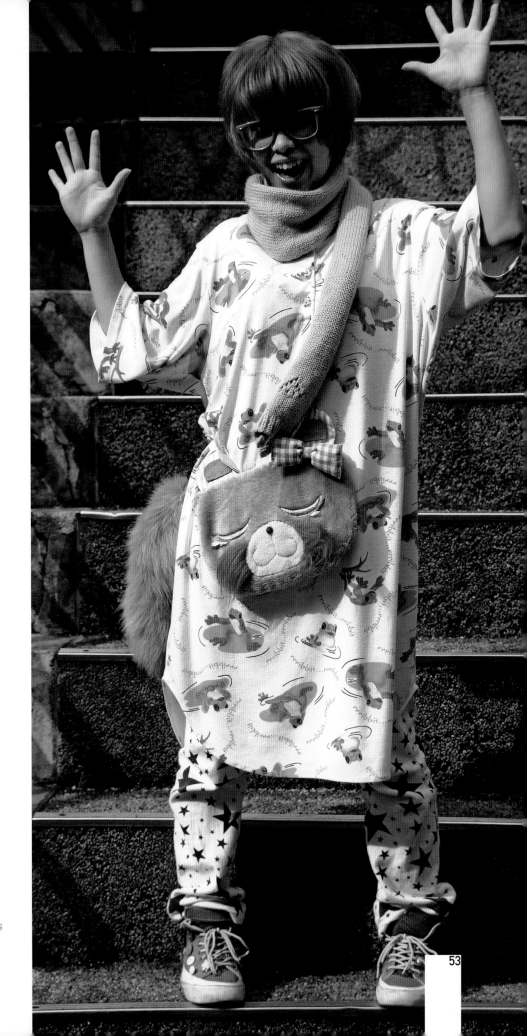

< **Yoji and Yukari** were made for each other, as you can clearly see.

> **Haruka from Sugamo** dressed as Velma from Scooby Doo.

53

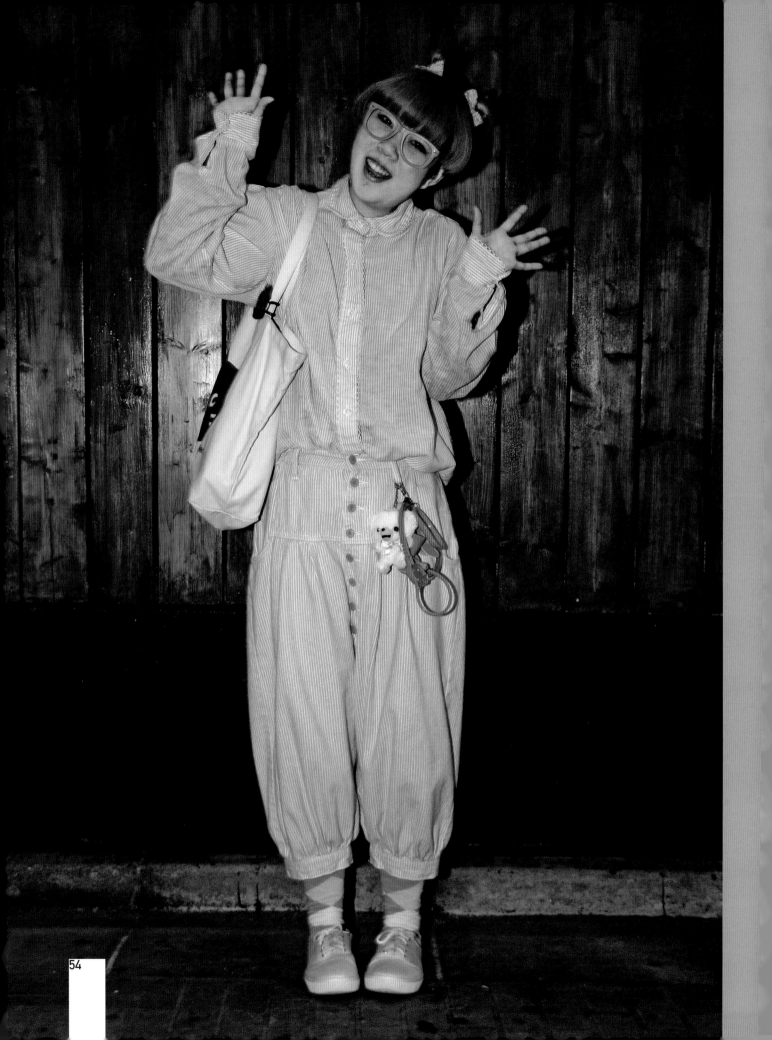

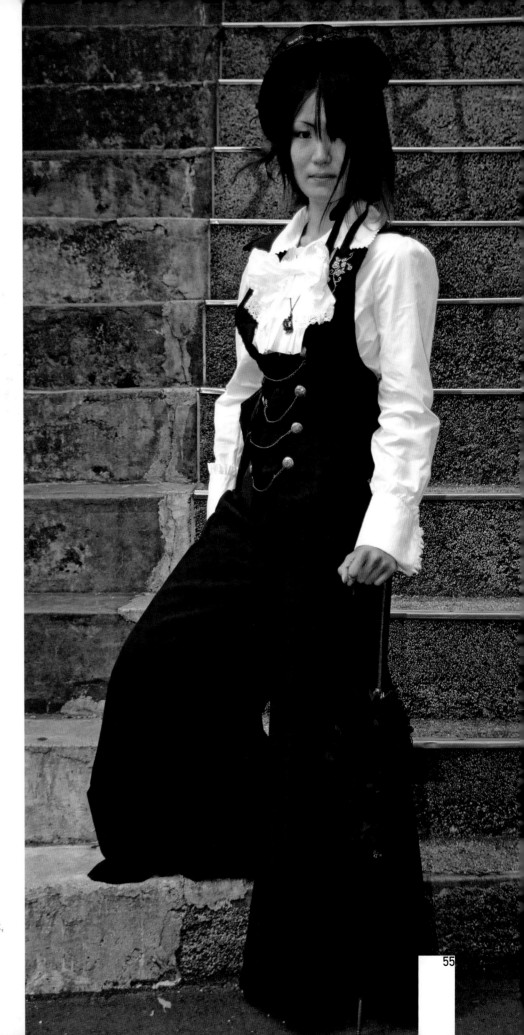

< **Happy, smiley people** like Liho from Kanagawa.

>**Elena stands proud** in her elegant, pirate-inspired outfit.

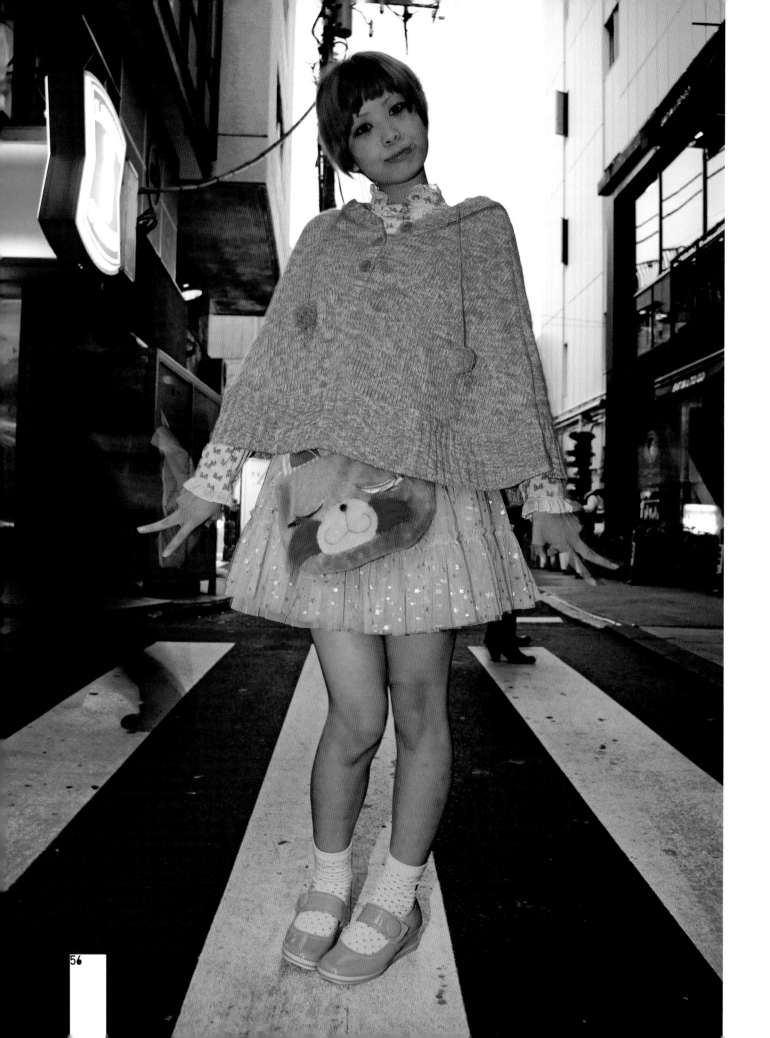

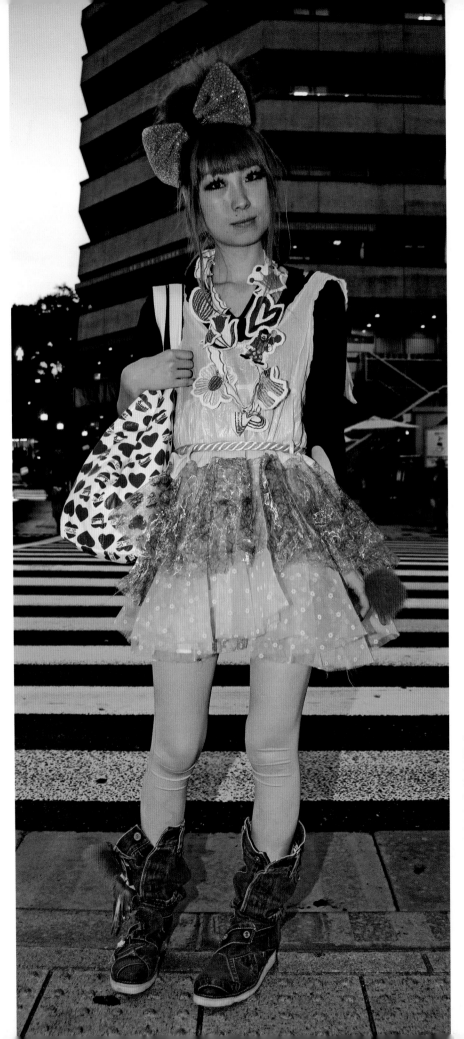

<< **Sweet and cute.** Kurebayashi from Harajuku wearing a lilac knitted cape with pompoms. A high-necked frilly blouse with pink bow detail, a pink skirt, and a sleepy-eyed friend to keep her company. Pop socks and yellow patent shoes complete her look.

< **A teenager poses for a picture** dressed in denim boots, with a bow in her hair, and displaying the classic multilayering style that is well-known in Harajuku.

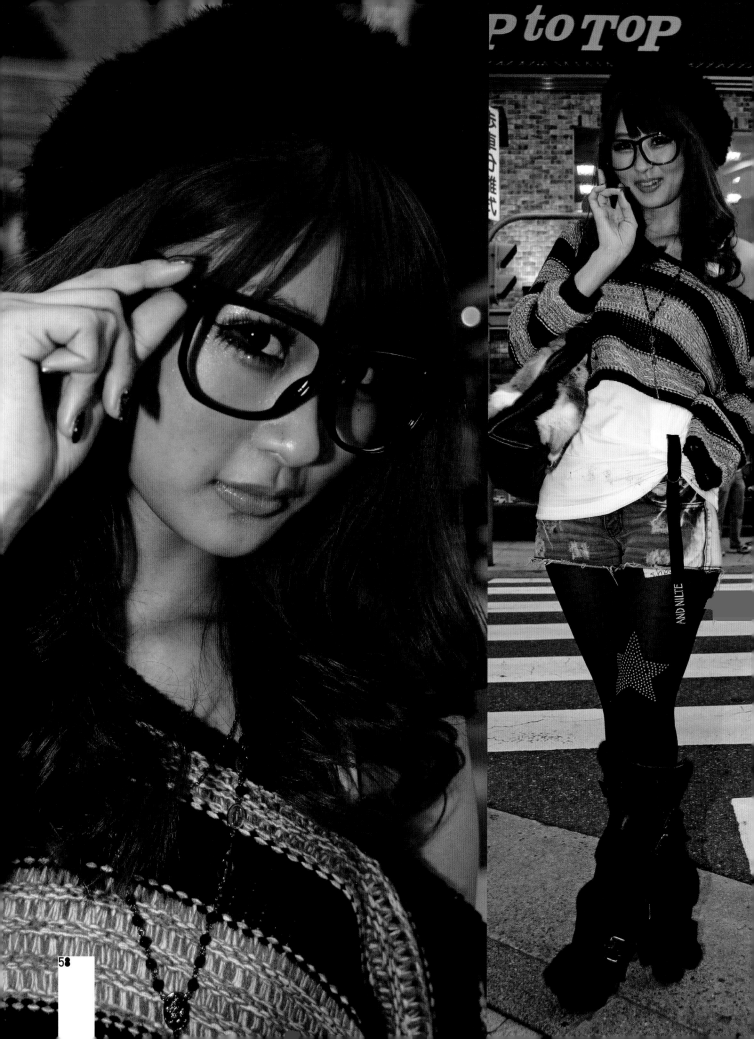

58

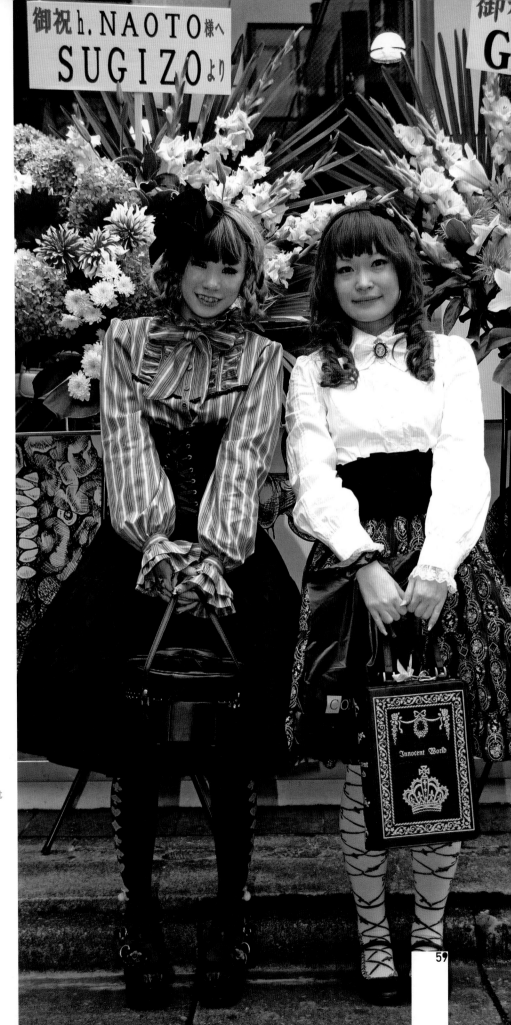

御祝 h. NAOTO 様へ
SUGIZO より

御初

G

Innocent World

<< Keeping an eye on her style.

< Just one more thing this young woman would like to point out. She's from Osaka, and her outfit of distressed denim shorts, boots, off-shoulder crop top with vest, bag with fur accents plus beret and oversized glasses makes her very much a star, and we shouldn't forget that.

> Two teenagers dressed in Elegant Gothic Lolita style outside the showroom of fashion designer h. NAOTO in Harajuku, Tokyo. Both are wearing the Lolita brand Innocent World with bags from the same brand.

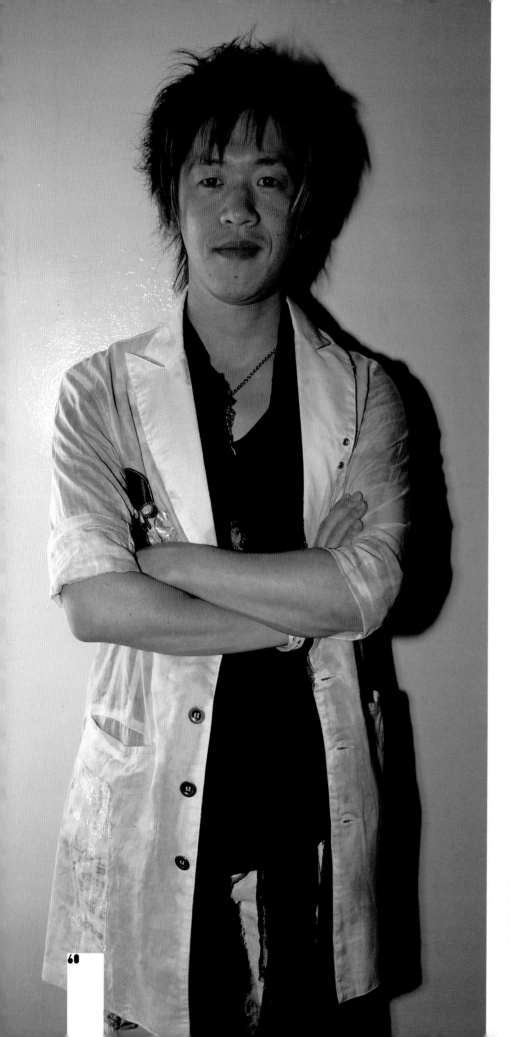

< Portrait of designer Hirooka Naoto
of the very popular Gothic fashion
brand h. NAOTO at his showroom in
Harajuku after his Spring/Summer
2011 show as part of Tokyo Fashion
Week. His avant-garde approach
to the Lolita fashion trend has won
him a global audience. Known for
taking inspiration directly from
the street and fusing it with punk
culture, you can clearly see the
influence of western designers he
admires such as Vivienne Westwood
and Alexander McQueen.

> Mad as a hatter! Not really when
you examine the complexities of this
teenager's style: multiple layering
techniques, colour coordination,
working the hugely popular Disney
character Stitch into his look with
the details finely balanced, all
coming together in this variation
of punk meets the Artful Dodger.
Japanese youth idols Malice Mizer
may also have played a hand in this
inspirational look.

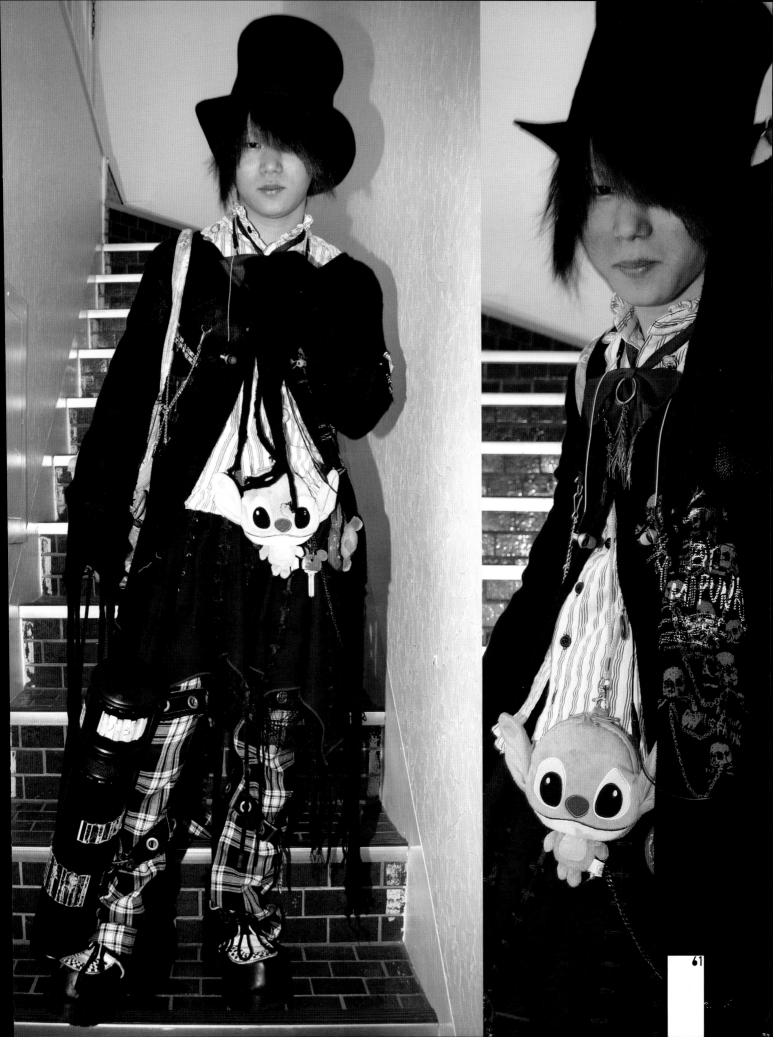

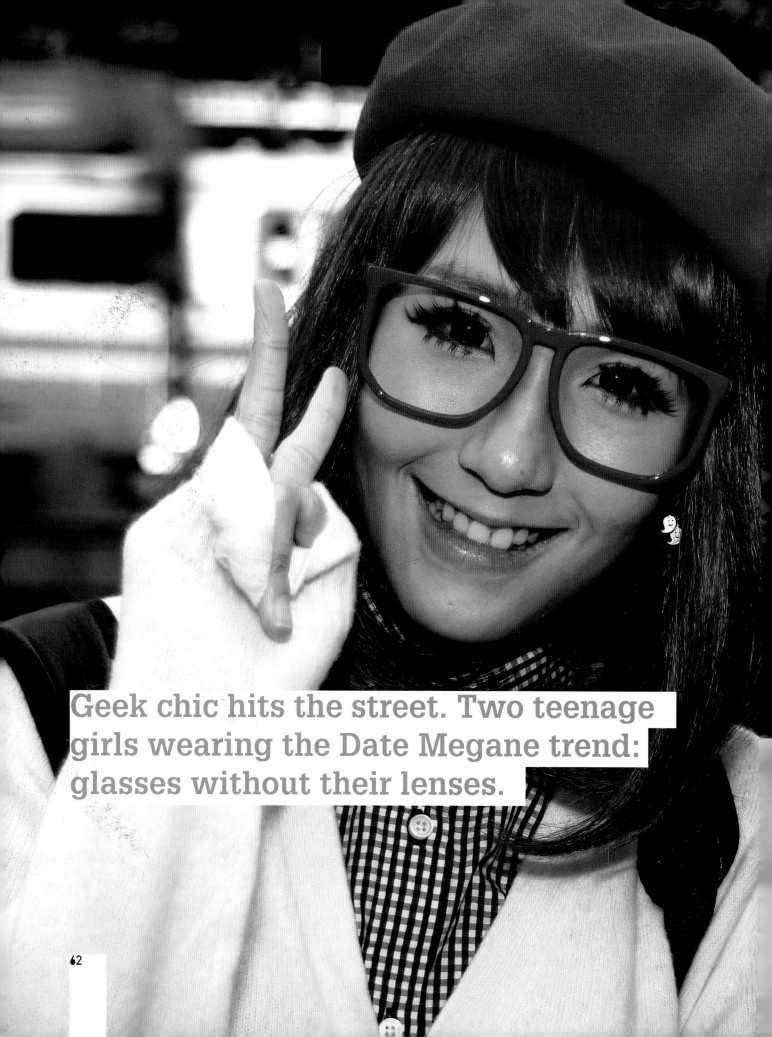

Geek chic hits the street. Two teenage girls wearing the Date Megane trend: glasses without their lenses.

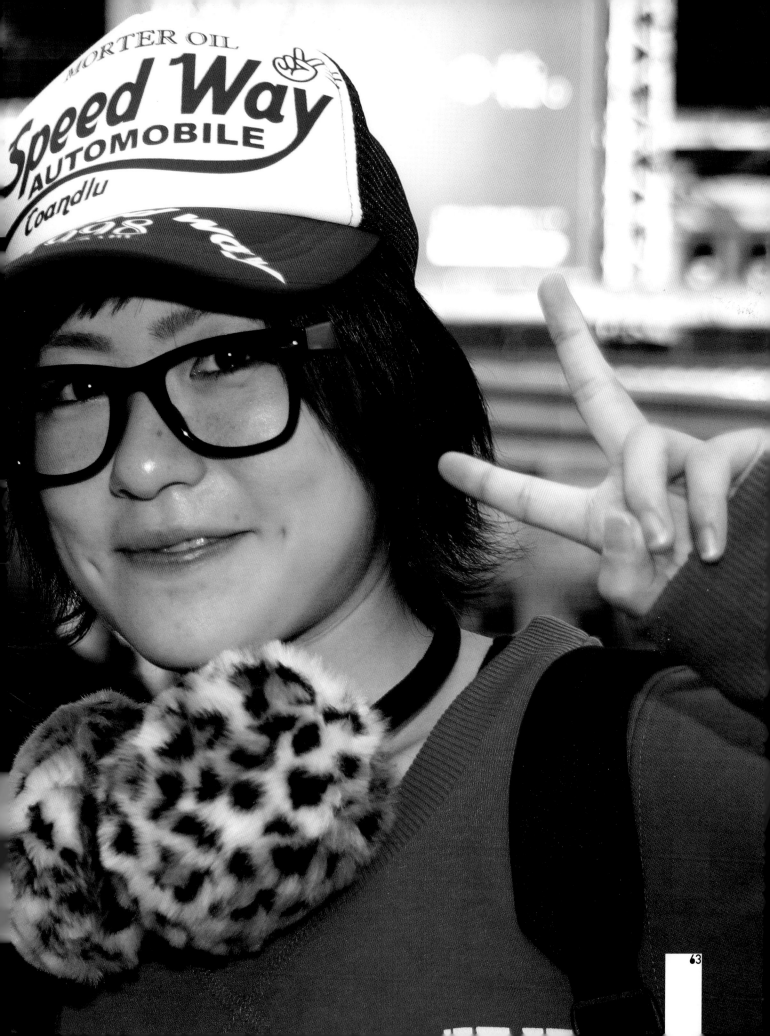

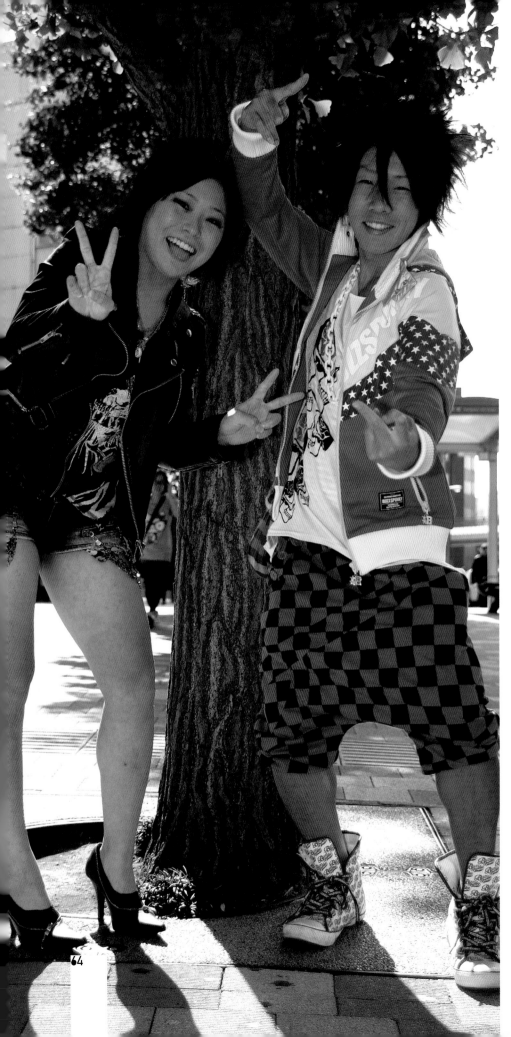

< **A couple of characters** pose for a picture outside the Takeshita Dori exit of Harajuku station. He's bright and vivid in colours with an eighties feel. She's a rock'n'roll biker-chick, really rockin' in denim shorts and heels. On a hot summer's day, fun is clearly the way forward.

> **Three little ladies went to town.** Three little ladies, one with a frown, one with a tutu, one looking down. Ask any Tokyo teen to pose for a picture and that's exactly what you'll get. A pose. Unscripted, unexpected, unbelievably smart – they all know how to do this and with such a clever manner.

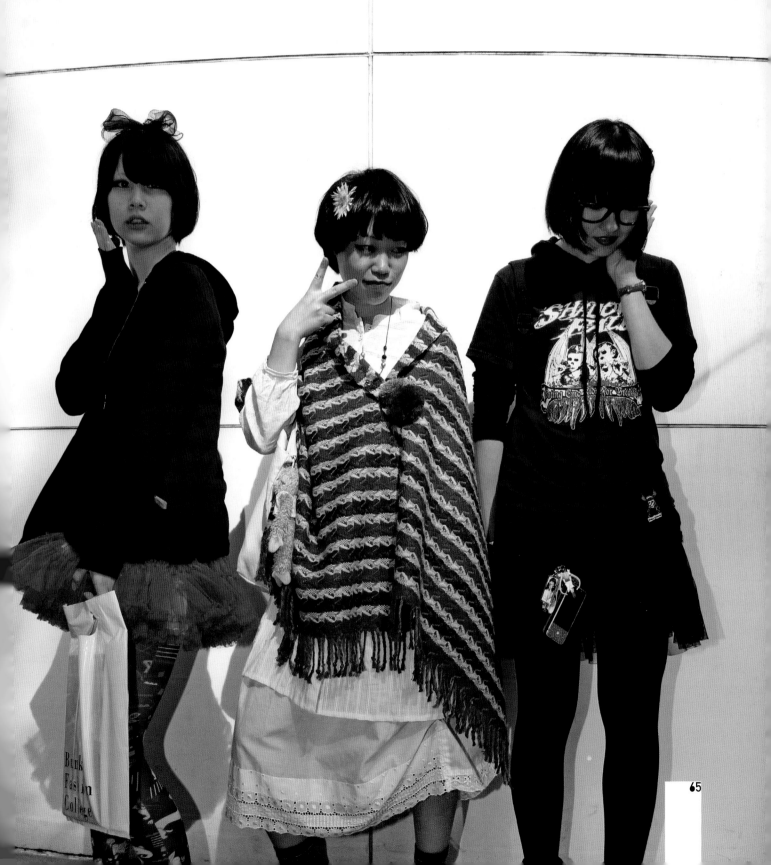

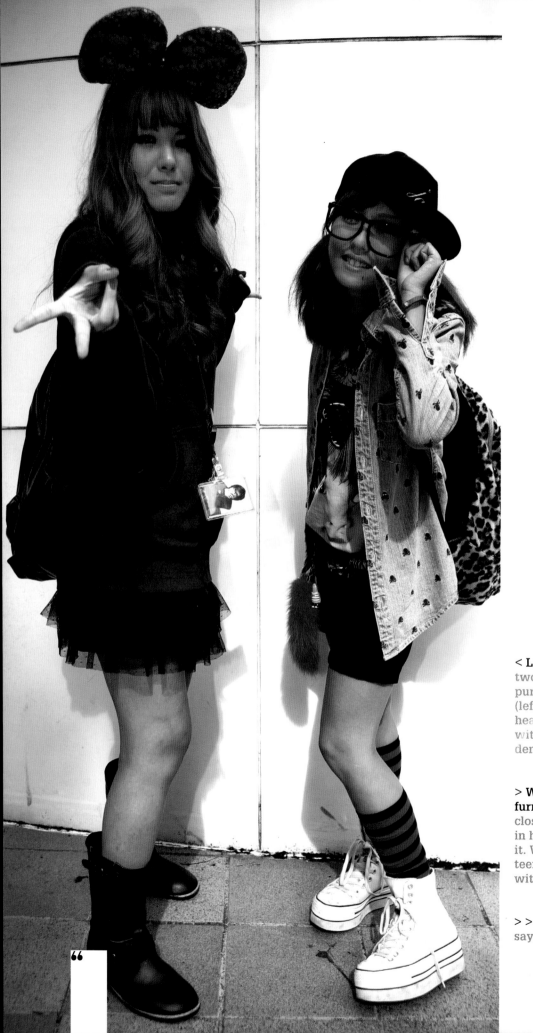

< **Looking up to her big sister.** These two teenagers work the colour purple into their look. Onee Chan (left) with her Mickey Mouse ears headband, and Imoto Chan (right) with the glasses and the skull-print denim jacket.

> **Why can't all things be cute and furry?** Kawaii ('cuteness' in its closest western translation) is held in high regard in Japan. Girls live it. Women strive to retain it. This teenager sports the trend for fur with her fun and playful demeanour.

> > **'Population Power'** is what it says on the label.

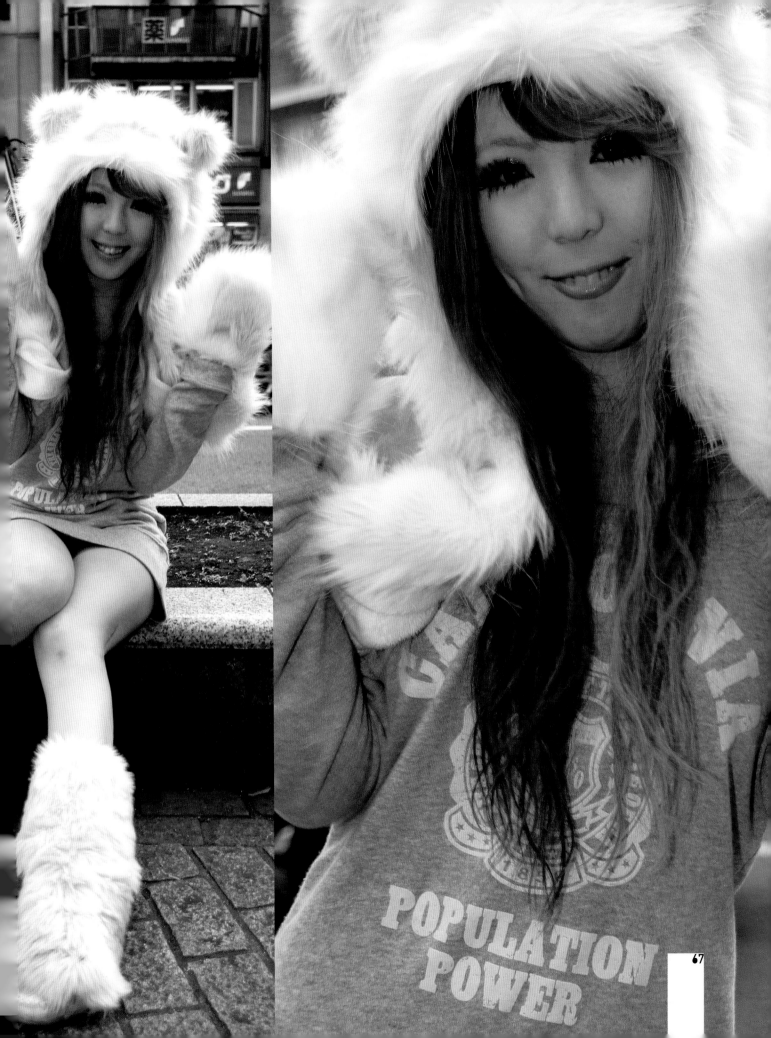

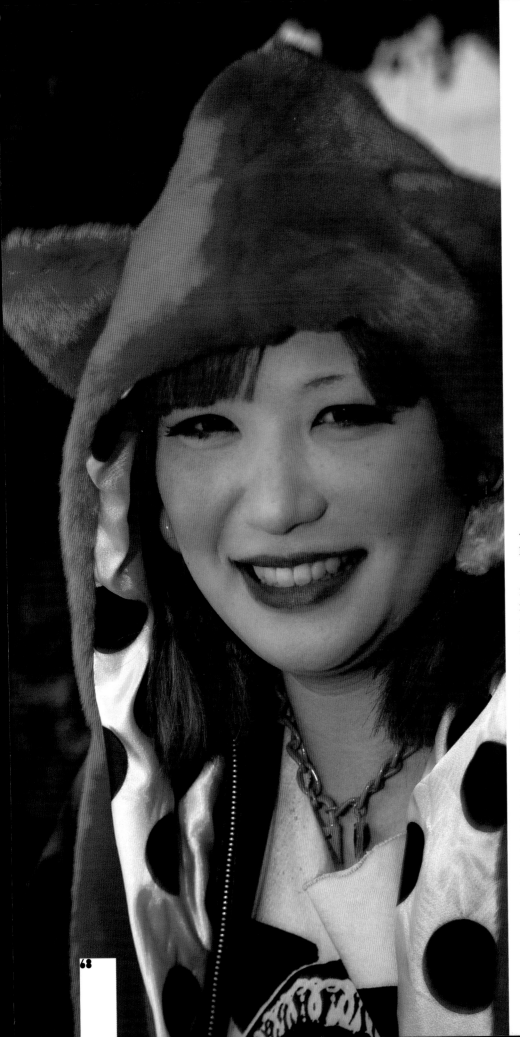

< **Pretty in Pink.** A teenager in her pink, furry Kigurumi costume.

> **A young woman in her beautiful floral-print silk kimono.** Brown with pink is the overall colour scheme, but it's the detail and the sheer beauty of this garment that dazzles. The kimono is one of the oldest and still most sought-after clothing items in the world, with an ability to transform the wearer. And when matched with the beauty of wearer, well, wow! Its impact is practically unrivalled. Sheer beauty.

>> **Note the intricate technique** used to tie the Obi at the back and how that is mirrored by how her hair is arranged. Also, notice how the flowers are placed as if flowing or falling like sakura, falling cherry blossoms, with their varying shades of pink. Tradition has always had a place in urban street fashion, and Japan is one of the many places you'll see this.

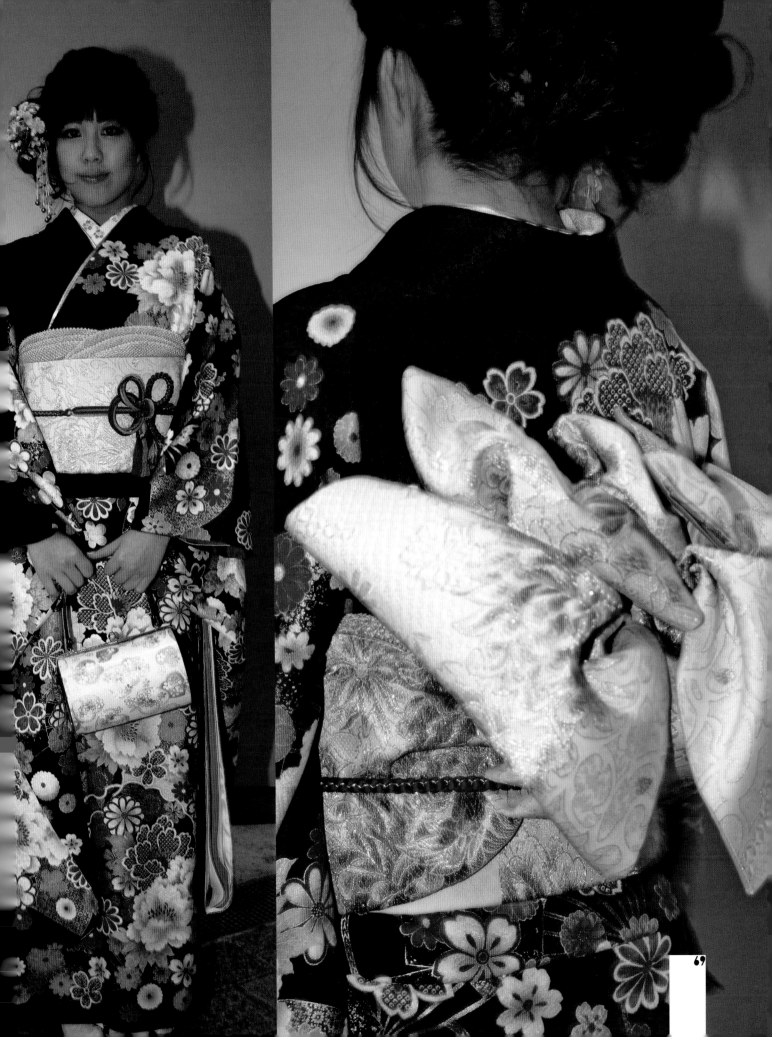

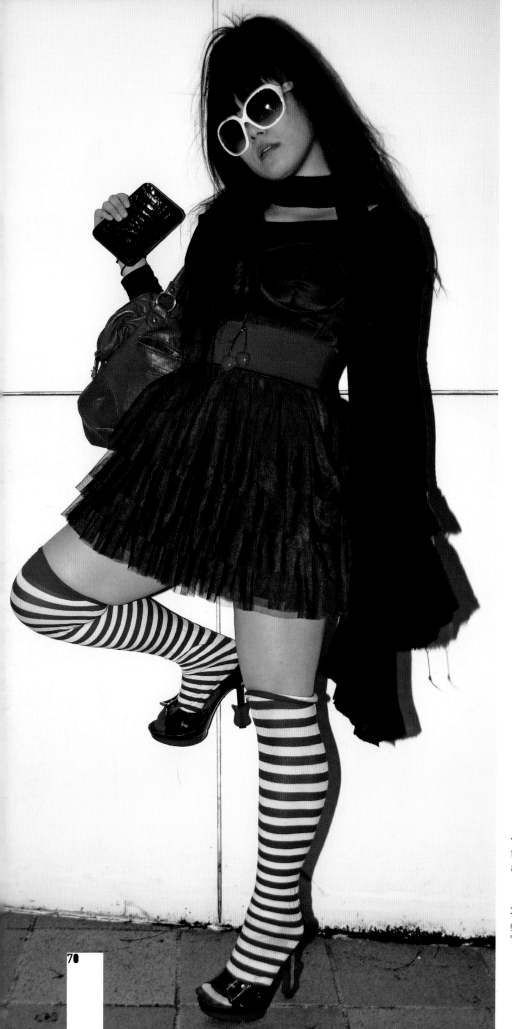

< Cherry-picked ripe for delight, the stylish street diva vivid late at night.

> Check out her amazing electric-guitar-heeled shoes from Vivid. They really rock.

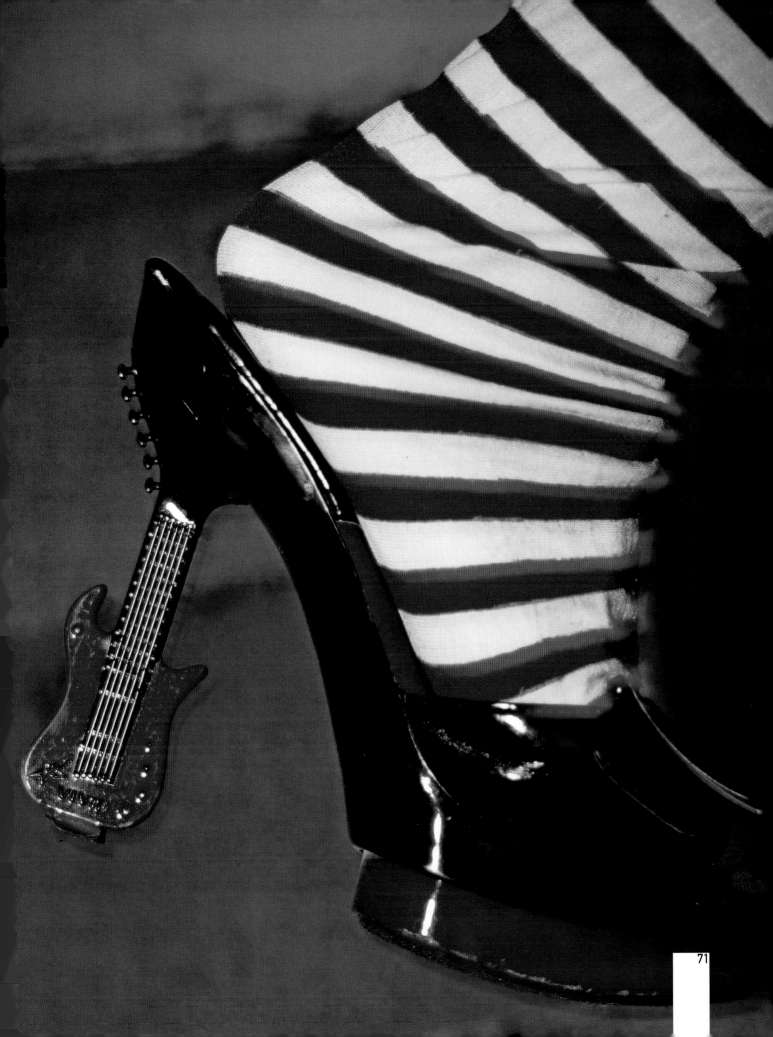

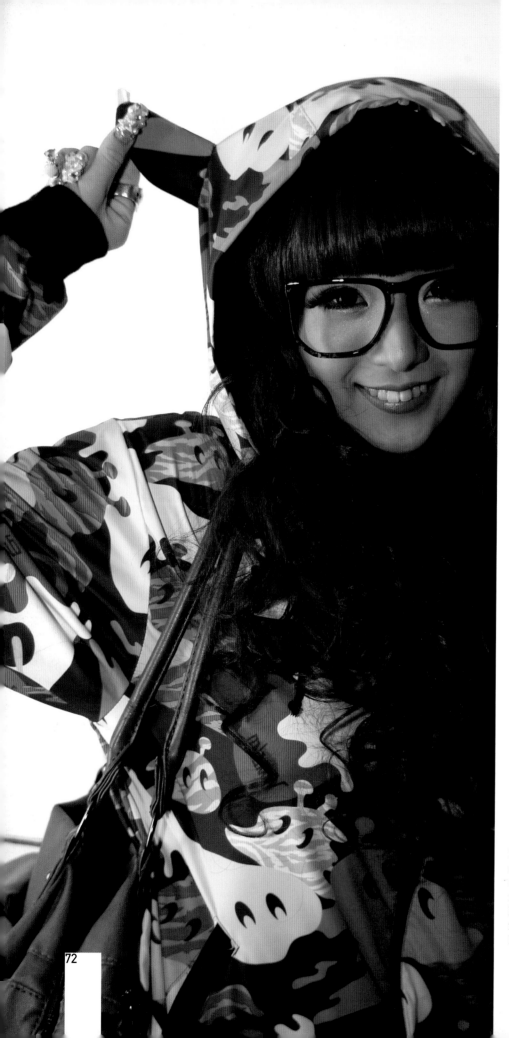

< **Honey Bunny** with fingernails of pearls, a hooded coat with ears and hair full of curls. Classic Kawaii style with the Date Megane trend highlighted.

> **Decorations to illuminate any night.** A classic example of Decora style seen here on this teenager at Takeshita Dori late at night. Multiple layers, alternately coloured with attention to detail. I love this style.

>> **This is what JStreetstyle is all about,** the chance to capture and share the perfect example of what fashion is. Freedom of expression based on how these young teenagers feel and how they choose to create looks with amazing visual impact.

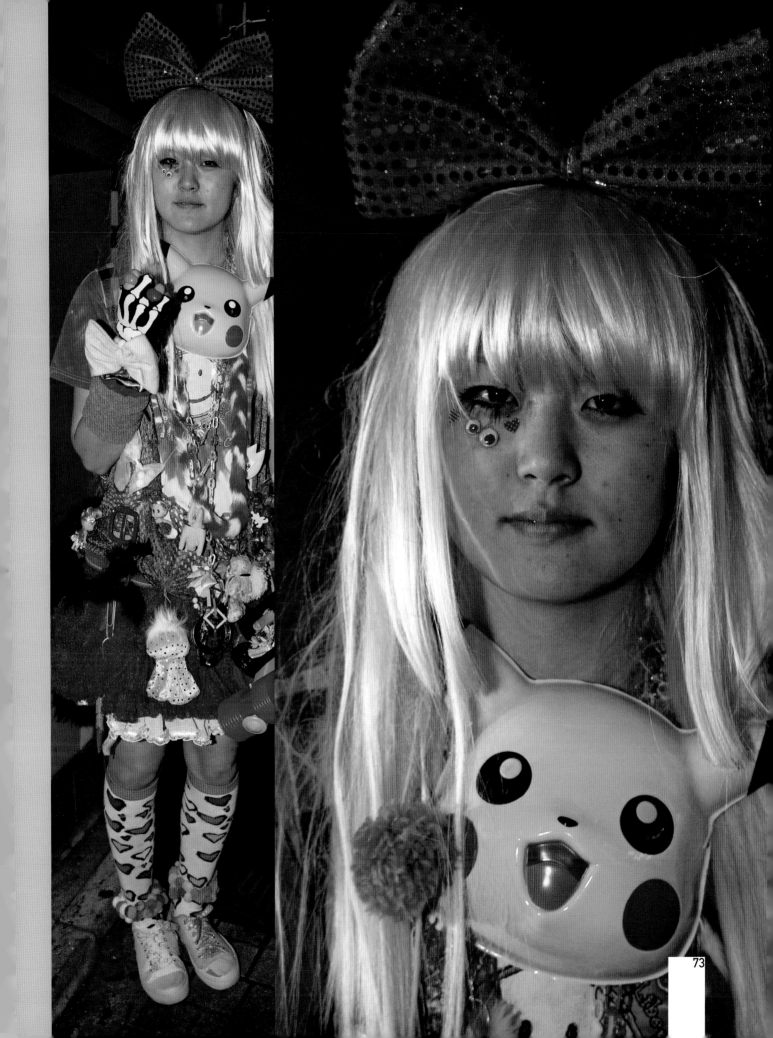

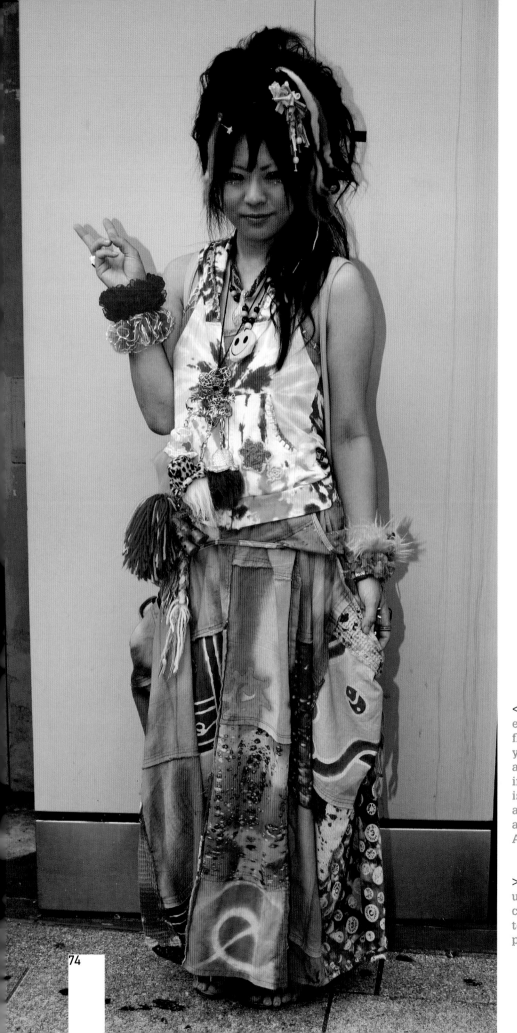

< **From her head to her toes.** An expression of colour that grows as it flows. The more you look the more you notice the attention to detail as well as the effort that has gone into perfecting this look. The look is apprently simple but is actually anything but, taking much effort and time to compose. I shot this in Ame Mura.

> **Four girls from Ame Mura** lined up in a row. Dressed in so many colours from their head to their toes. Witness an Osaka Decora style parade here on show.

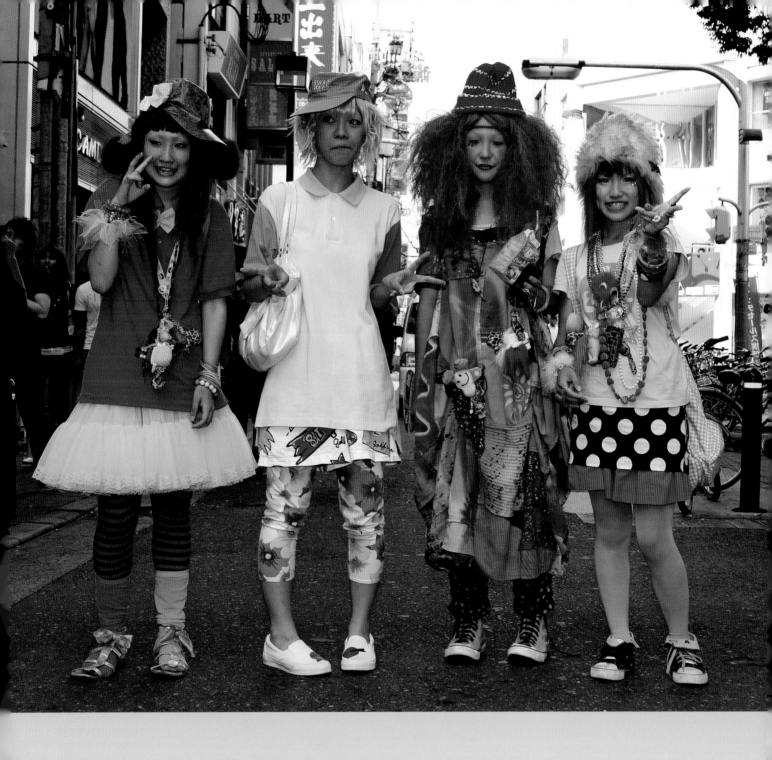

> **Two young girls dressed in Decora style in Ame Mura.** Surf culture and the reworking of American male sportswear is clearly evident in their look. Play this game: see if you can count how many different items in each look there are within this image.

>> **More Decora and Kawaii visual style.**

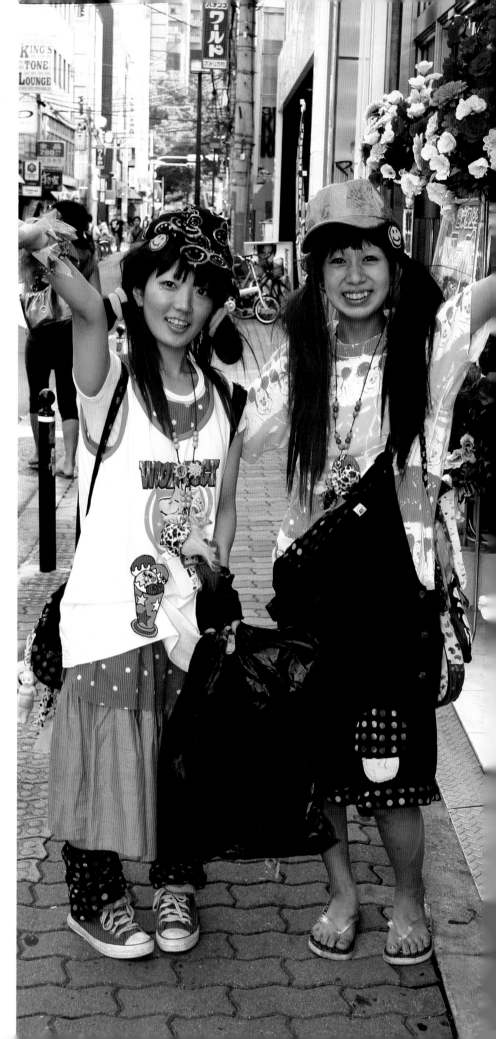

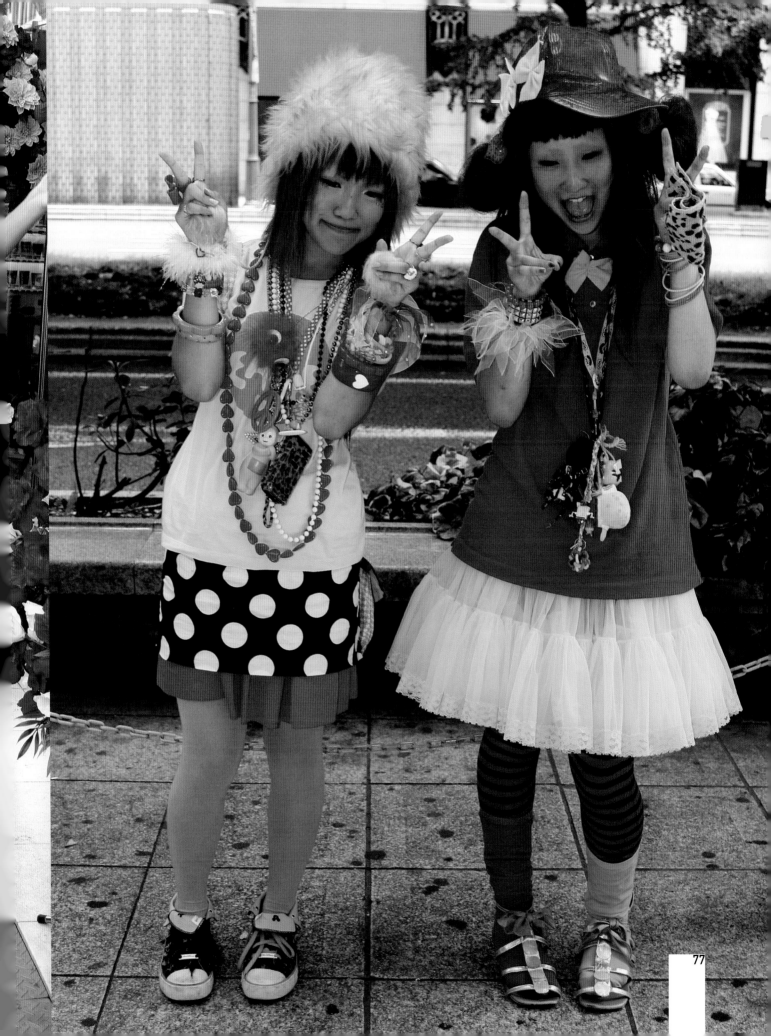

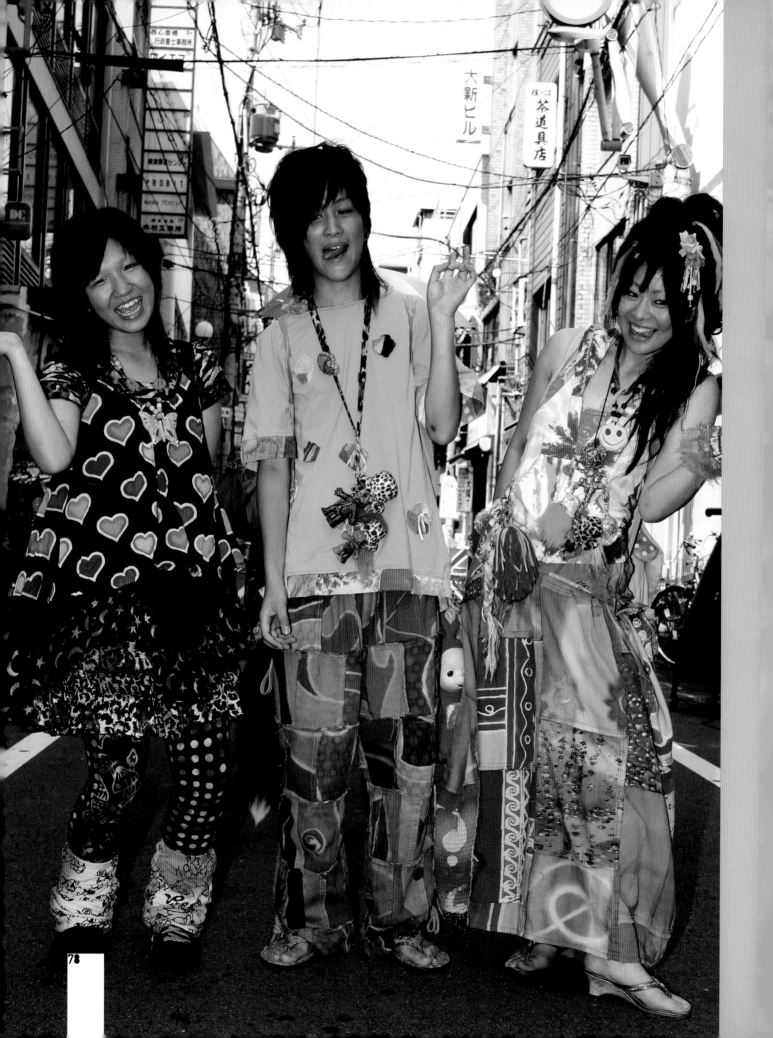

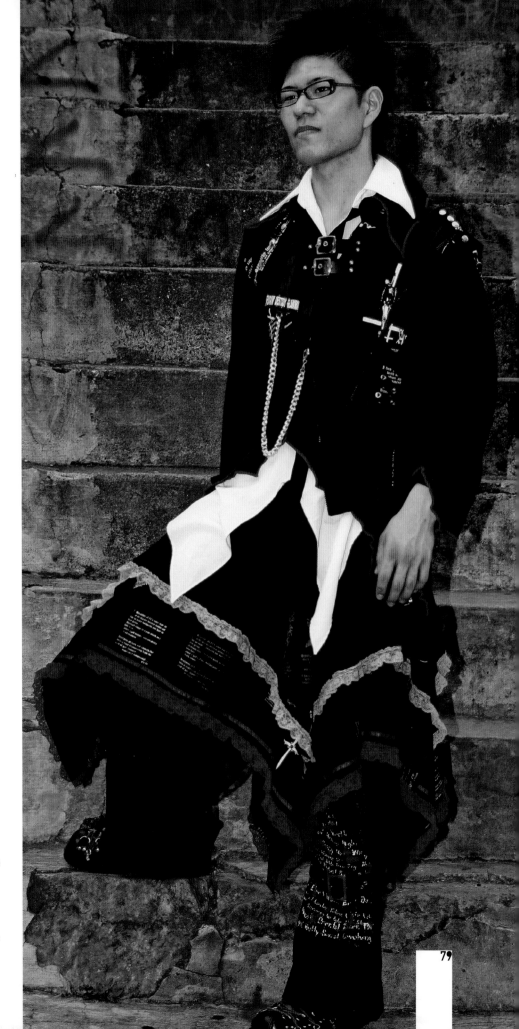

< **Three's a crowd** but one to be proud of.

> **A young man dressed head to toe** in his favourite designer's work: clothing by h. NAOTO. Trousers under a skirt, with accents of red and purple. Note the text used to adorn his skirt, trousers and jacket.

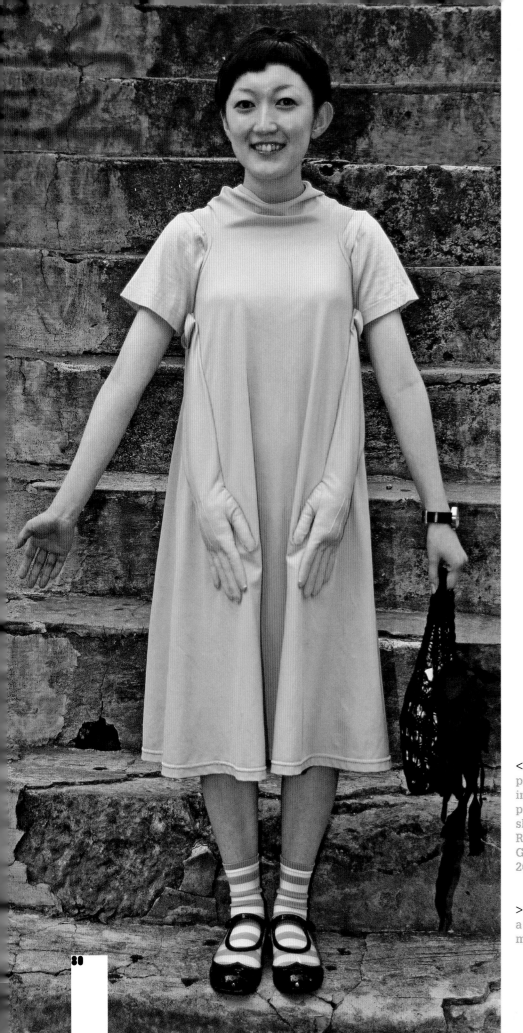

< **A young woman poses** for a picture on the steps of Omotesando in Harajuku, Tokyo. She wears a pink dress with matching socks and shoes all by her favourite designer, Rei Kawakubo of Comme des Garçons, from the Autumn/Winter 2007 ready-to-wear collection.

> **The Union Jack flag** has become a hugely popular style icon among many Japanese teenagers.

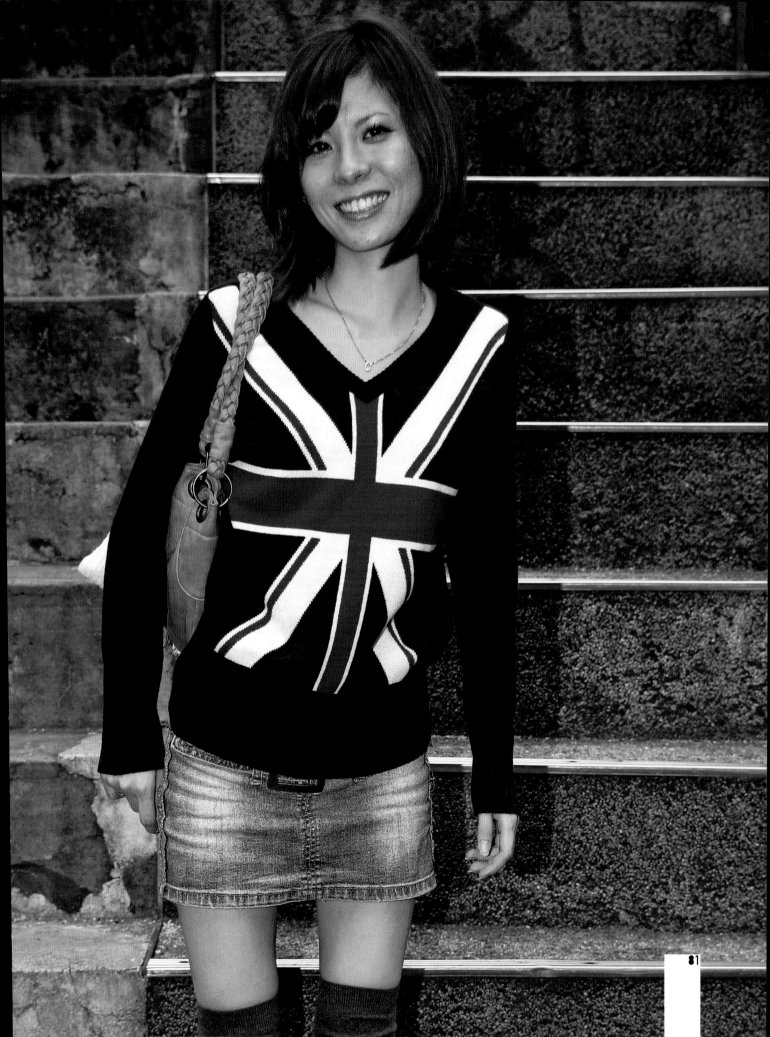

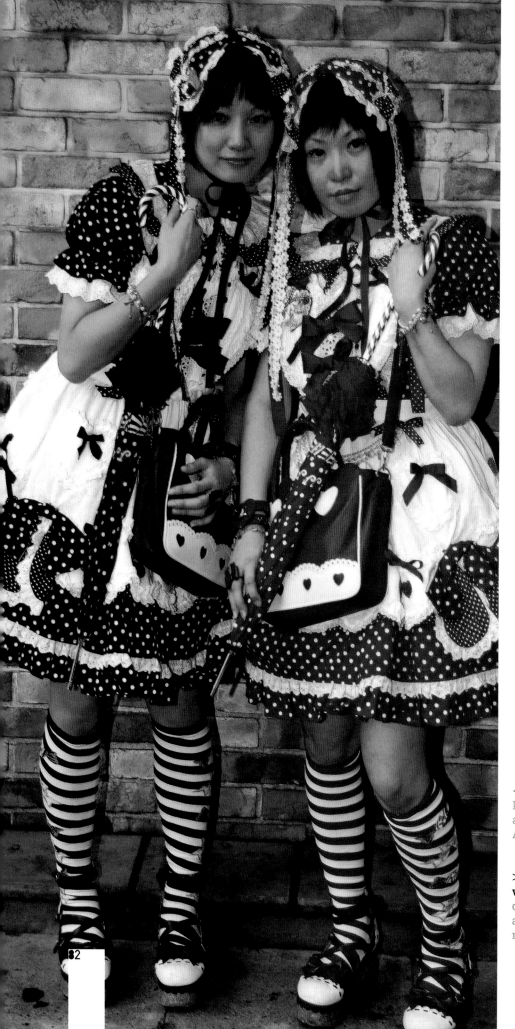

< **Two young women** dressed in Elegant Gothic Lolita style pose for a picture, Kuro Loli on the left and Akai Loli on the right.

> A young woman dressed in vintage 1960s Mary Quant style, complete with black plastic earrings and a bob hairstyle to match her monochrome minidress.

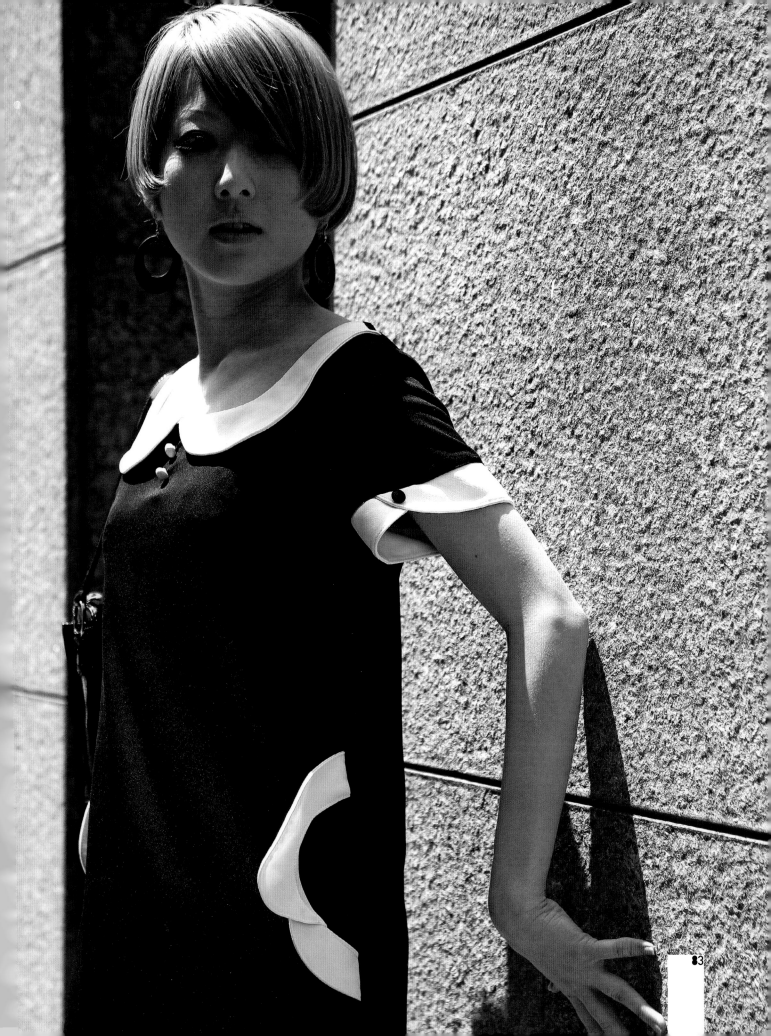

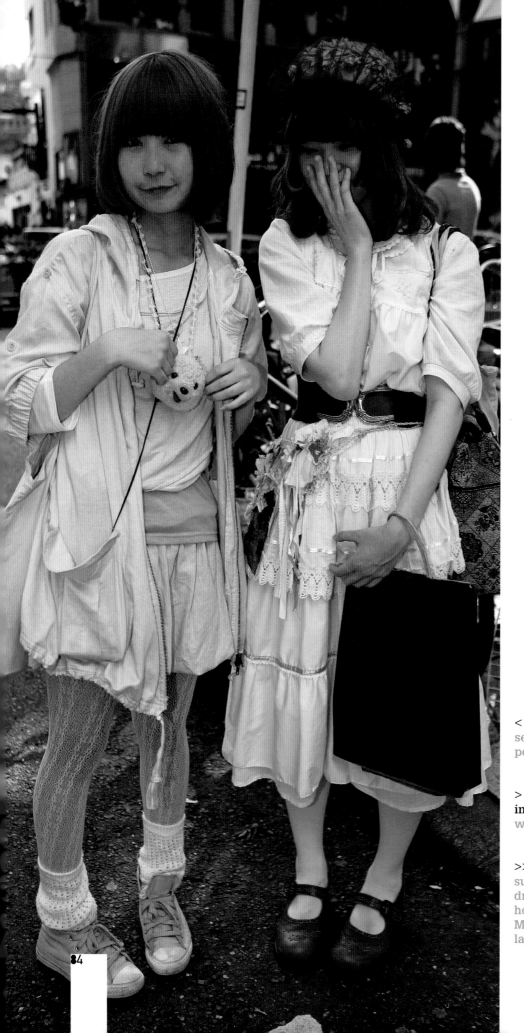

84

< **Two teenage girls** displaying their sense of style and their individual personalities.

> **How do you top that when you're in a top hat?** By simply dressing the way this teenage girl does.

>> **I love her style.** On a hot summer's day when everyone is dressed for comfort she doesn't let her sense of style slip one single bit. Mary Janes and socks and, multiple layers – she's got the lot.

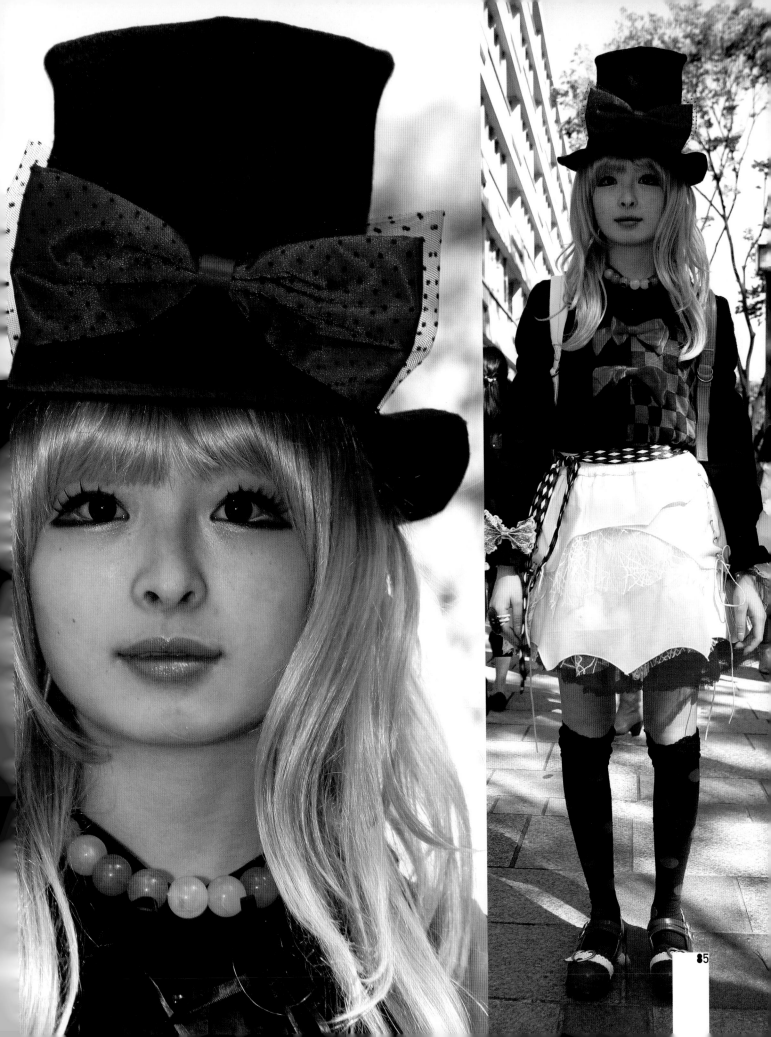

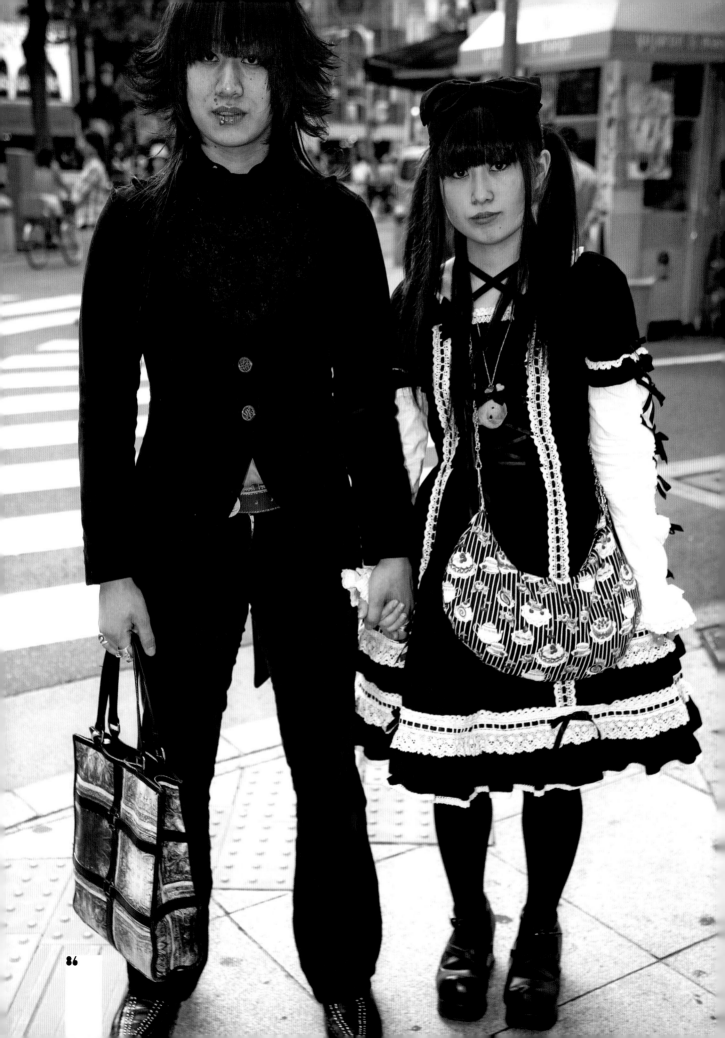

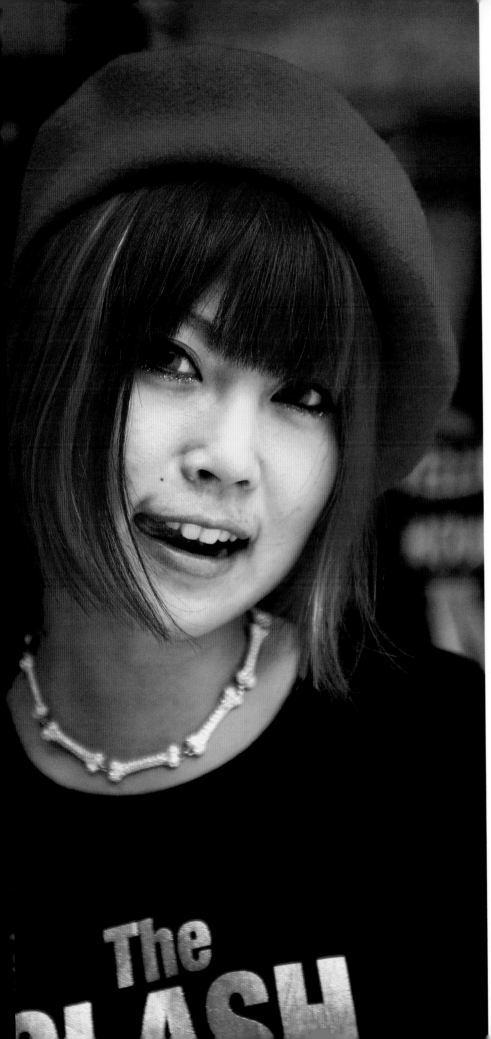

<< A young couple pose for a picture. She's dressed in Kuro Loli style while he's dressed in Kodona style.

< Portrait of a teenage girl wearing a T-shirt of the UK band The Clash. I love the details in this image: the bone necklace, the blue contact lenses, the glitter eye liner and the accents of purple and red.

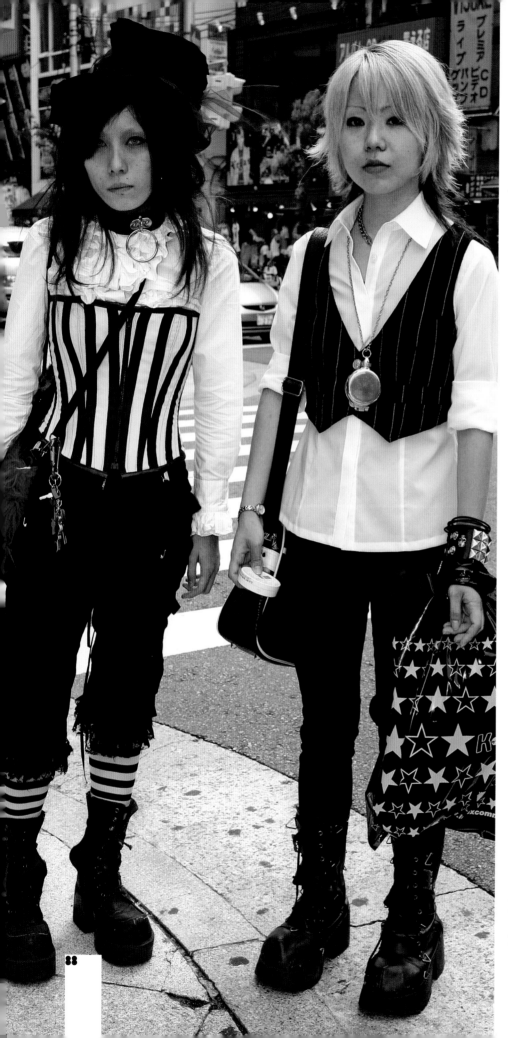

< Two teenage girls in Ame Mura, Osaka, both dressed in masculine style, one in Kodona. I love the level of complexity with these two. One plays a feminine role to the dandy style, with grey contacts, frills on her blouse and a corset, while her friend on the right uses a more obvious masculine approach with the waistcoat and white-collar shirt. The addition of the schoolboy-style blonde wig gives the look a more open definition, demanding that you do a double take.

> Two teenage girls pose for a picture on Omotosando in Harajuku, Tokyo. The girl on the left wears a Lolita skirt by Baby The Stars Shine Bright with one of its classic sweet cherry desert prints. Her top and pinny are by Mezzo Piano. Her friend to the right wears a monochrome Lolita style dress with shopping bags from Baby. Note the lace detail at the top of her socks.

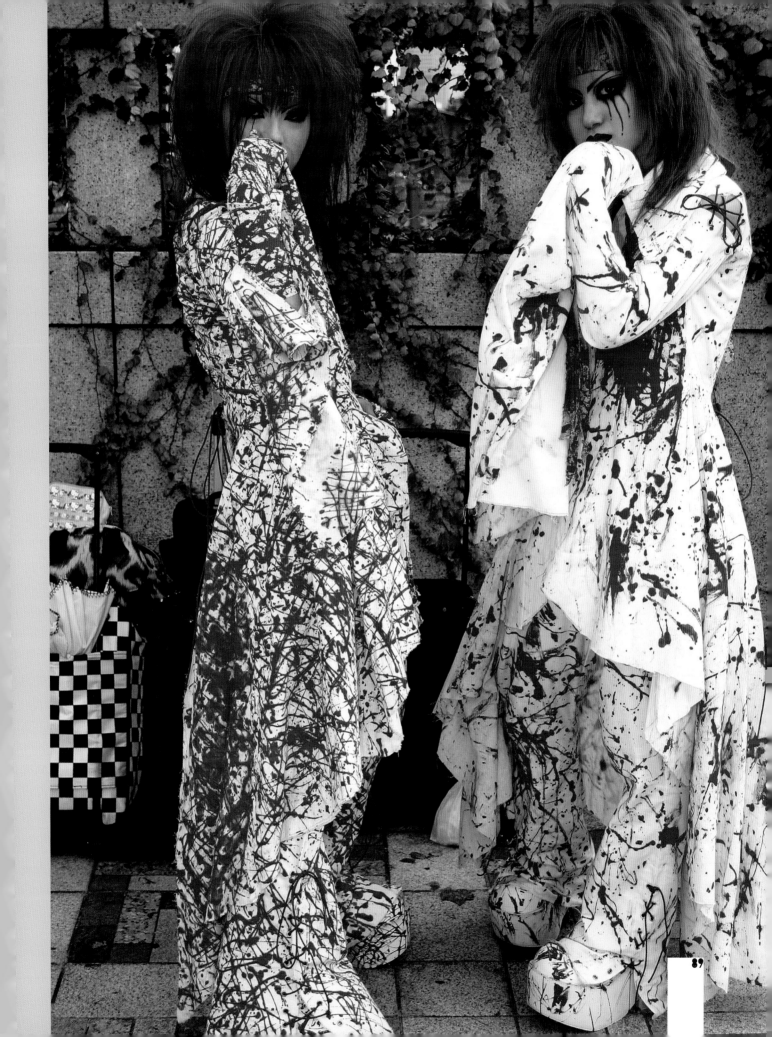

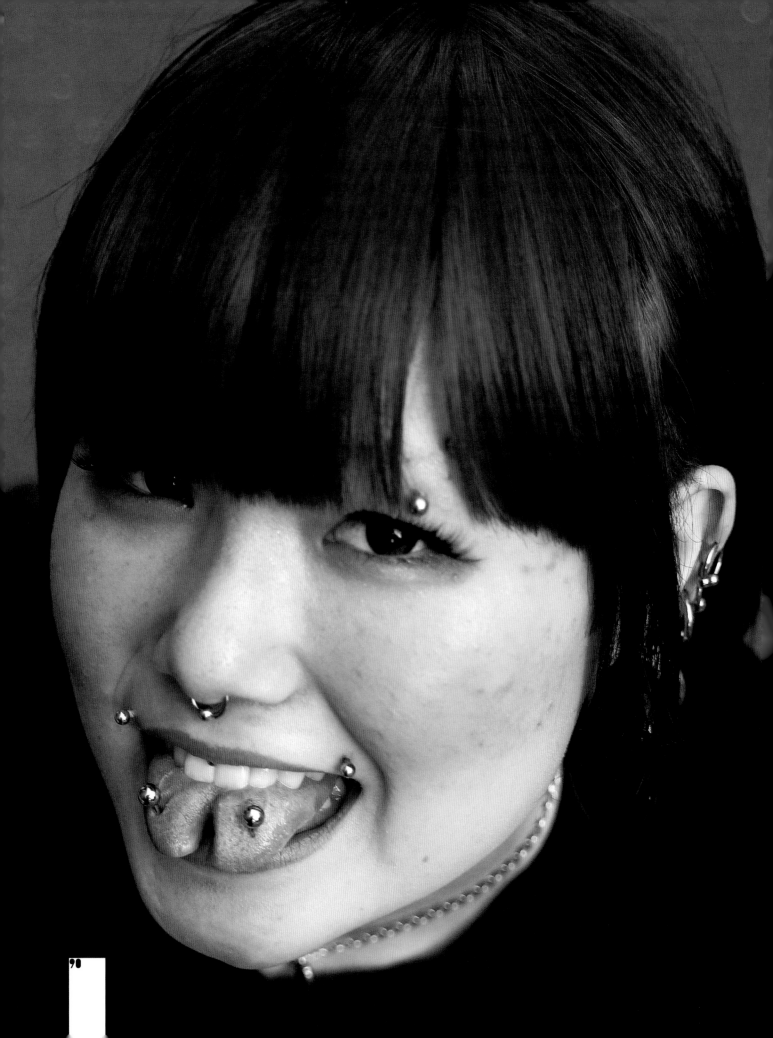

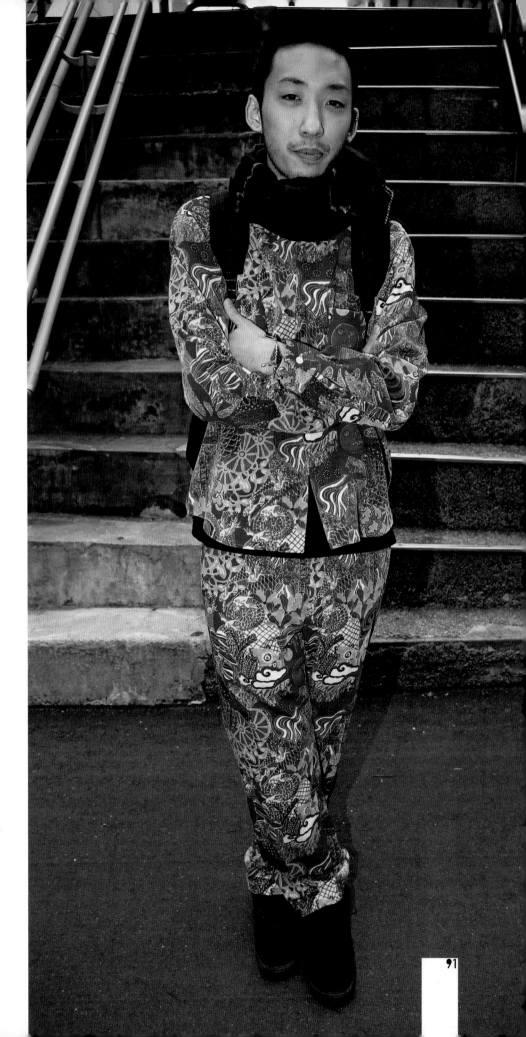

> A colourful young man wears a
suit by Rei Kawakubo of Comme
des Garçons. She's one of the most
prolific Japanese designers to be
based in Europe. This particular
design of hers is a traditional
Japanese print with a western
twist.

< Split decisions.

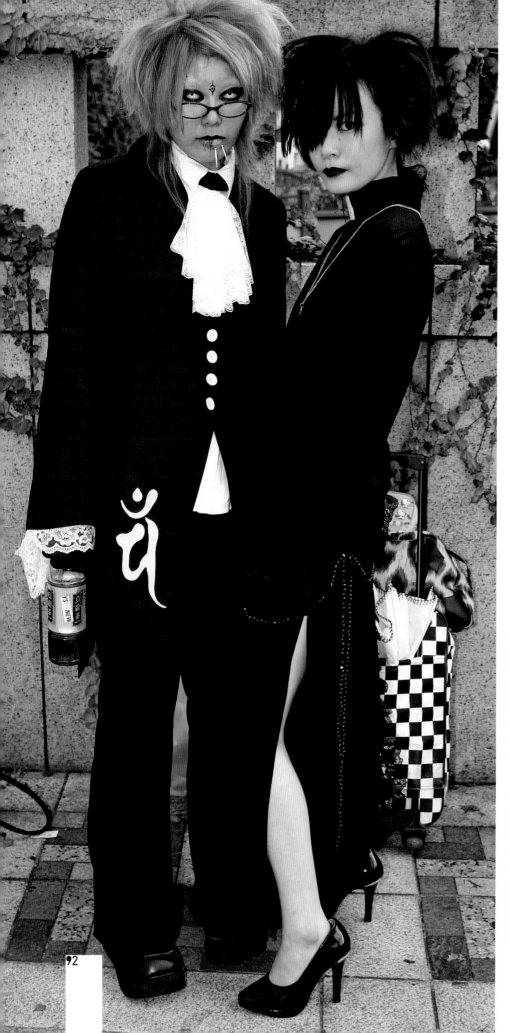

< **A young couple pose for a picture** at the bridge in Yoyogi Park in Harajuku. This was the world-famous Mecca for Japanese street style every Sunday from the 1980s until as recently as 2008. Now the thing to do to parade along Omotesando. These two are dressed in Gothic theme.

> **Subject: eye contact.** Target acquired. I love shooting street fashion from a perspective angle. Why do the same as everyone else when you can take a different approach? The contact lenses are awesome and shooting hairstyles from this angle really highlights the work that has gone into them. Facial piercing adds another dimension to the look.

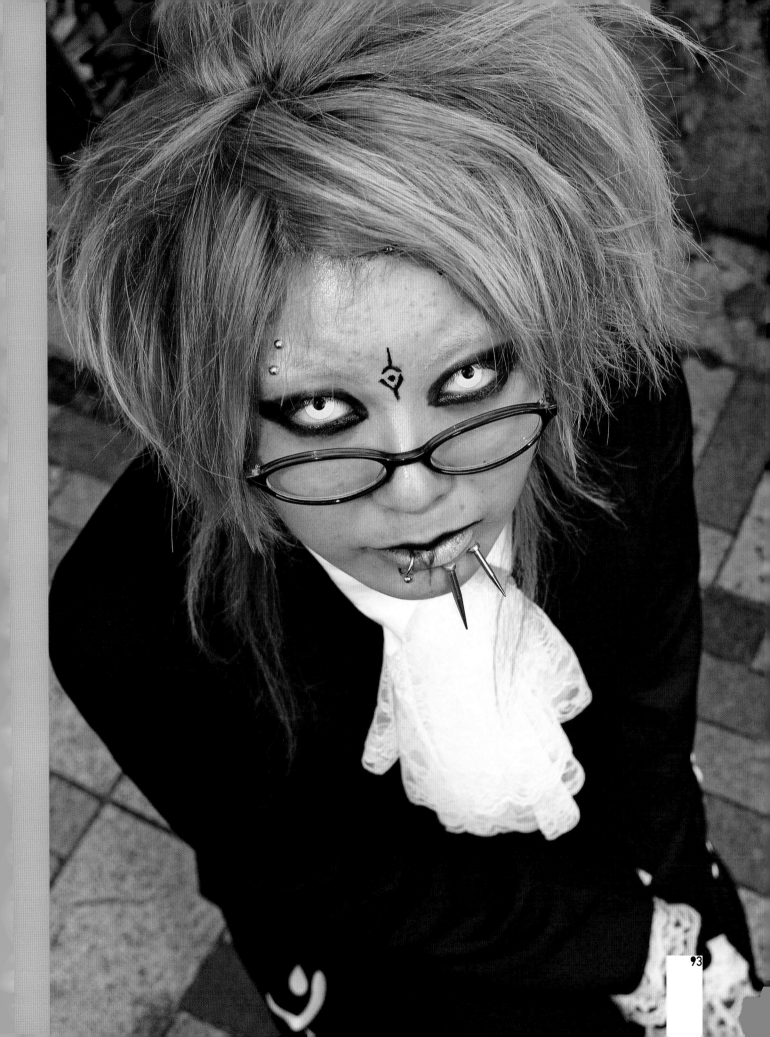

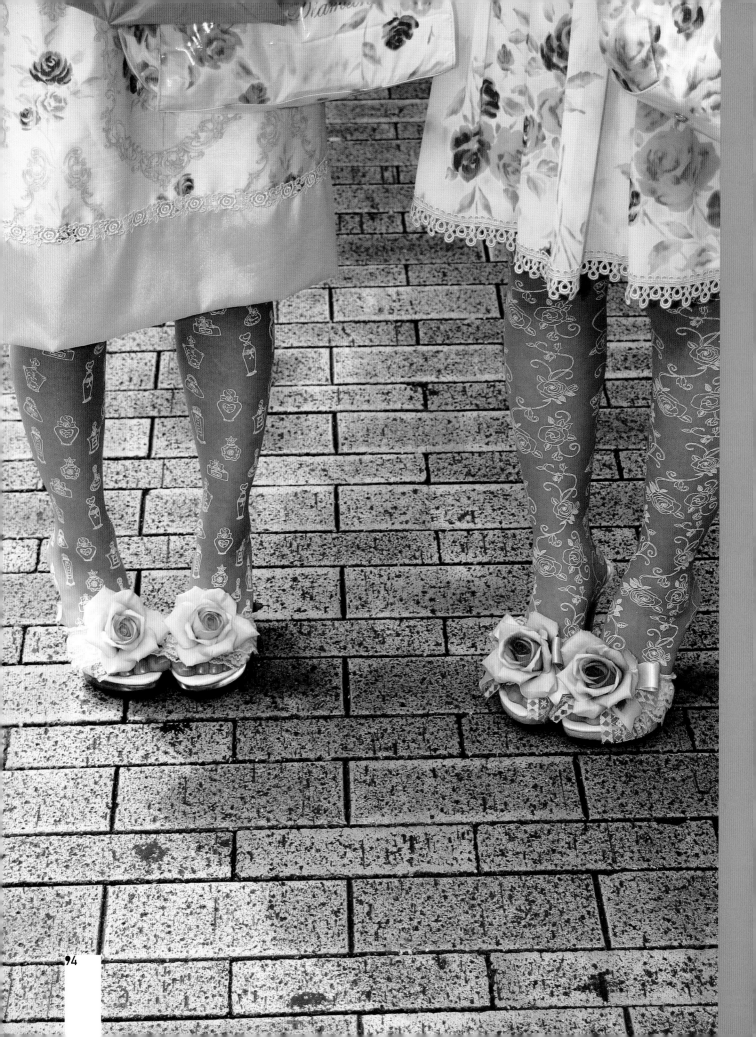

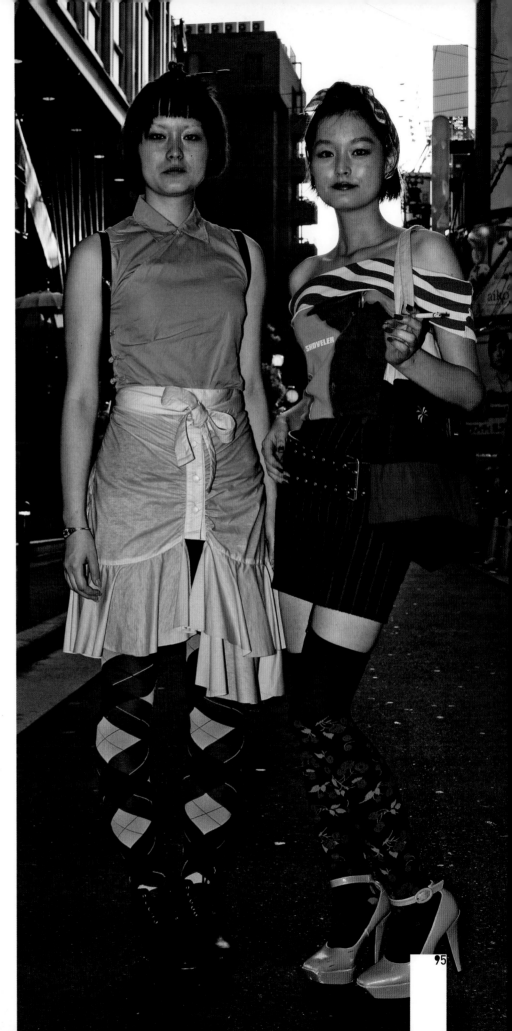

< **Pretty in pink, as everyone knows.**
So picture-perfect, with roses
on their toes. Two girls dressed
completely in the diffusion Lolita
brand called Jesus Diamante.
This brand's identity is ideal for
those into cute culture. Few could
compete, with picture perfection
right down to their feet.

> **Style on the backstreets** of Ame
Mura.

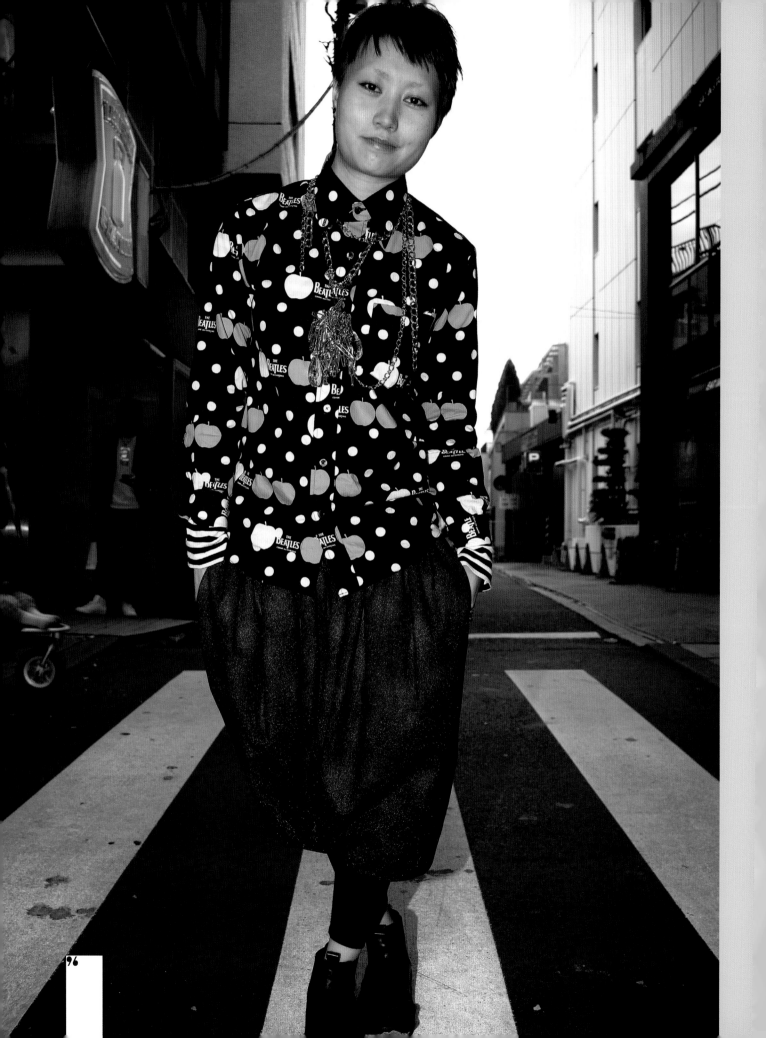

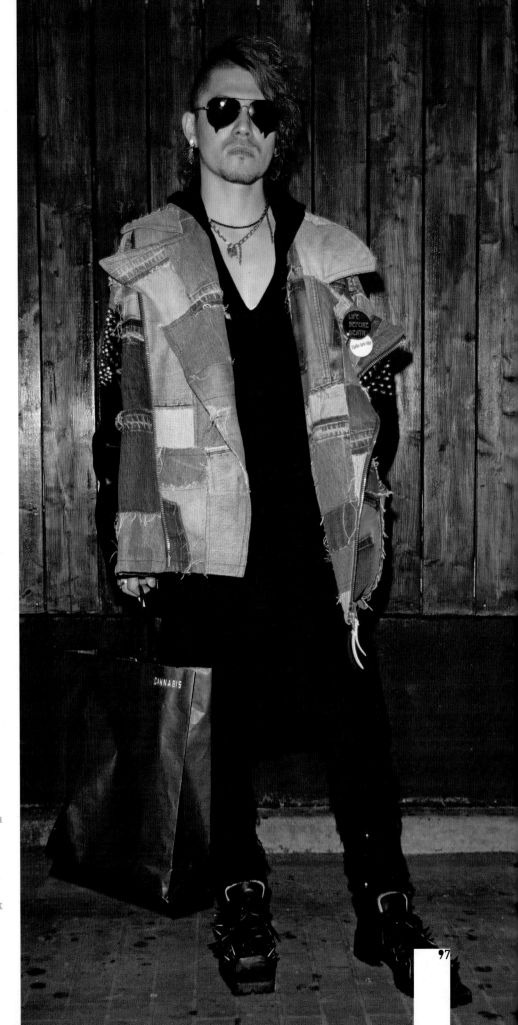

< **You are what you wear.** Karin is wearing Comme de Garçons. She's a shop assistant for the brand.

> **Norimi is a fashion designer** from Harajuku wearing a patchwork denim jacket by Juveniceroll. Check out his shoes by Hiro. Serious 'don't mess with me' attitude to them.

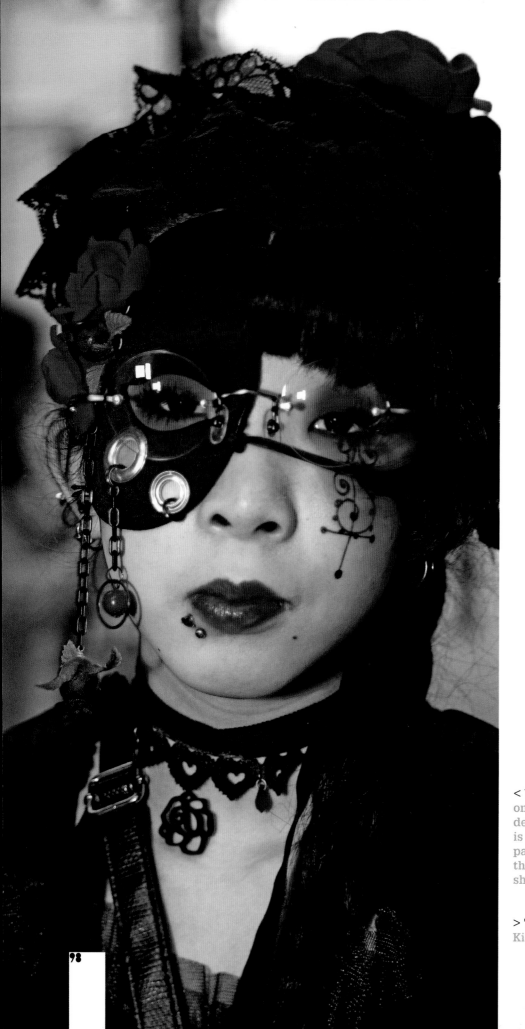

< **Your style is good,** but not a patch on this teenager. The exquisite detail that has gone into her look is exciting, highlighting her eye patch with a Gothic theme. I love the accents of pink from her eye shadow.

> **Two cute and fluffy teenagers** in Kigurumi hats.

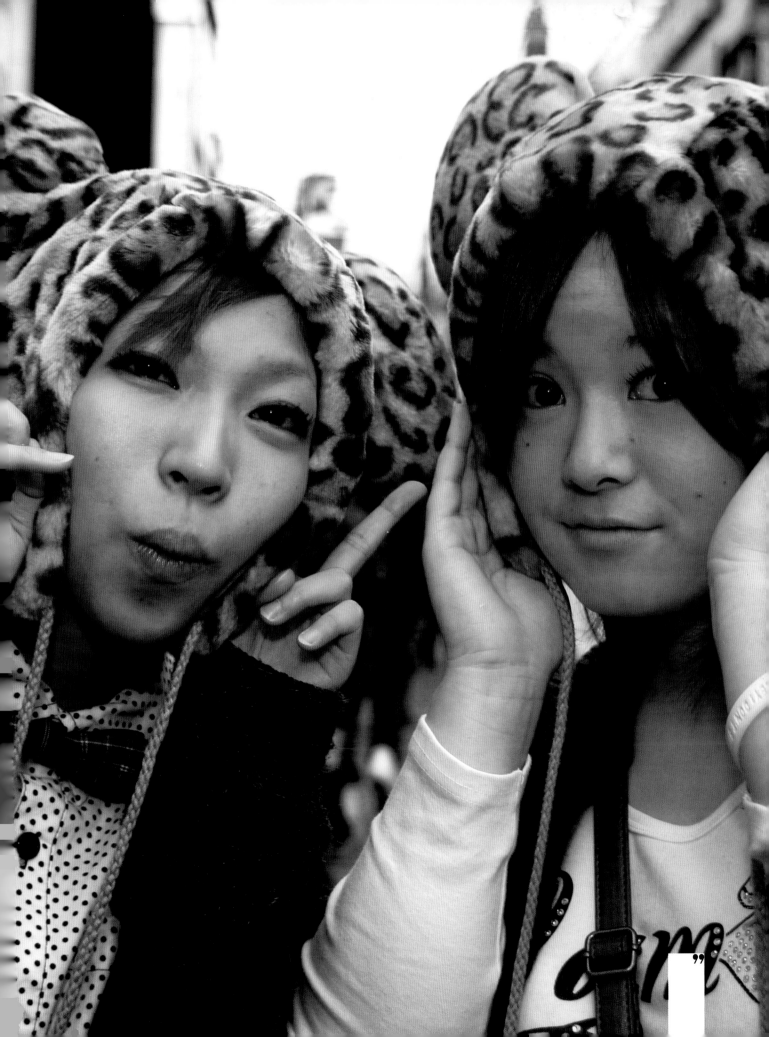

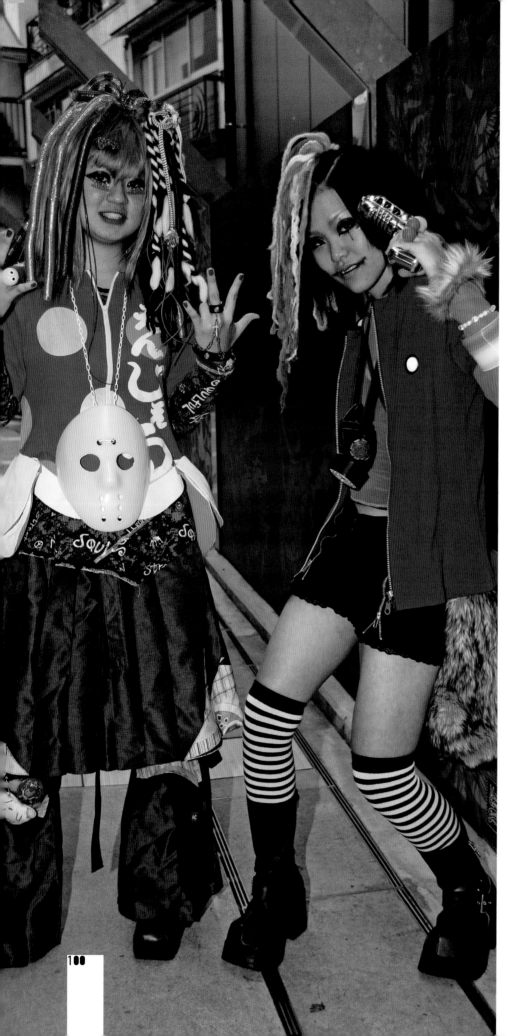

< **The Dynamic Duo.** Two teenage girls dressed in electro-cyberpunk worn with their own twist. Note the Joker's make-up on one of the girls and the mask of Jason from the movie *Friday the 13th*.

> **Hey you!** Portrait of a teenage girl dressed in cyber punk style. The level of detail is amazing. I love her double eyelashes. One layer of orange and yellow, the other layer a message saying Happy Halloween.

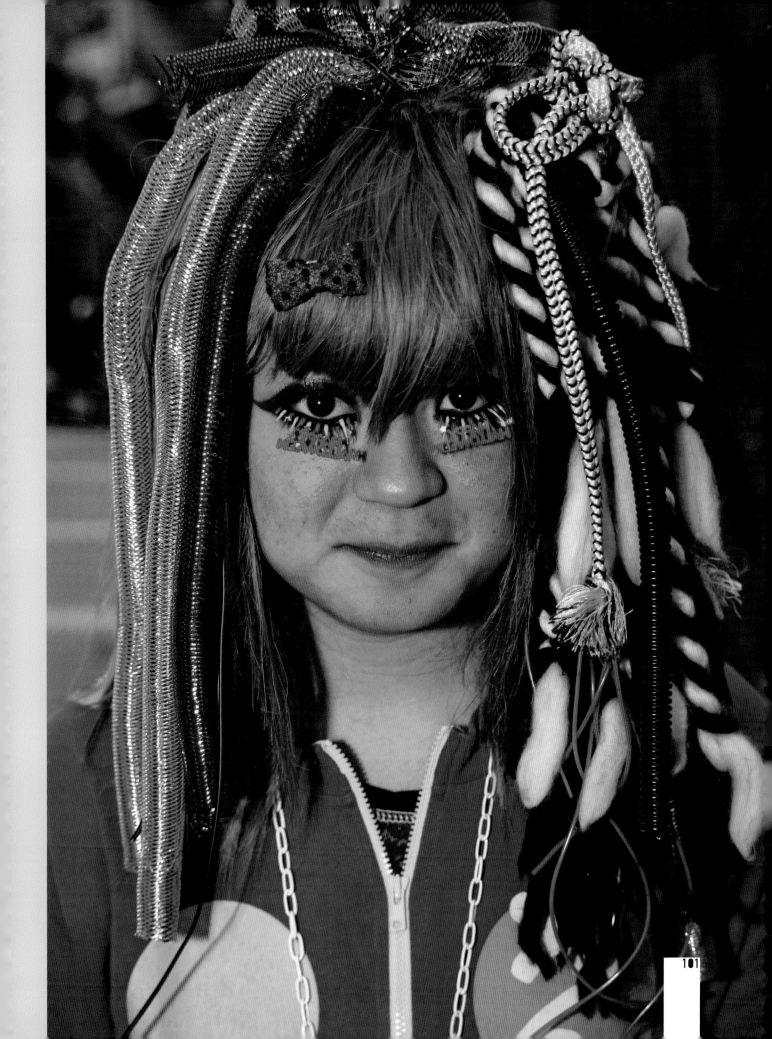

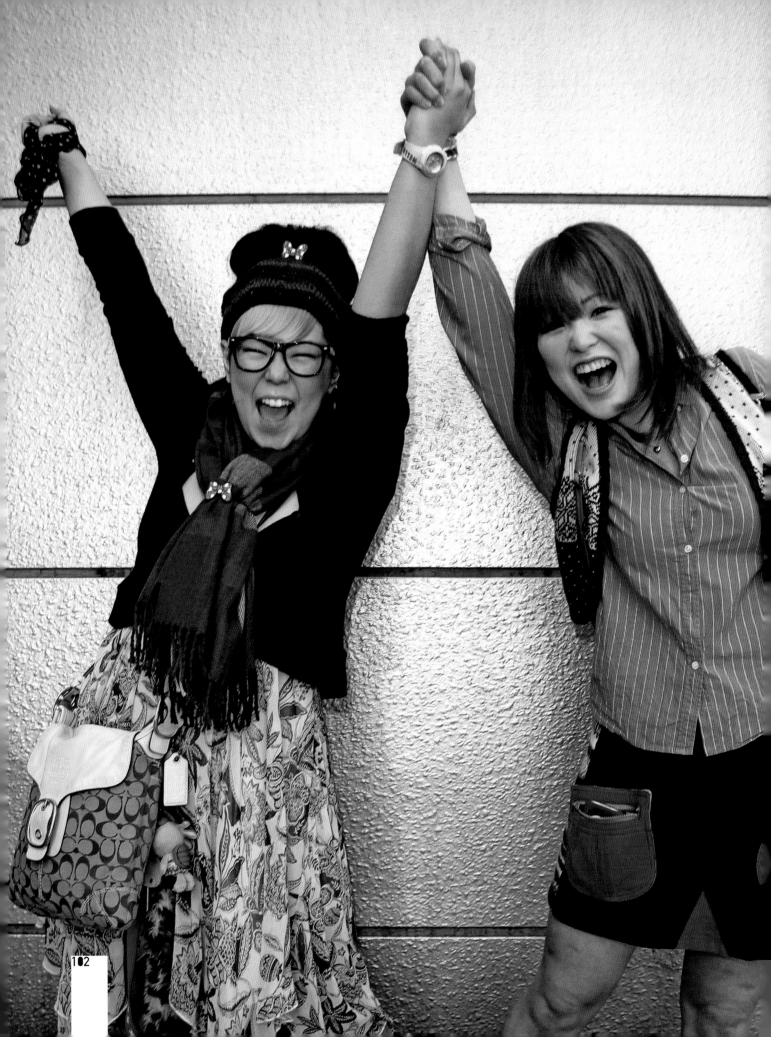

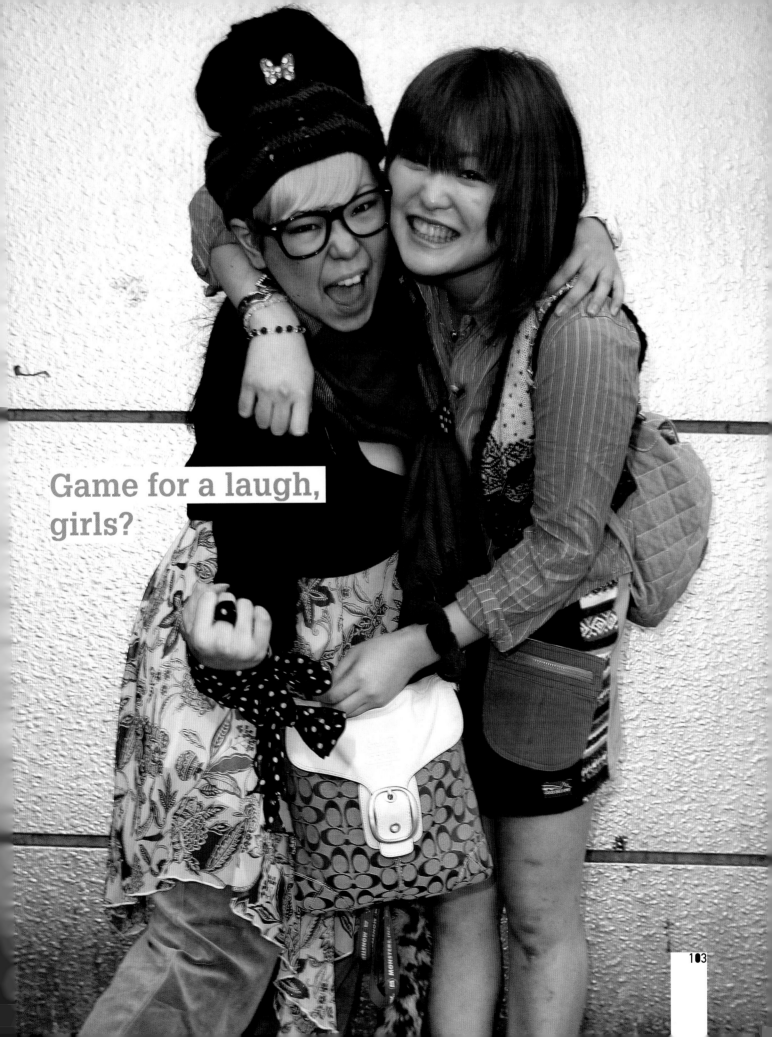

Game for a laugh,
girls?

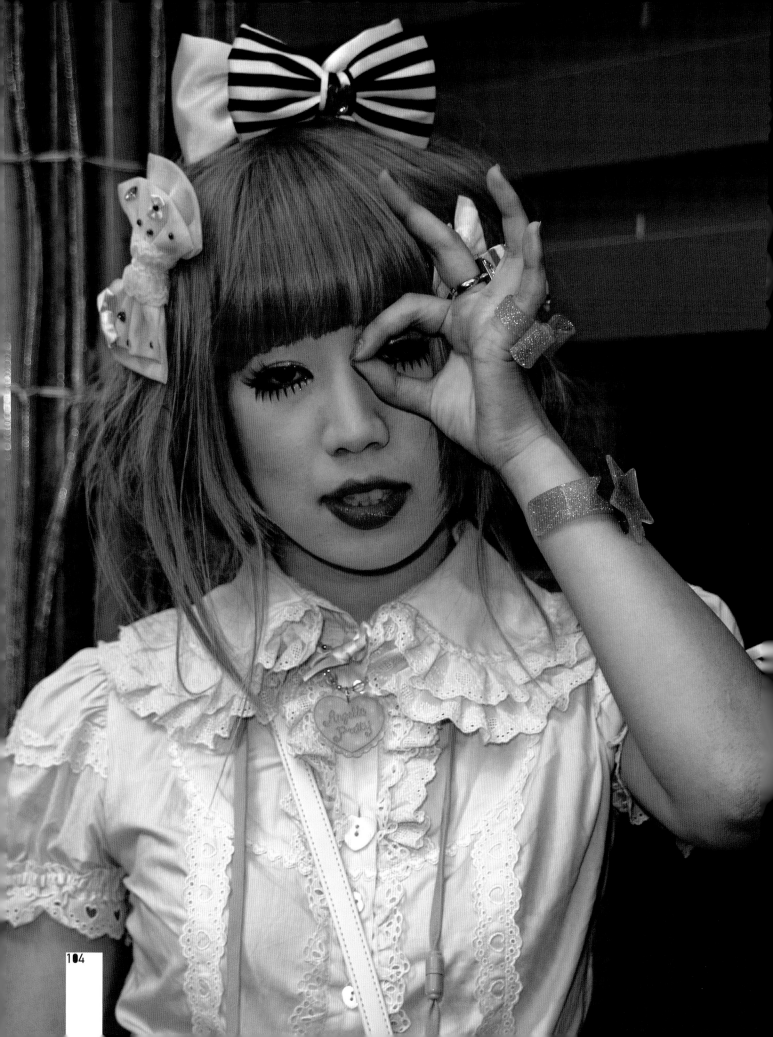

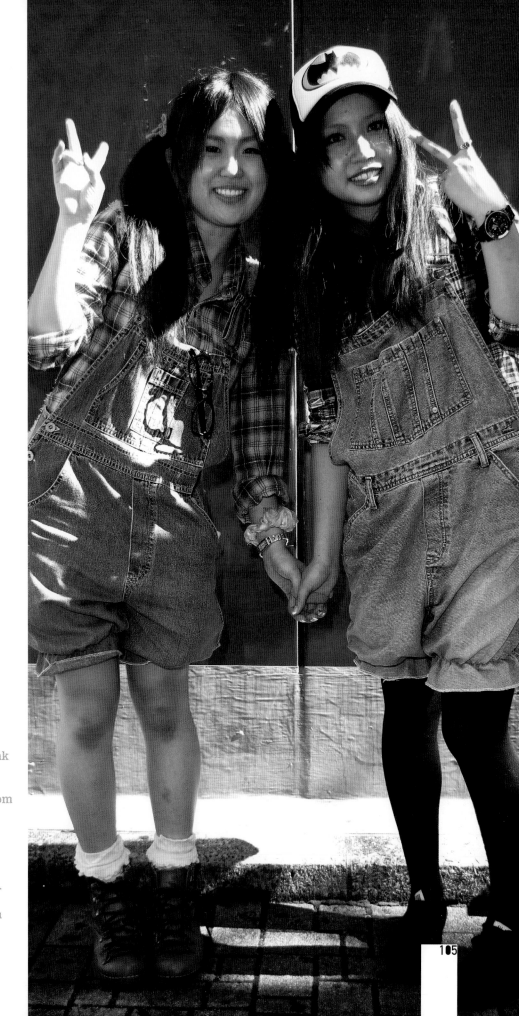

< **Tokyo.** Seen here wearing all pink as her theme. Her style is Sweet Lolita. I love the bows in her hair and the lacework on her blouse from Angelic Pretty.

> **Two teenage girls** from the fashion shop Panama Boy on Takeshita Dori in Harajuku, Tokyo. On the left is Chiori and on the right is Momoko. Both wear denim dungarees and alpine shirts.

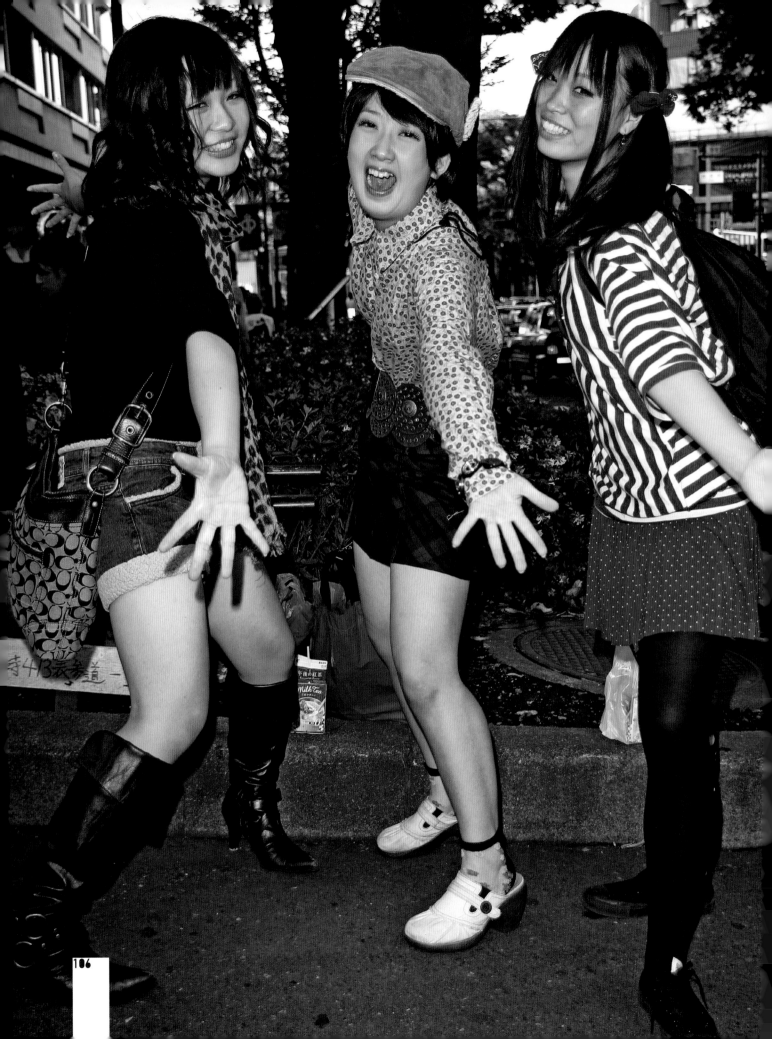

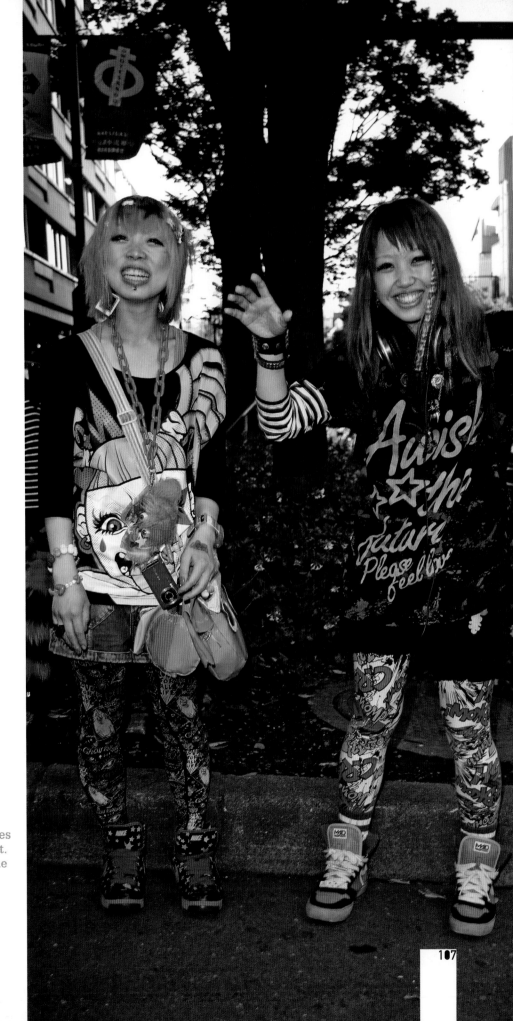

< **By the power of three.** Three times the fun, three times the excitement. Their way of doing things times the power of three.

> **A couple** of colourful characters from Tokyo.

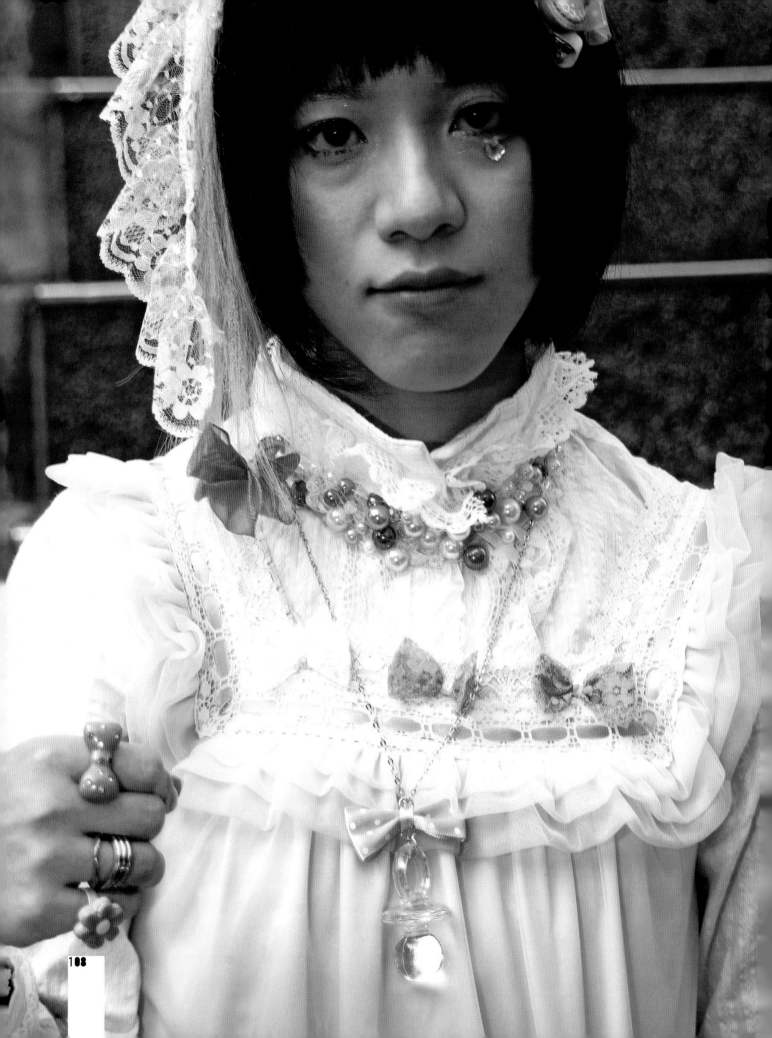

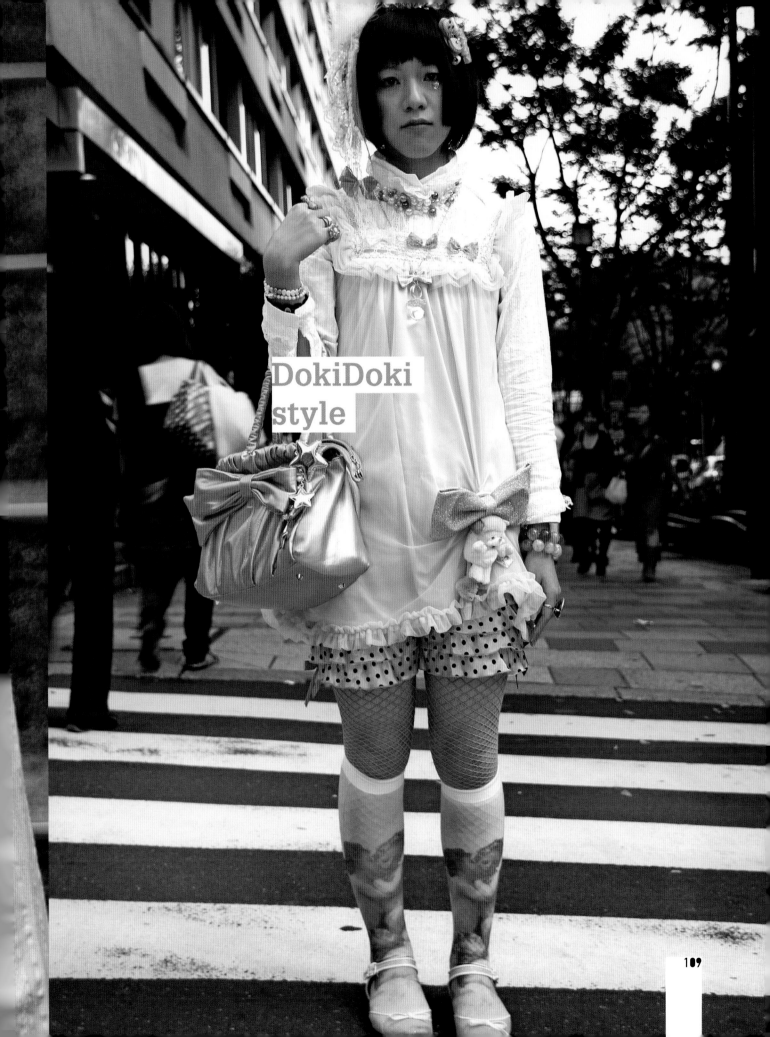

DokiDoki
style

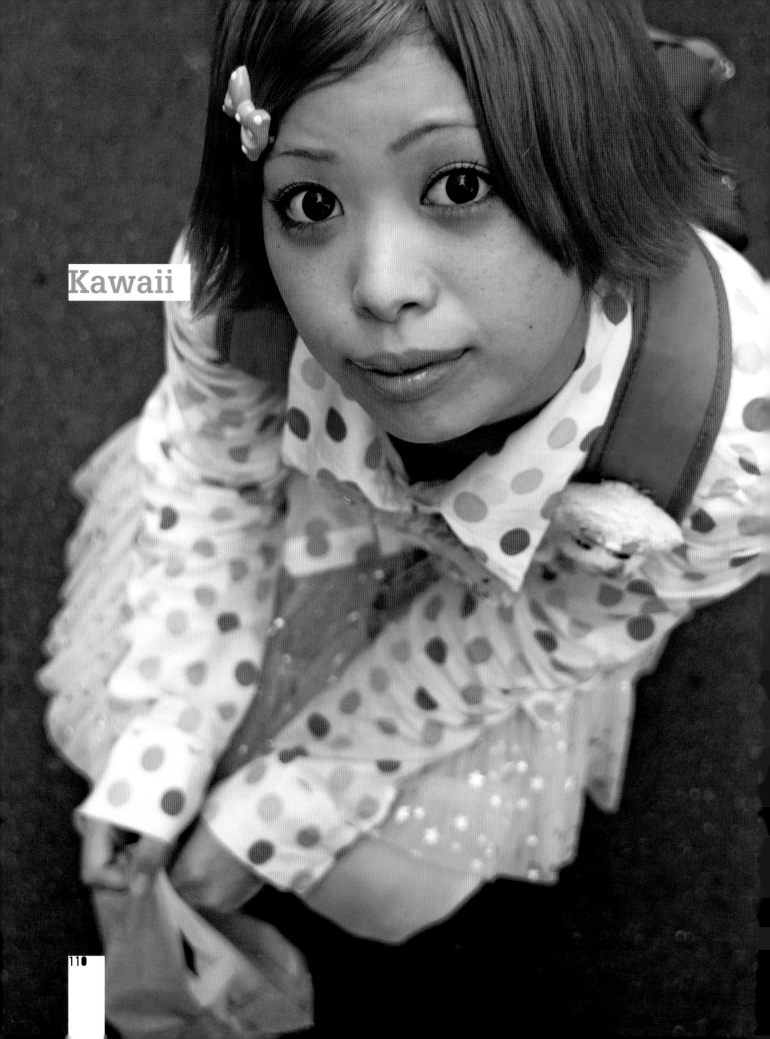

Kawaii

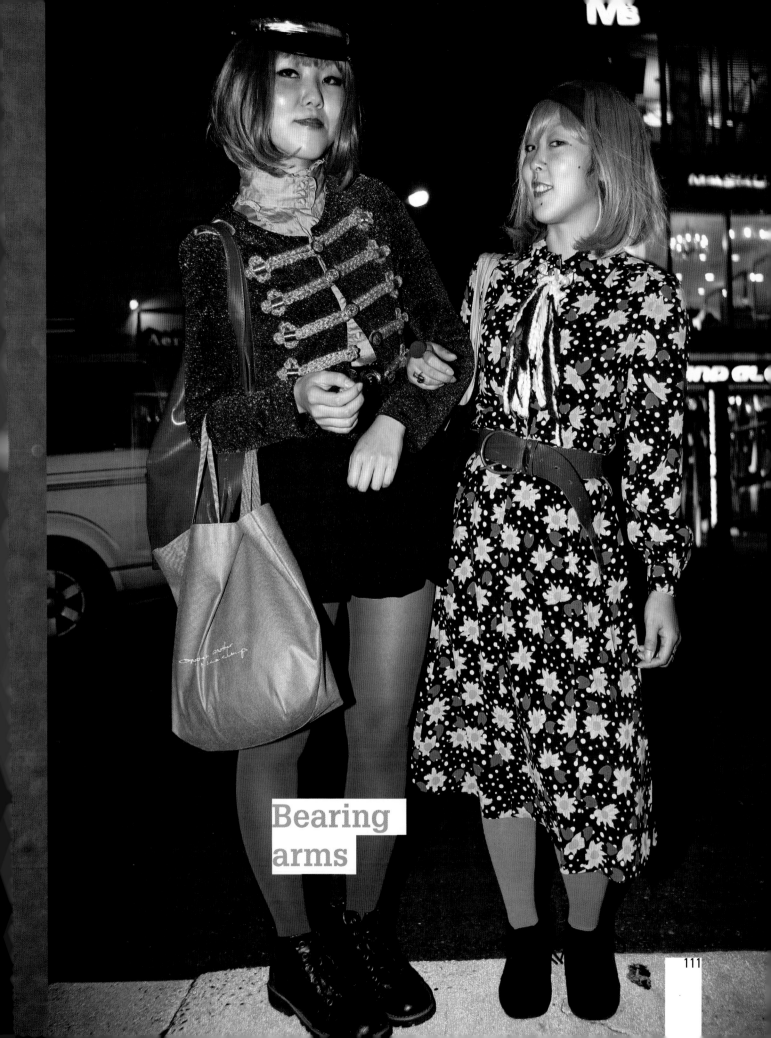

Bearing
arms

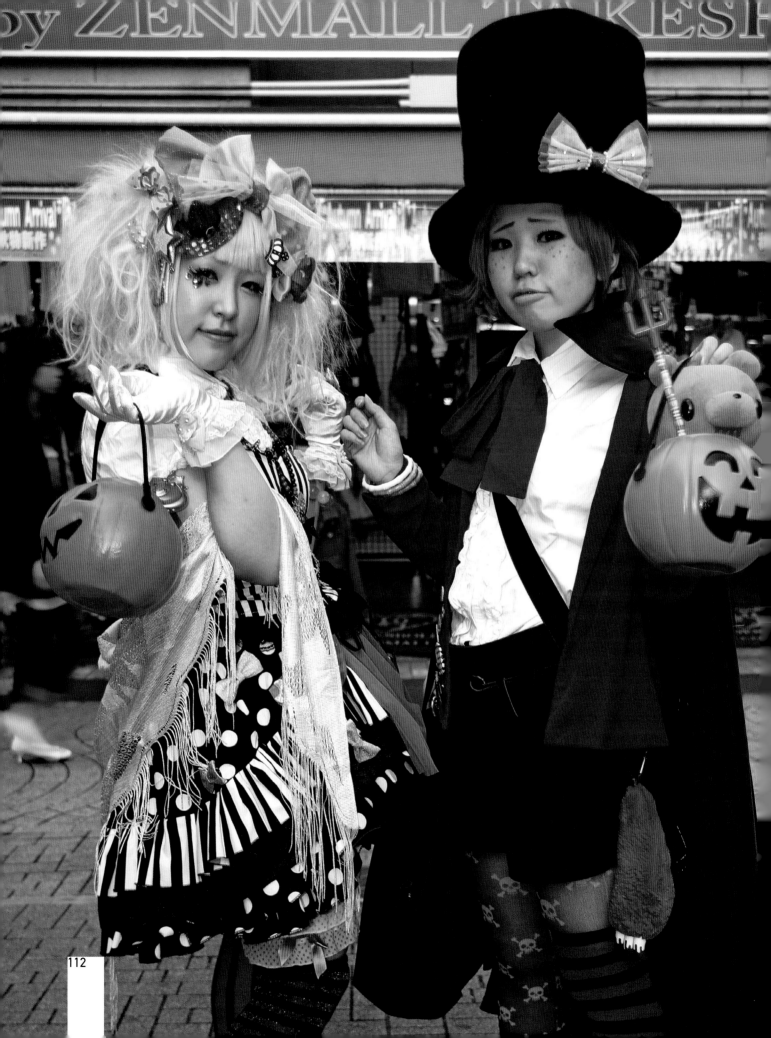

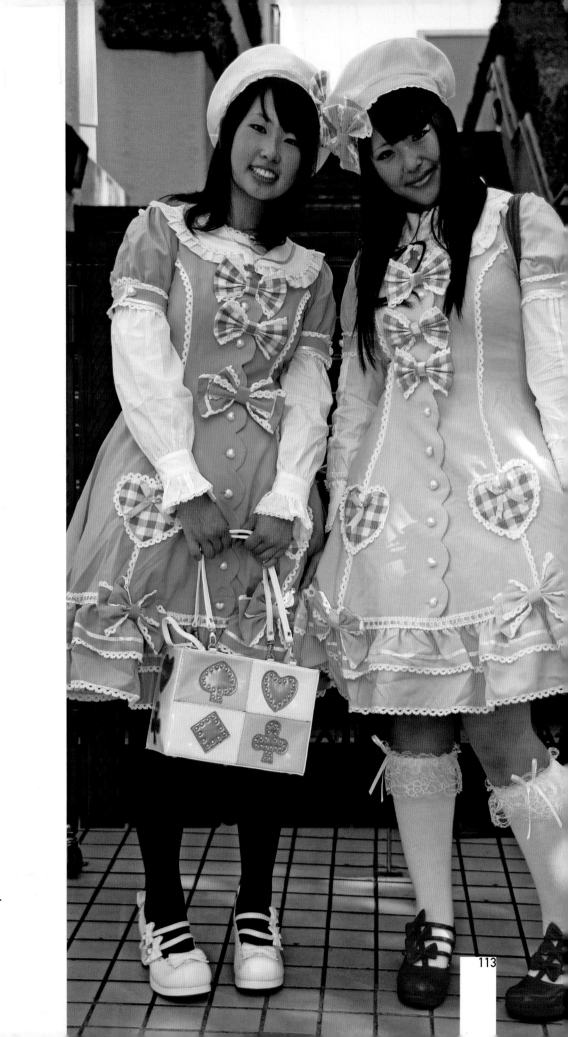

< A delight on Fright Night.

> Lolita style.

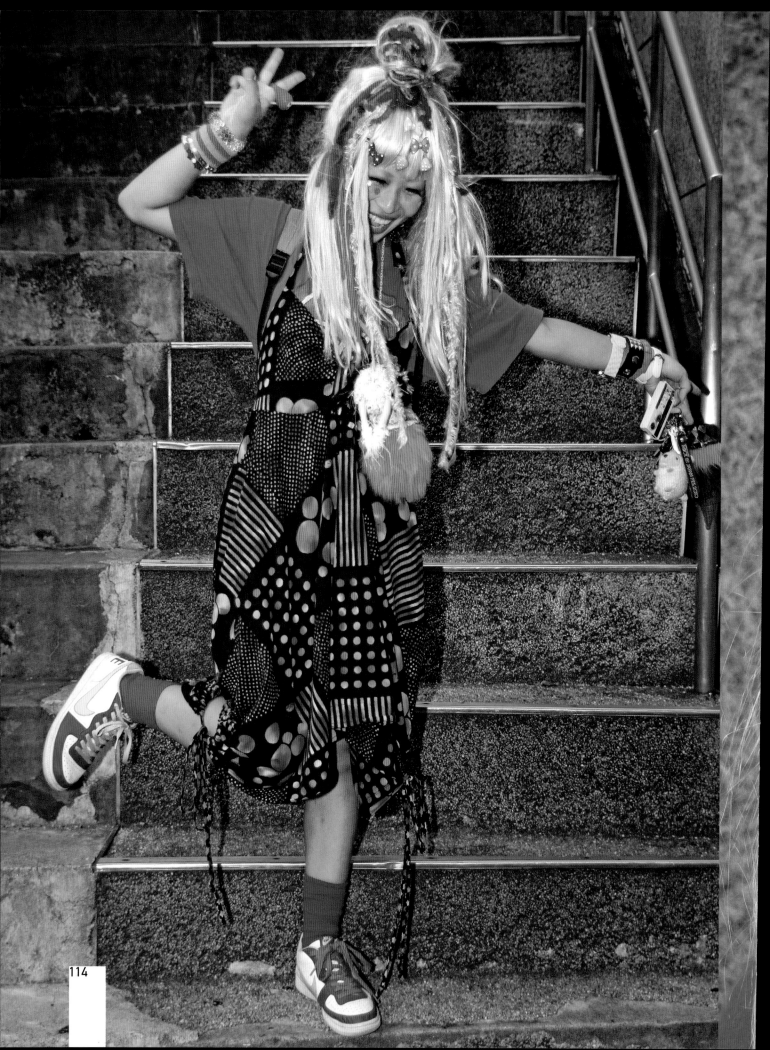

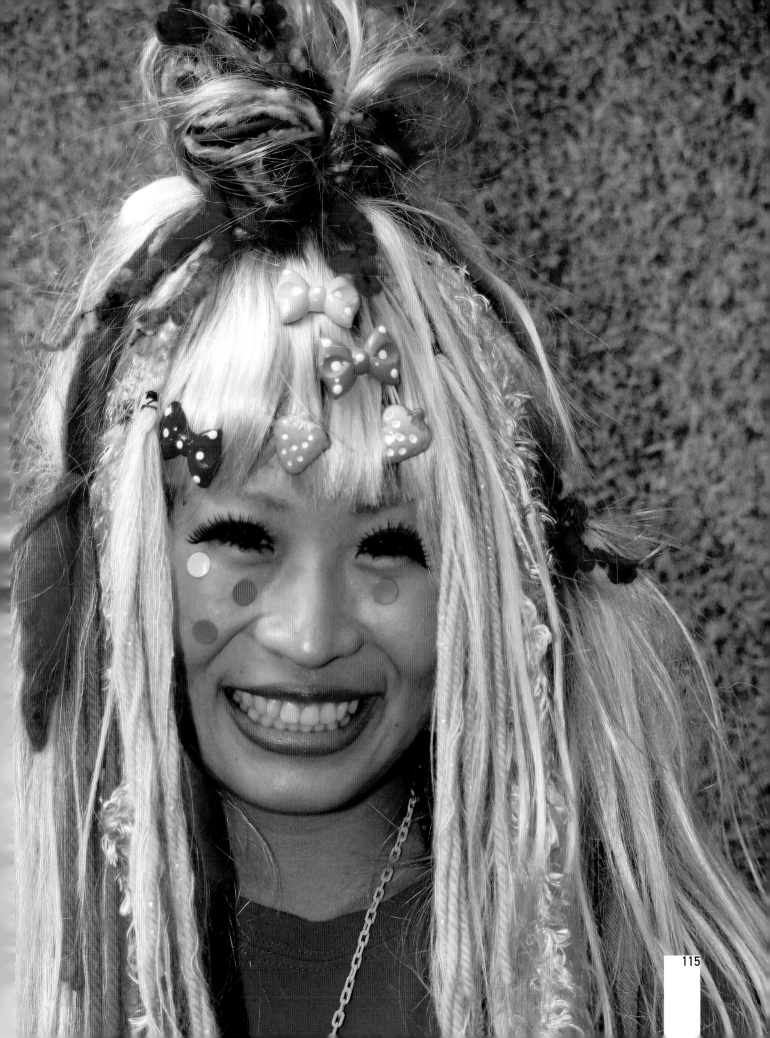

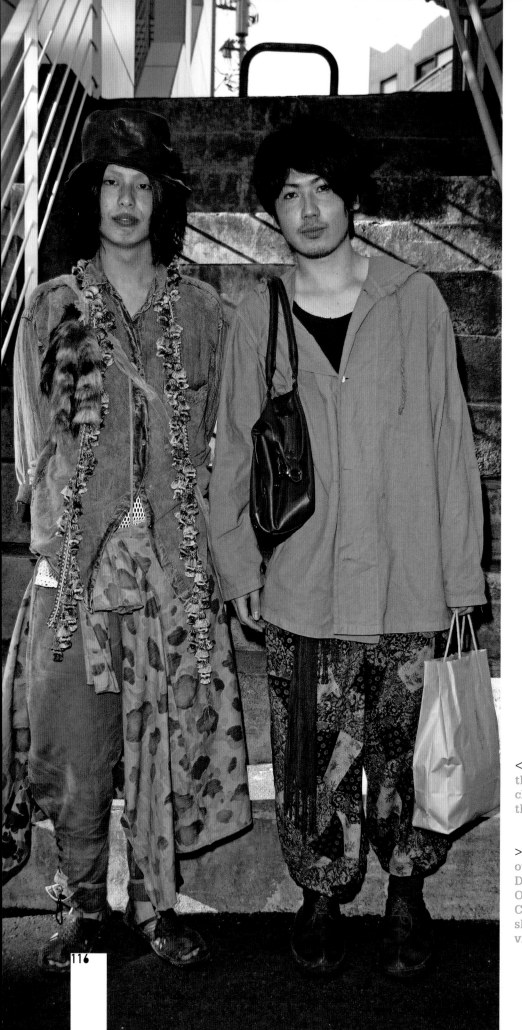

< **Browned off!** These two guys with their very individual sense of style choose the colour brown as their theme.

> **On the left is Hitomi Nomura,** owner of Grimoire, the amazing Dolly Kei shop in Shibuya, Tokyo. On the right is her assistant Heri. Centre is Saori Takemura. They share a passion for European vintage fashion.

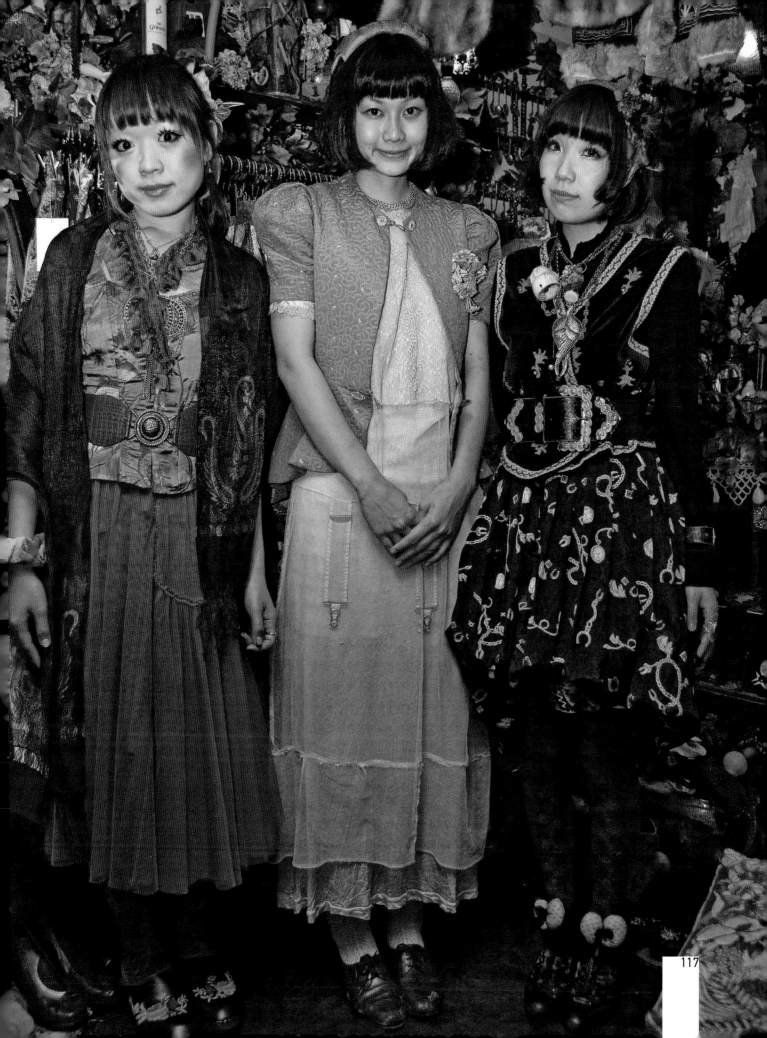

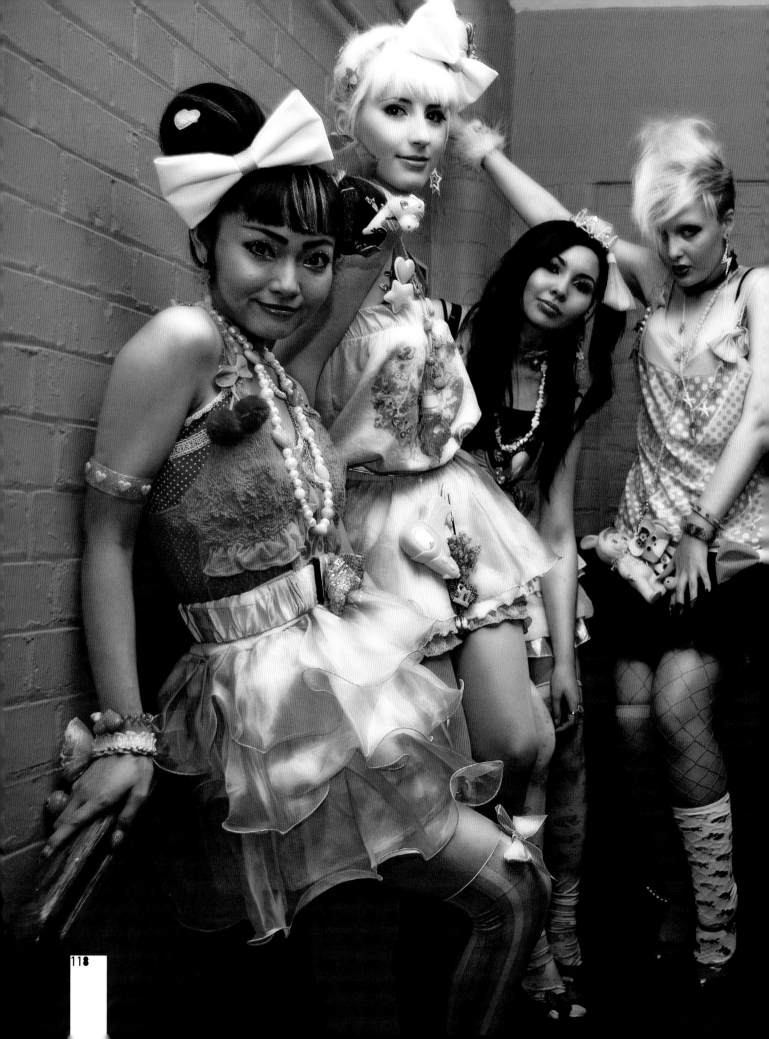

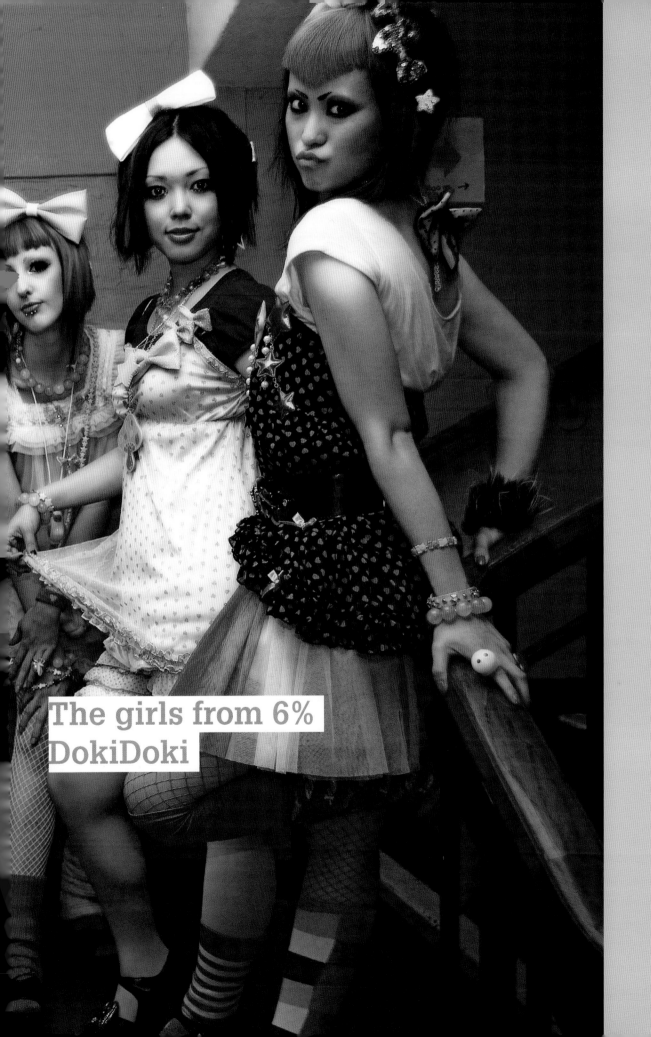

The girls from 6%
DokiDoki

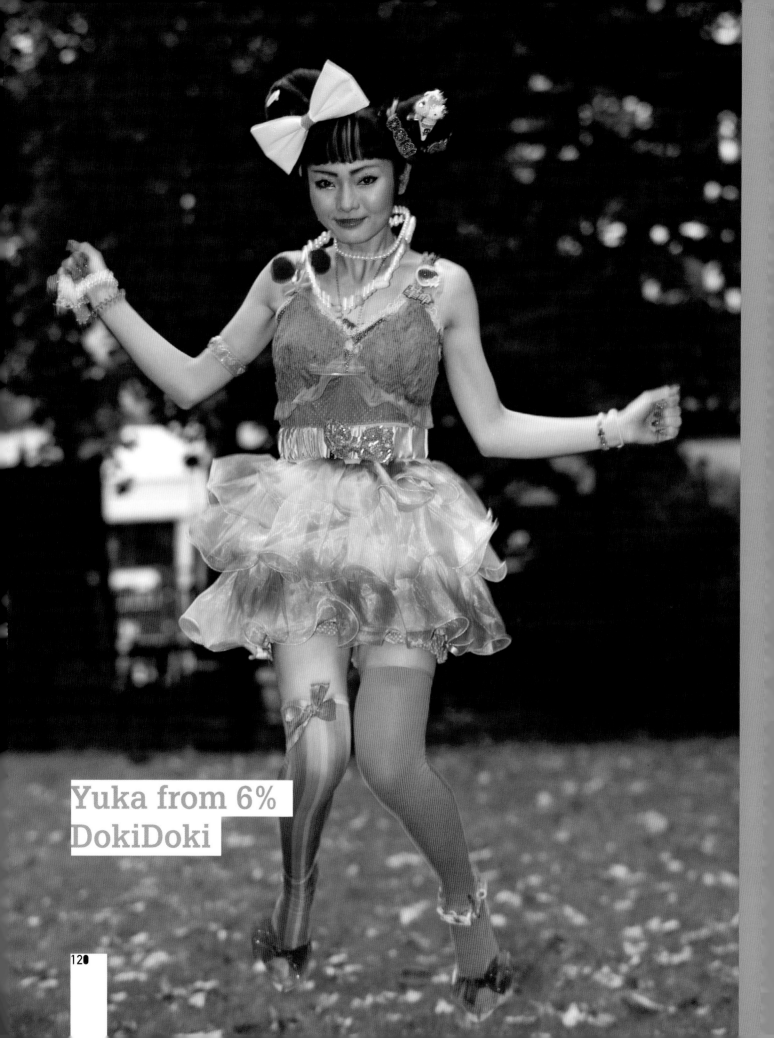

Yuka from 6% DokiDoki

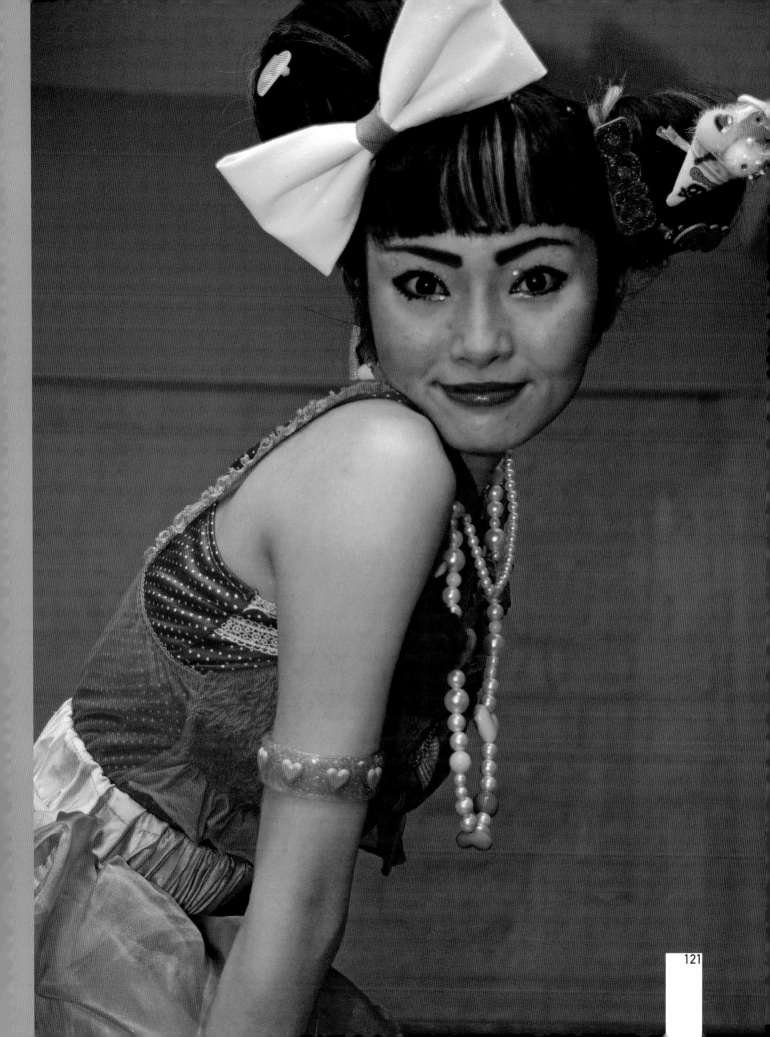

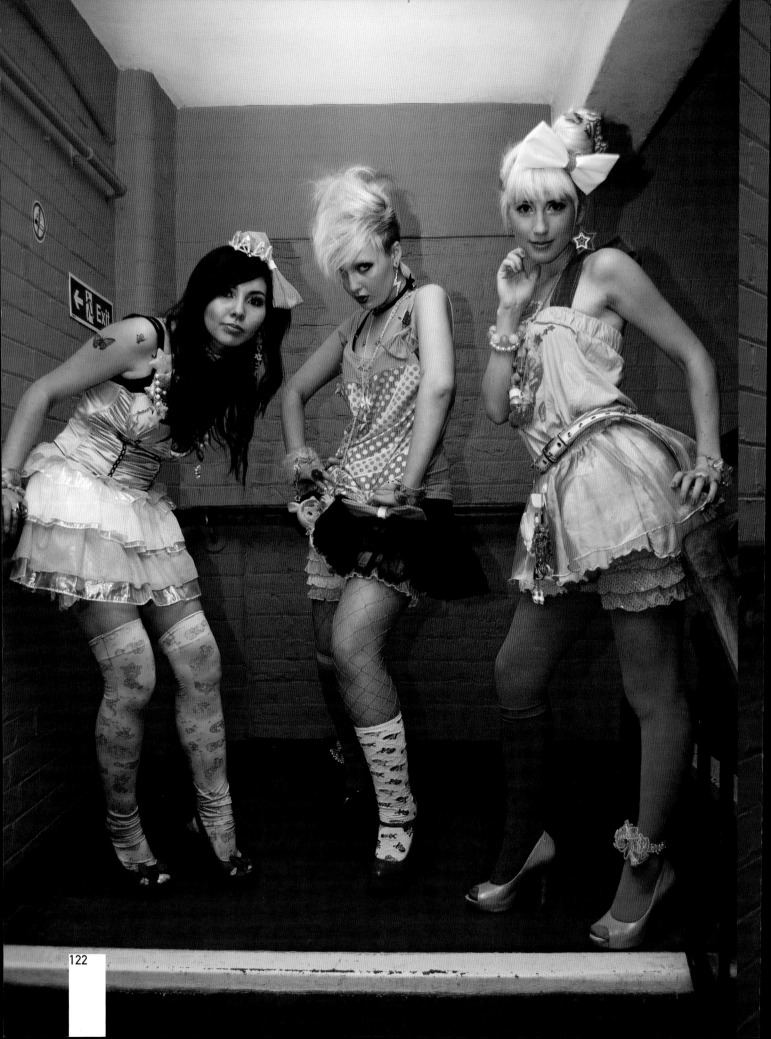

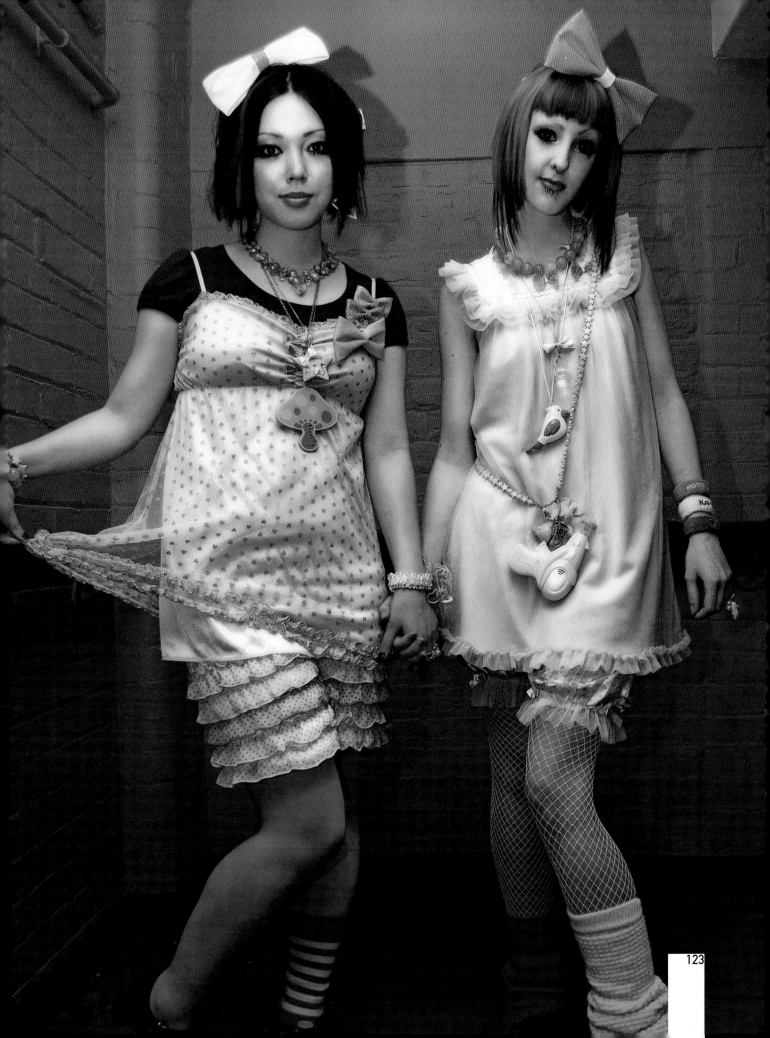

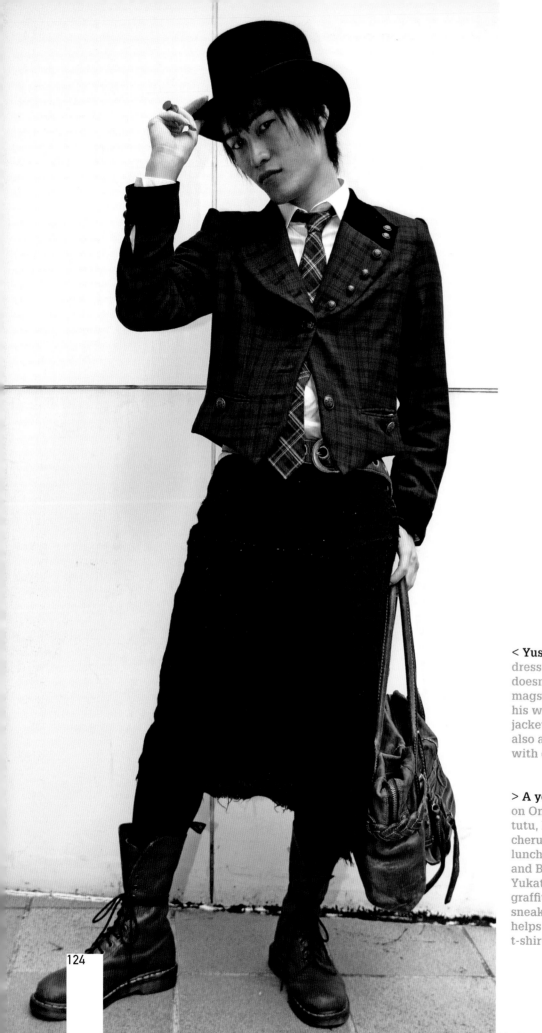

< **Yuske from Osaka** seen here
dressed the way he enjoys. He
doesn't like being told by fashion
mags what to wear. He does things
his way. His jacket is a woman's
jacket, as is the skirt, but there's
also a man's shirt and top hat paired
with classic Dr Martens boots.

> **A young couple** pose for a picture
on Omotosando. She wears a pink
tutu, blue wig, a wool sweater with
cherub image and carries a Barbie
lunch-box. Her theme is pretty bows
and Barbie-love. Her friend wears a
Yukata style shirt, with lizard detail
graffiti print trousers with high-top
sneakers. His obi or cummerbund
helps connect his floral themed
t-shirt.

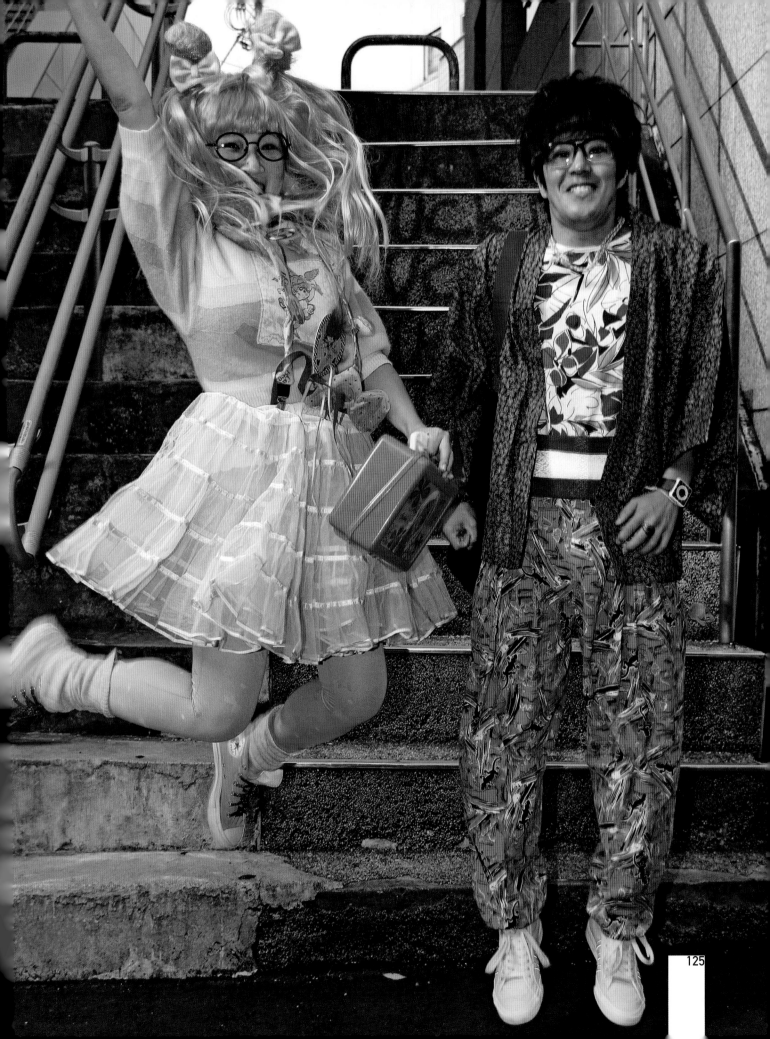

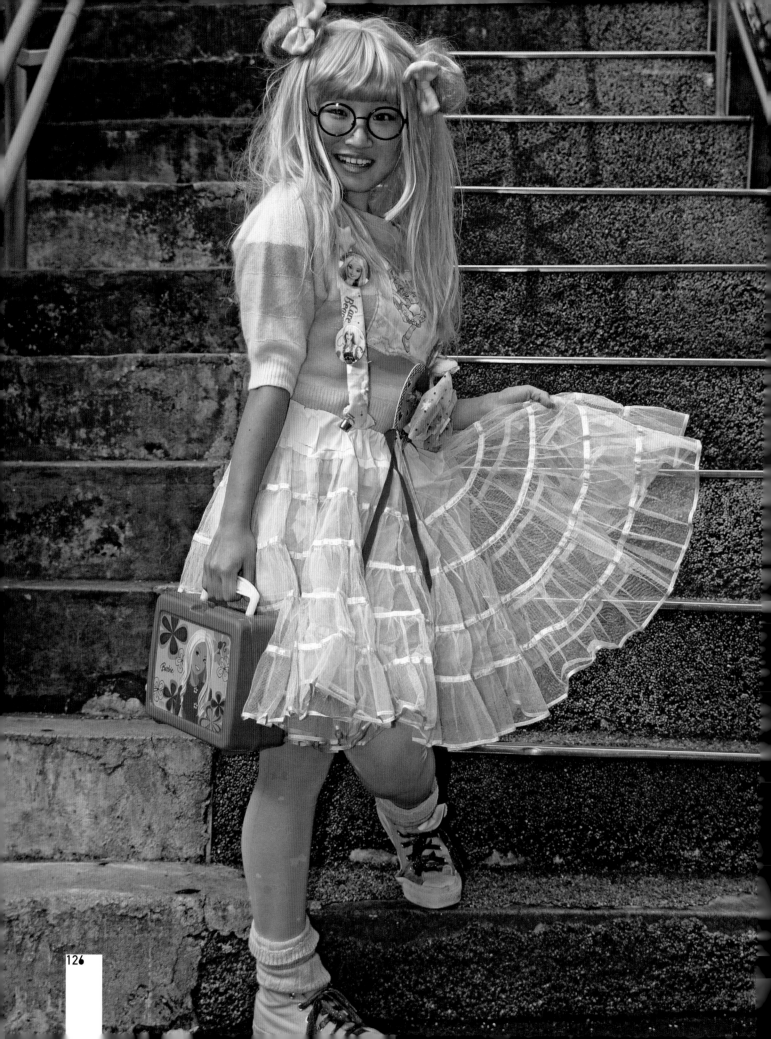

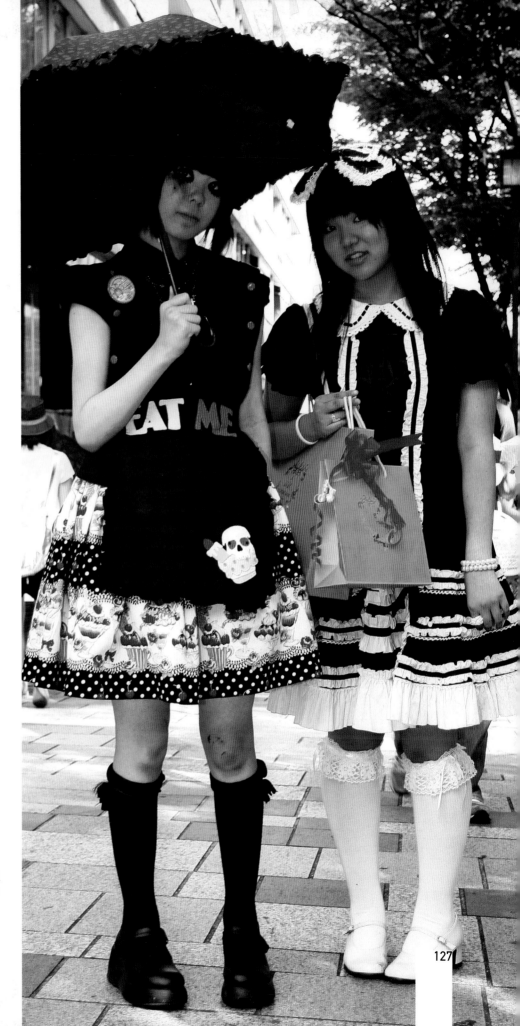

> A bloody sight. Two girls dressed amazingly in Visual Kei style. Wigs and paint splattered to simulate blood. Amazing work for an amazing look.

127

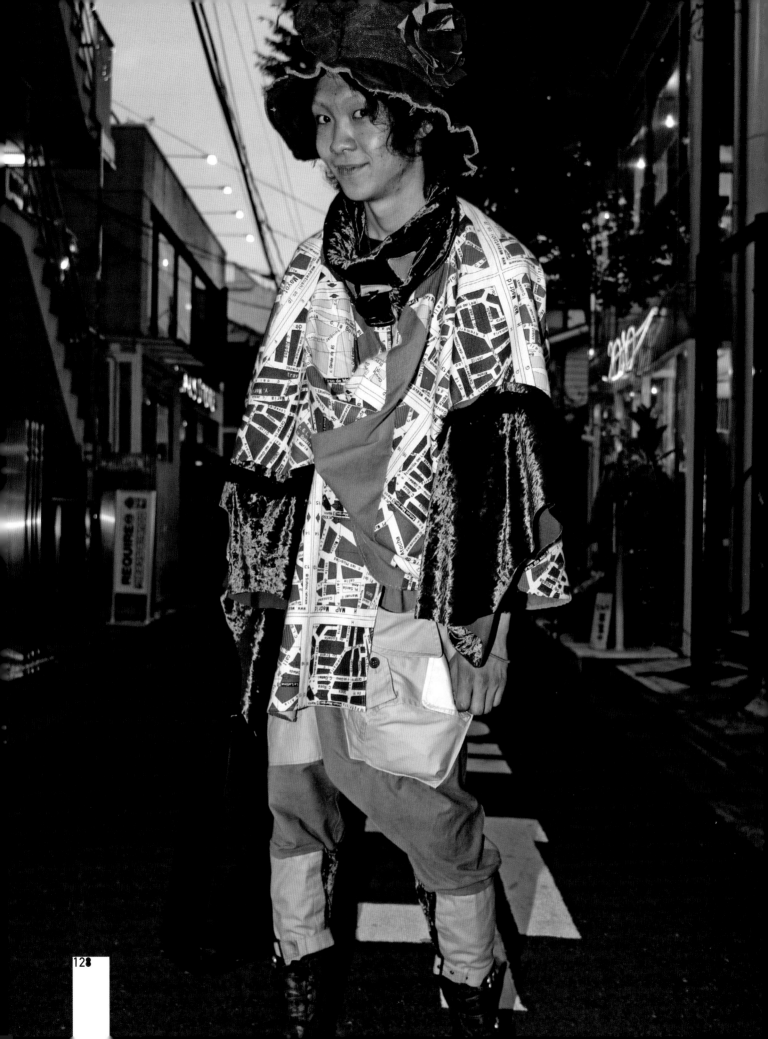